IMPRESSIONISM

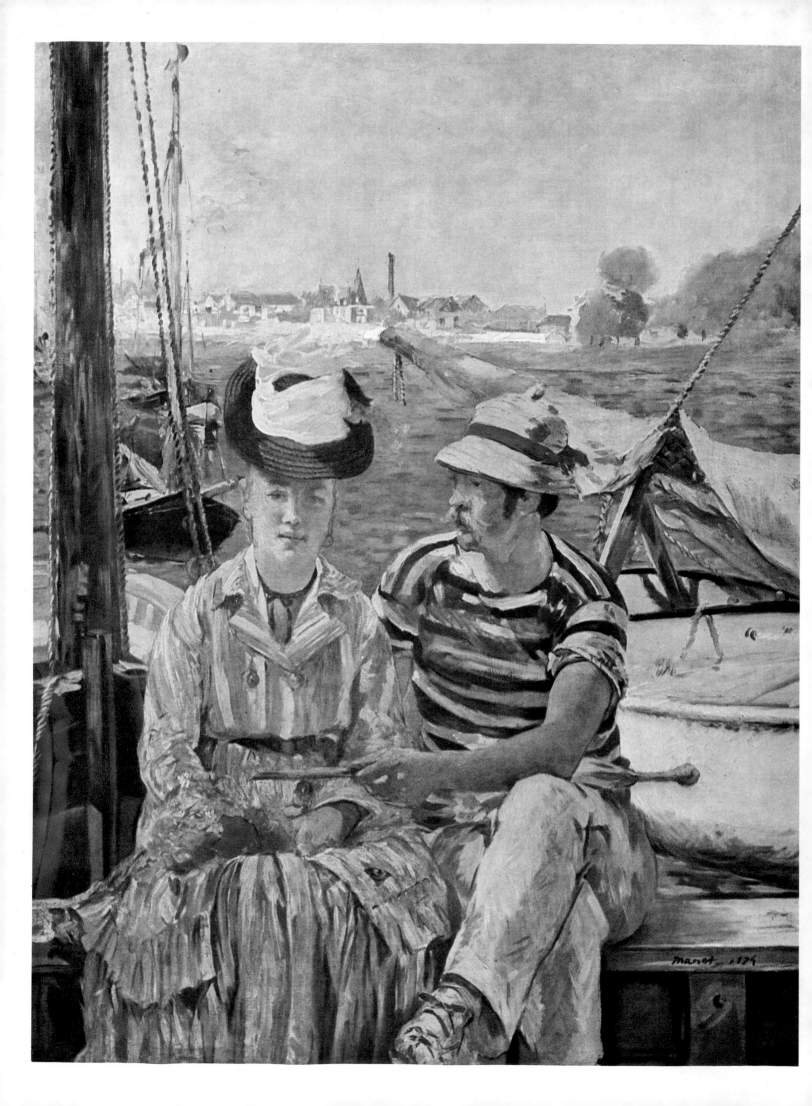

Pierre Courthion

IMPRESSIONISM

Translated by John Shepley

Harry N. Abrams, Inc., Publishers, New York

EDOUARD MANET (1832–1883)

Painted in 1874

Argenteuil

Oil on canvas, $58\frac{5}{8} \times 51\frac{1}{2}''$
Musée des Beaux-Arts, Tournai, Belgium

This picture, posed for by the painter Rudolph Leenhoff, Manet's brother-in-law, and a woman who regularly attended boating parties, is one of the finest *coups de soleil* of Impressionist painting. Despite its technique of broad patches of color on a wide surface, everything here breathes the open air, the light, the heat of summer. It is the period when Claude Monet—following Daubigny's example—painted in his floating studio, as Manet one day caught him in a picture.

It is noon on the water, striped with sunlight. The poses are completely natural, the boating accessories adroitly placed. The landscape blends into the pale daylight.

Manet was frivolously reproached for making the Seine "an extravagantly blue Mediterranean." Someone accused him of "going back to the state of a twenty-year-old student." "It is a despicable daub," wrote a so-called critic.

For all his desire to please women and be admitted to the Salon, Manet, as we can see, was one of the most spurned of painters. He was a revolutionary in spite of himself.

Two years after painting *Argenteuil*, he wrote to Théodore Duret: "Today I go before the jury. This evening or tomorrow morning I will know my fate." And the next week he wrote: "My two pictures were rejected."

Argenteuil was the fourth painting in the sale of Manet's studio in 1884. It was bought back for 12,500 francs by Mme Manet, and resold in September, 1889, to the painter Van Cutsem, who in his turn bequeathed it to the Tournai museum.

Library of Congress Cataloging in Publication Data

Courthion, Pierre.
 Impressionism.

 Bibliography: p.
 Includes index.
 1. Impressionism (Art) 2. Art, Modern—19th
century. I. Title.
N6465.I4C6813 1977 759.05 76-50479
ISBN 0-8109-2067-0
ISBN 0-8109-1112-4

Library of Congress Catalogue Card Number: 76-50479
Published in 1977 by Harry N. Abrams, Incorporated, New York

CONTENTS

IMPRESSIONISM

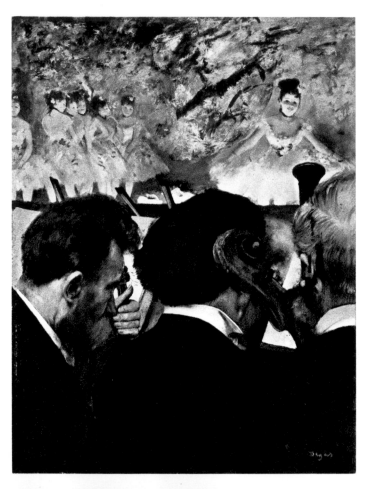

Edgar Degas. *Musicians in the Orchestra.* 1872.
Oil on canvas, 27⅛ × 19¼″.
Städelsches Kunstinstitut, Frankfort

bottom left: Claude Monet. *Women in the Garden.*
1866–67. Oil on canvas, 100½ × 80¾″.
Museum of Impressionism, The Louvre, Paris

bottom right: Camille Pissarro. *Gathering of Apples.*
1881. Oil on canvas, 25½ × 21¼″.
Collection Mr. and Mrs. William B. Jaffe, New York

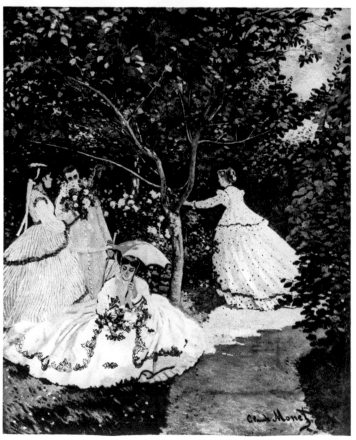

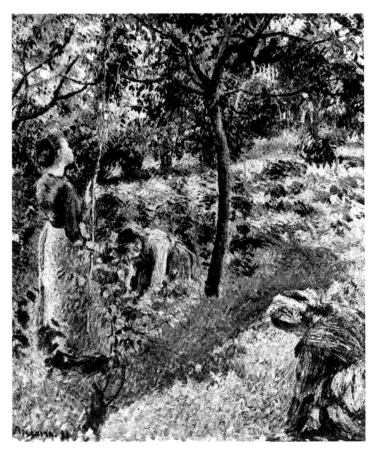

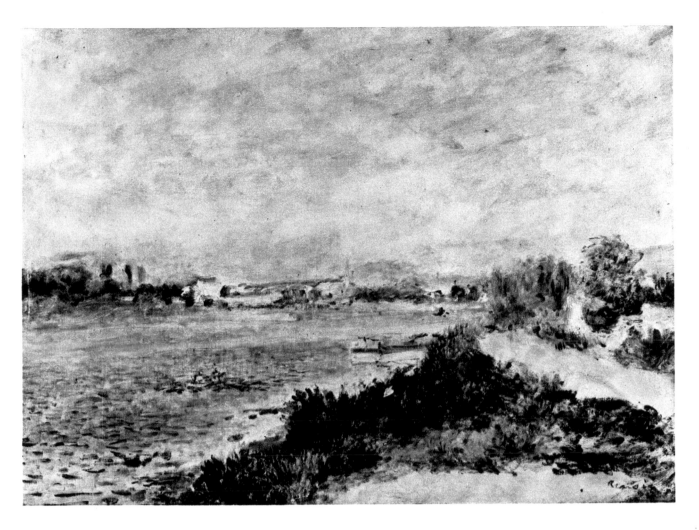

Pierre-Auguste Renoir. *The Seine at Argenteuil*. c. 1873.
Oil on canvas, 18¼ × 25⅝".
Museum of Impressionism, The Louvre, Paris

THE THEMES

Green, violet, flowing pink. In lively, proliferating brushstrokes, light trembling foliage, zigzag reflections on the water, the wakes of fishing boats and yawls. A dress, only seemingly green, gliding at the bend of a garden path; a zebra pattern of sunlight on the couples stretched out on the grass. A heightening of colors, almost of the very odors, in the sap-filled orchards. The noonday sun reigns over the summer, and the leaves are thick behind the table cleared of dishes. Nudes with opalescent flesh before the boundless sea. Couples dancing, the close of a meal, streets decked with flags, boulevards swarming with carriages and pedestrians, ballerinas in the glare of theater spotlights, Sunday promenades on the islands of the Seine—such are the themes of Impressionist painting.

The great historical machines, the *tours de force*, are over. No more the Last Judgment, the Rape of Europa, the Fall of Babylon. No more the worship of the antique, no more of its cumbersome models. The warmth of life will replace the tepidity of such superseded art. No longer does the artist display his knowledge of anatomy and legend. Doors are opened, opened wide on the real sky and the freshness of the countryside. From now on the open air will be enchantment enough.

THE DEVELOPMENT

Two centuries after Claude Lorrain, the precursor who, intoxicated morning, noon, and evening by the effects of light and shadow, had painted his expanses of sea between Roman porticoes, a new group of artists came to the fore.

These eager young painters had met for the most part in two Paris academies: the tuition-free studio that a former model named Suisse had opened after the Restoration on the Quai des Orfèvres, and the academy directed by Charles Gleyre, an admirer of Ingres from the Swiss canton of Vaud.

In *père* Suisse's studio, there were neither teachers nor pupils. Anyone, young or old, could attend, and each was free to paint as he liked, after the model or from his own imagination, in pursuit of any style or technique. Delacroix had worked there, as had Bonington, Courbet, and Manet.

This democratic workshop was located on the second floor, reached, according to a former habitué, "by a very old, very dirty, wooden staircase."[1] It was a large, well-lighted room, with nothing remarkable but its walls, blackened by the smoke of generations of workers. The effect of bareness was only increased by the thinly padded benches and the total nakedness of the model.

The first of the future innovators to work there was Camille Pissarro, in 1857, and he was to be joined by Claude Monet, Armand Guillaumin, and Paul Cézanne.

Charles Gleyre's academy was quite different, and there in 1862, with Renoir, Sisley, Bazille, and Monet among the pupils, we find almost all the early shoots of Impressionism. Gleyre himself, a short man with glasses, was enamored of Classicism. Generous, modest, "a solitary by nature and by choice,"[2] he was hostile to reality and to what he called "that infernal color."[3] A misogynist, or rather a *gynophobe*, but obsessed by the female body (a passion which Renoir will owe to him), he painted icy nudes in his state of erotic repression.

In his studio, where he emphasized the importance of drawing, Gleyre was much esteemed by his pupils (had he not, in the course of his apprenticeship, copied the Giottos in Padua?). Monet alone resisted him, and kept himself apart. "In drawing a figure," said the master one day, "one should always think of the antique."[4] Bristling at these traditionalist words, Monet led his friends out of the studio. It was the first anti-academic reaction by the new group of artists.

DAY AND NIGHT

As the movement grew, of artists who were brought together by their interest in the world around them, it recruited an impressive following. We think of the Impressionists as a group, but they differed considerably among themselves. There were the partisans of *plein air*, of light, of nature rendered poetically (Monet, Pissarro, Sisley, Berthe Morisot, Renoir); there were those who might be called "Impressionists in spite of themselves," and who either adapted themselves to the movement or went beyond it (Degas, Bazille, Cézanne); those who later were to study optics and the science of the solar spectrum (Seurat, Signac, Dubois-Pillet); precursors of the Fauves (Gauguin, Van Gogh); and finally the lesser ones (Guillaumin, Mary Cassatt, etc.).

Some, painting by day, found their themes in the variations of light on landscapes and nudes. Others were nocturnal, working mostly by gaslight and the illumination in theaters. But whatever their inclination or bent, why should we eliminate certain painters from Impressionism simply because they were not whole-hearted practitioners of the *plein-air* school? All of them, sun-worshippers and night-walkers alike, composed their works with color, seeming to hum with Laurent Tailhade:

> *Si tu veux, prenons un fiacre*
> *Vert comme un chant de hautbois.*

> (If you like, let's take a carriage
> Green as the sound of an oboe.)

Pierre-Auguste Renoir. *Garden at Fontenay*. c. 1873.
Oil on canvas, 19⅞ × 24¼".
Collection Oskar Reinhart, Winterthur, Switzerland

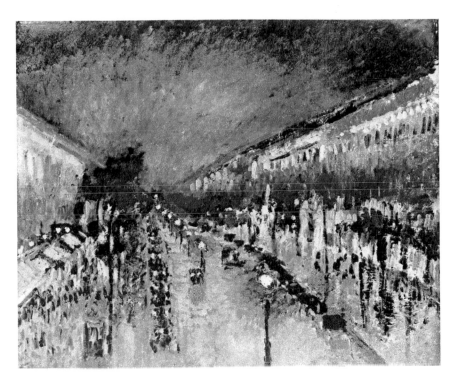

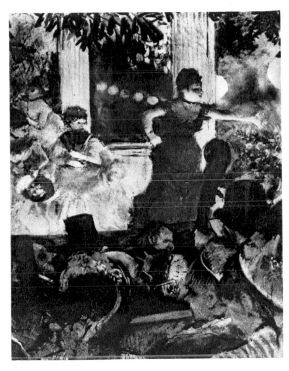

Camille Pissarro. *Paris, the Boulevard Montmartre at Night.*
1897. Oil on canvas, 21 × 25½″. National Gallery, London

Edgar Degas. *Café-Concert: At Les Ambassadeurs.*
1876–77. Pastel over monotype on paper,
14½ × 10⅝″. Musée des Beaux-Arts, Lyons

Richard Parkes Bonington. *The Water Parterre at Versailles.* 1826. Oil on canvas, 16½ × 20½″. The Louvre, Paris

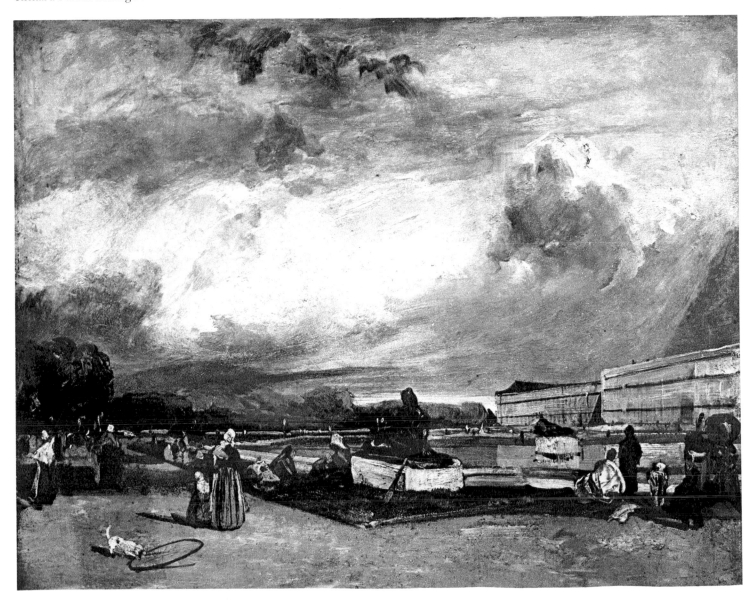

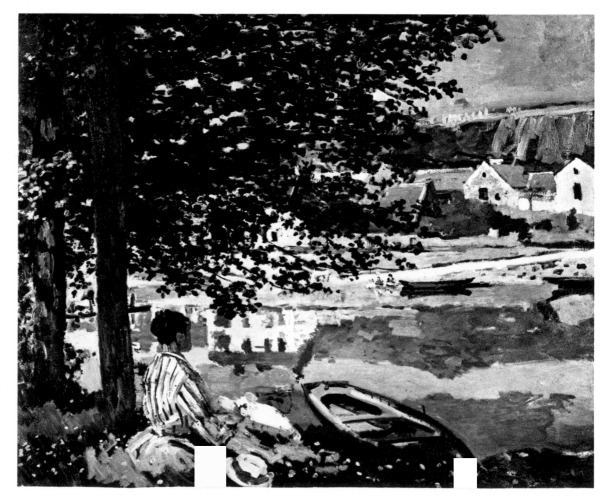

Paul Cézanne. *Gustave Geffroy*. 1895.
Oil on canvas, 45¾ × 35".
Private collection, Paris

As an historical witness of the movement, Gustave Geffroy gave this definition of it: "Impressionism, in its most representative works, is painting that approaches phenomenalism, the appearance and significance of things in space, and which tries to catch the synthesis of these things in their momentary appearance."[5]

For Claude Monet and those of his companions who are the most typical representatives of this poetic tendency, it was above all a question of a moment of sunshine, an instant of light. "To break up the ray of light, to catch its vibrancy in the air, to follow it as it glides around objects enveloping them with color,"[6] such was the first characteristic of their endeavor.

Although the Goncourts were the creators of the genre to which they gave literary expression even before it received a name,[7] the term Impressionism was coined in derision after a canvas painted by Claude Monet in 1872. This work, entitled *Impression, Sunrise*, was hung in the first exhibition of the new painting, which opened in April, 1874, on the Boulevard des Capucines in Paris, in the studios with red-brown walls lent for the occasion by the photographer Nadar.[8]

Previously the group had been divided. After its members had hesitated over calling themselves Actualists as proposed by Zola, or Realists as suggested by Degas, or

Claude Monet.
The River. 1868.
Oil on canvas,
32 × 39½".
The Art Institute
of Chicago. Potter
Palmer Collection

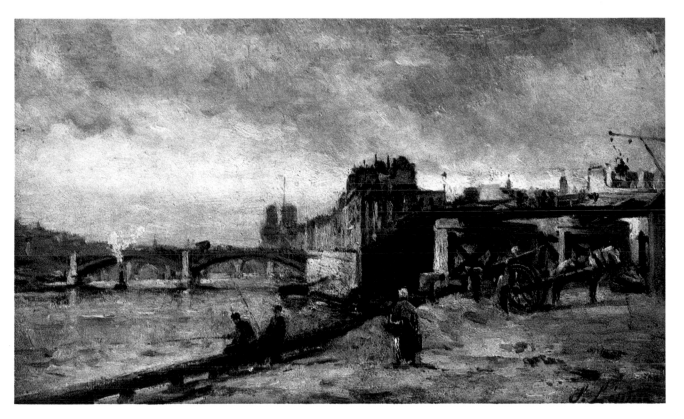

Stanislas Lépine. *The Pont de l'Estacade in Paris.* 1886. Oil on canvas, 5½ × 9¼″. Private collection, Paris

Intransigents, the new Salon assumed the innocuous title of the *Société anonyme coopérative d'artistes peintres, sculpteurs, graveurs, etc....*[9] It included among others Boudin, Lépine, Cals, Degas, Cézanne, Monet, Guillaumin, Pissarro, Renoir, and Sisley.

Louis Leroy, the bantering critic for *Le Charivari,* used the title of Monet's picture—a scene rendered in bold, sweeping, Turneresque strokes—as a pretext for dubbing the whole group *impressionnistes.*[10] Intended derisively, the name was then taken up with pride by the new painters, who made it their battle standard.

THE PRECURSORS

The signal given by Monet's "rising sun," round as a red moon and reflected in the waters of the port of Le Havre, corresponded to a "school of vision"[11] that had had its precursors in Rubens, Watteau, and Delacroix. Above all there had been the Englishman Turner, who, dazzled by the luminous enchantment of Claude Lorrain, had gone to the point of imitating him, before revealing himself a creator of marvels at once magical and terrifying in which the ruins of reality were concealed under sumptuous color. When Monet and Pissarro were in London in 1870, they had been to see the paintings of this wizard whose eye had seized that delicate, hazy, fleeting thing— nuance. And it was by nuance that French painters were

henceforth to be fascinated, seeking it in water and sky, in mists and flowers, in the dappled sunlight on the blouses of strolling women and the jerseys of boatmen.

Paul Cézanne. *Paul Alexis Reading to Emile Zola.* 1869–70. Oil on canvas, 51¼ × 63″. Museum of Art, São Paulo, Brazil

13

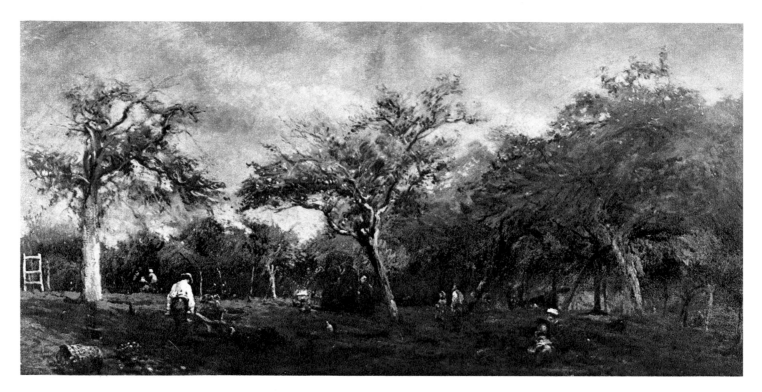

Félix Cals. *Sunday at the Saint-Siméon Farm* (*La Cueillette des pommes*).
1876. Oil on canvas, 23⅝ × 47¼″. Collection Count Arnauld Doria, Paris

Eugène Delacroix. *The Sea from the Heights of Dieppe*.
1852. Oil on wood, 13¾ × 20″. Collection Marcel Beurdeley, Paris

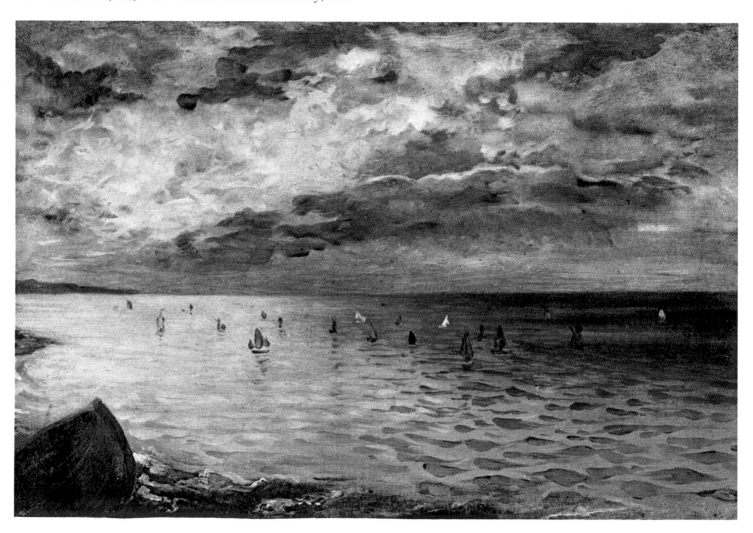

Closer to home there was Courbet and his *Demoiselles des bords de la Seine,* a *plein-air* picture painted in 1856. The artist, later to be exiled,[12] here demonstrated to the younger painters the realism of a compact, corporeal. richly colored painting on a fresh and healthy theme. Thus in the beginning, Impressionism, as Albert Aurier wrote, is "merely a kind of realism, a refined, spiritualized realism. . . . The aim is still the imitation of the subject matter, perhaps no longer in its own form, but in its perceived form, its perceived color. It is the translation of the instantaneous sensation with all the distortions of a rapid and subjective synthesis."[13] That is to say that imbued as they were with the reality that lay before them, the Impressionists unconsciously sought the means to transform it poetically in the Baudelairean sense.

Jongkind, "that great mad Dutchman with his bad French, a tireless drunkard listening to the wind," had already laid the groundwork for Impressionism.[14] And Boudin had abandoned his frame and art-supply shop in Le Havre to take up painting vacationers and ladies in crinolines on the beaches of Calvados. He thus became the painter of atmospheric phenomena, of wind and clouds. "Three strokes of the brush after nature," he said, "are worth more than two days of laboring at the easel."

Finally there was Edouard Manet, a revolutionary in spite of himself. His superb and stunning *Lola de Valence,* with its soft savory impasto, the *Déjeuner sur l'herbe,* and the justly famous *Olympia,* had set off waves of mockery in the Paris of trifling journalists and *boulevardiers.* Manet, in opening his art to *plein-air* subjects and the light of day, proceeded partially to adopt the technique of Claude Monet, whom he watched painting—and whom he himself painted—in his studio-boat on the Seine at Argenteuil. As Armand Silvestre has said, "Manet, not being

Gustave Courbet. *Les Demoiselles des bords de la Seine.* 1856. Oil on canvas, 68⅛ × 81⅛". Musée du Petit Palais, Paris

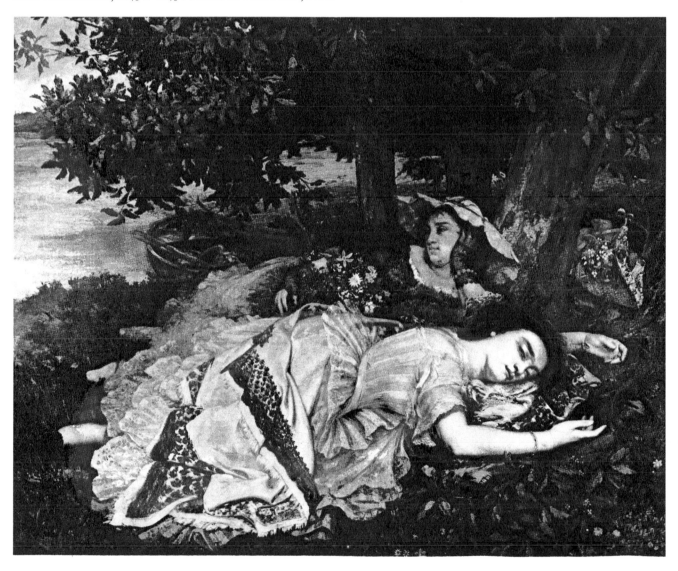

15

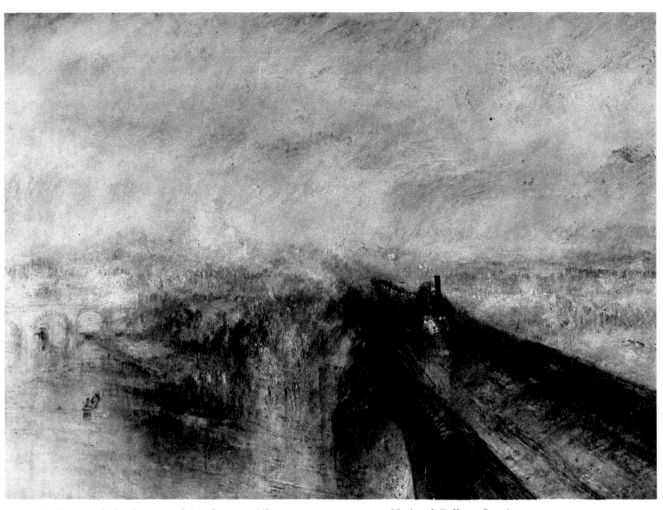

J. M. W. Turner. *Rain, Steam, and Speed.* 1844. Oil on canvas, 35¾ × 48″. National Gallery, London

J. M. W. Turner. *Interior at Petworth.* 1830–37. Oil on canvas, 35¾ × 47¼″. Tate Gallery, London

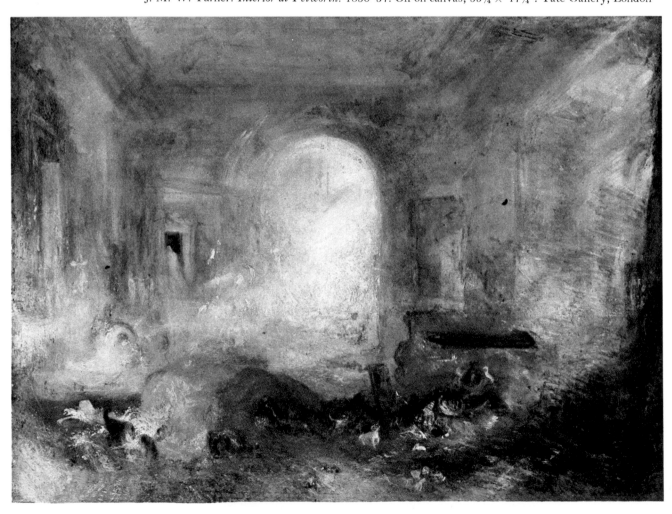

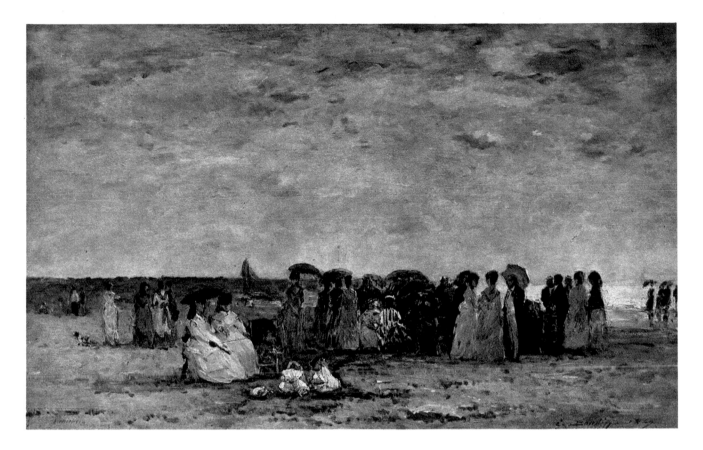

Eugène Boudin. *Bathers on the Beach at Trouville.* 1869.
Oil on wood, 11¾ × 18⅞". Museum of Impressionism, The Louvre, Paris

a solemn painter, was the first to brighten and restore light to the French palette."[15] At almost the same time, in the United States, Winslow Homer, four years younger than Manet, was painting open-air scenes in a similar range of clear tones.

What the horse had been for Romanticism, and the oaks of Barbizon for Realism, the sun became for Impressionism: it was its symbol and god.

It was the end of the *tenebrosi*. From now on, illumined and sparkling even in Whistler's nocturnes and Degas's ballets, painting was to be "definitely rid of litharge, bitumen, chocolate, tobacco juice, and burnt fat and crust."[16]

PICTORIAL CLIMATE

After Courbet's *Demoiselles*, the Seine and its banks from Paris to the sea would be the open-air studio for all of Impressionism. Here begins the long, luminous sequence of works which make Le Havre, Honfleur, Trouville, and Deauville the cradle and workshop of the new painting. It all begins here. It is at *mère* Toutain's inn at the Saint-Siméon farm on the heights of Honfleur that Boudin, Baudelaire, Courbet, and Monet meet; and it is not far from there, at Port-en-Bessin, at Grandcamp, that after the innumerable views of the river and its banks at Paris, Argenteuil, Vétheuil, Giverny, and Rouen done by his predecessors, Seurat will complete the circuit of Seine painting.

Although it would be a mistake to assign it only to France, Impressionism in other countries was little more than superficial. If it is not bound to a particular race, it nevertheless seems to belong to one country, and to a climate situated between the Seine estuary and Paris (only some of its last representatives will migrate toward the Mediterranean coast).[17] German art historians have likewise recognized that in its rare manifestations, Germanic Impressionism is "more turbid, more somber, and more problematic than the French."[18]

The unforeseen light of the moment—is that not for the Impressionist the ideal situation? In the Seine estuary—and particularly on the bay of Sainte-Adresse—there are moments at the height of summer when the light is as blinding as in Sicily Then it softens to the whiteness of a pearl.[19]

Let us not forget the beach at Etretat, which before Courbet had attracted the fashionable society of the Second Empire. "There," writes Michel Belloncle, "the best weather for the eye, if not for one's comfort, is when it is overcast with rifts in the clouds. The light, shifting

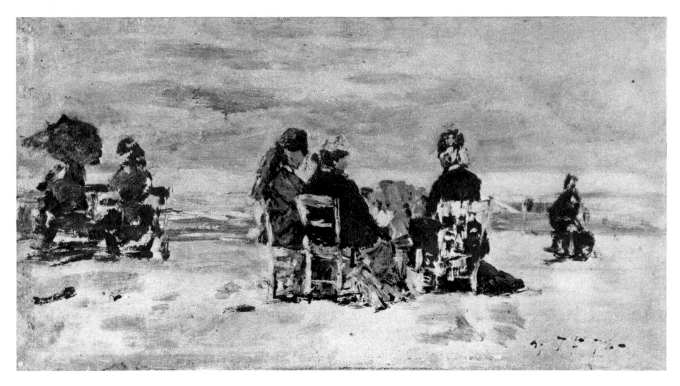

Eugène Boudin. *Women on the Beach at Trouville*. 1872. Oil on wood, 5½ × 10¼″. Musée Eugène Boudin, Honfleur

Claude Monet. *La Grenouillère*. 1869. Oil on canvas, 29⅜ × 39¼″. The Metropolitan Museum of Art, New York. Bequest of Mrs. H. O. Havemeyer, 1929. The H. O. Havemeyer Collection

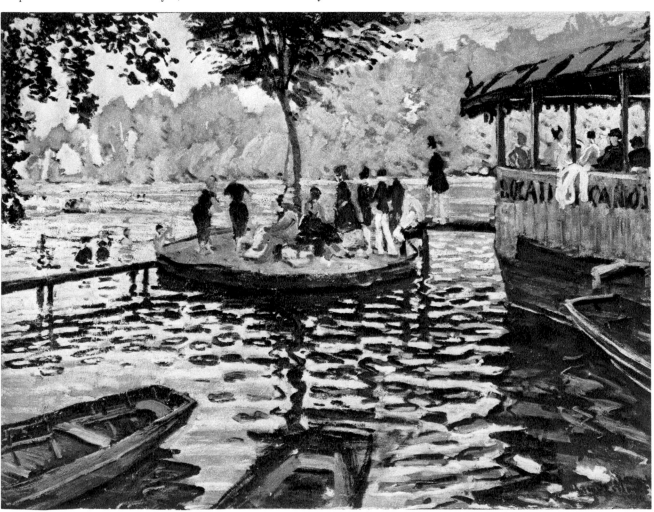

Johan Barthold Jongkind. *Rue Saint-Jacques in Paris*. 1876.
Oil on canvas, 22¼ × 17¾″. Private collection, Paris

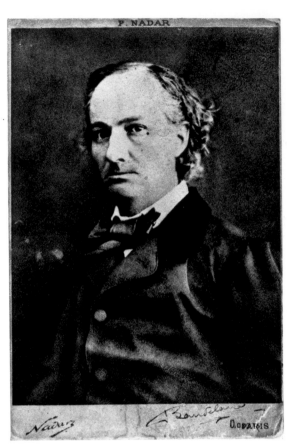

A.-M. Lauzet. *Albert Aurier*. 1893.
Etching

Baudelaire. Photograph by Nadar.
Bibliothèque Nationale, Paris

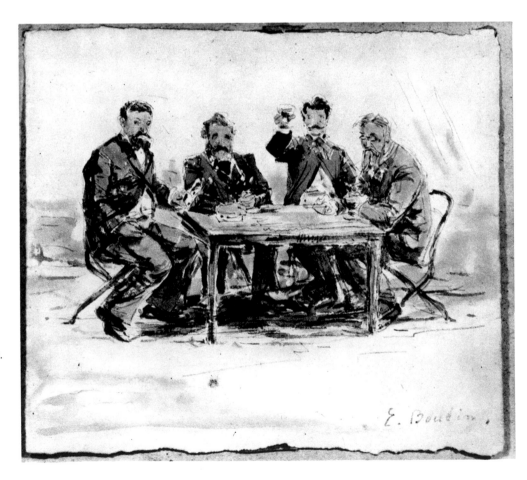

Eugène Boudin.
At the Saint-Siméon Farm.
c. 1867. Watercolor.
Galerie Schmit, Paris.
(*Left to right*: Jongkind,
the animal painter Emile
van Marcke, an unknown
drinker, and *père* Achard,
a friend of Boudin's)

Henri Fantin-Latour.
*Studio in the
Batignolles Quarter.*
1870. Oil on canvas,
68½ ×82″.
The Louvre, Paris.
(*Left to right*:
Scholderer, Manet, Renoir,
Astruc [seated], Zola,
Maître, Bazille, Monet)

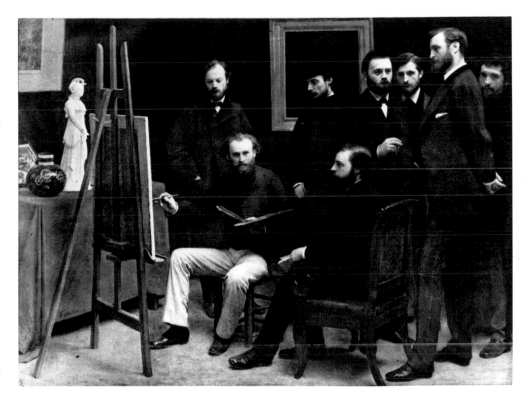

below:
Edouard Manet.
Le Déjeuner sur l'herbe.
1863. Oil on canvas,
84½ × 106¼″.
Museum of Impressionism,
The Louvre, Paris

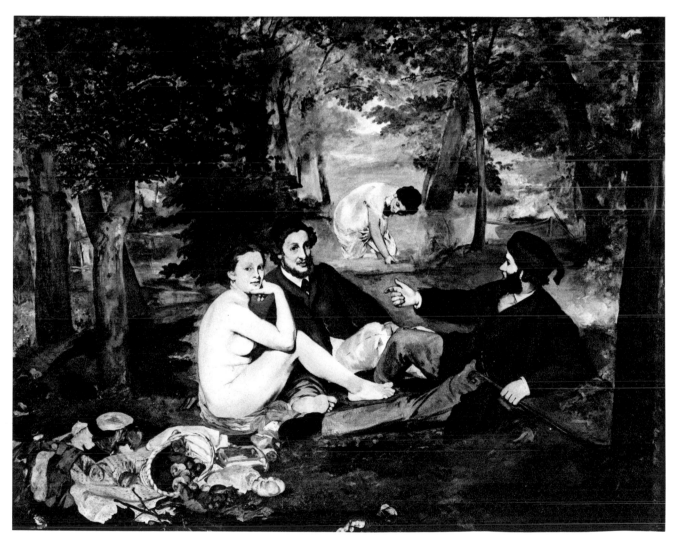

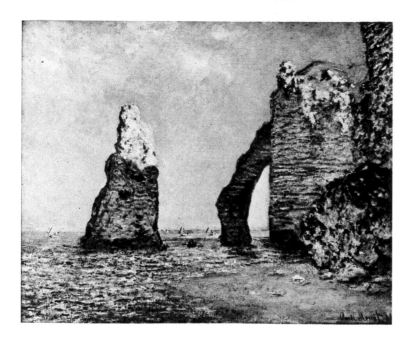

Claude Monet. *The Cliffs at Etretat*. 1885.
Oil on canvas, 25½ × 32″. Sterling and Francine
Clark Art Institute, Williamstown, Mass.

from one moment to the next, imparts surprising tones
to the water, the strand, the cliff."[20]

At Etretat the young Guy de Maupassant followed
Claude Monet in his search for impressions. "He was no
longer in truth a painter," he wrote, "but a hunter. He
went out, followed by a child who carried his canvases,
five or six canvases representing the same subject at
different hours of the day and with different effects. He
took them up and put them aside in turn, according to the
changes in the sky. And the painter, facing his subject,
lay in wait for the sunshine or for the cloud that passed,
and disdainful of error or propriety, painted them ra-

pidly on his canvas. I have seen him thus seize a glitter-
ing play of light on the white cliff and fix it with a flow of
yellow tones which rendered in a strangely surprising
way the effect of that unseizable and blinding brilliance.
Another time he took the rain beating on the sea in his
hands and dashed it on the canvas."[21]

THE IMPRESSIONIST TOUCH

It is time to speak of technique.

As a reaction against the minute technique and smooth
modeling practiced by the traditionalists, the brushwork
became more and more apparent. Dry or moist, extended
or short, in slashing strokes or gradual ones, applied
heavily or scarcely grazing the canvas, it chopped zigzag
reflections on the water, brought to life the woman or
the flower, illuminated the shadows, and accented the
picture with a marvelous disorder.

Impressionism meant also the suppression of line and
of chiaroscuro, the objects no longer being separated from
their setting, but enveloped by atmosphere and height-
ened by reflections. No longer was the drawing fixed or
the outline sharp. Instead all was undefined, following
the variations of time, light, and taste.

Still worse perhaps than the brilliant color, in the eyes
of the formalists, was the abandonment of that finished
quality that had played its tricks on more than one painter
since the reign of David. How many had foundered in dull
monotony for having lost the freshness of a sketch by too
much application! And here all of a sudden, on the heels

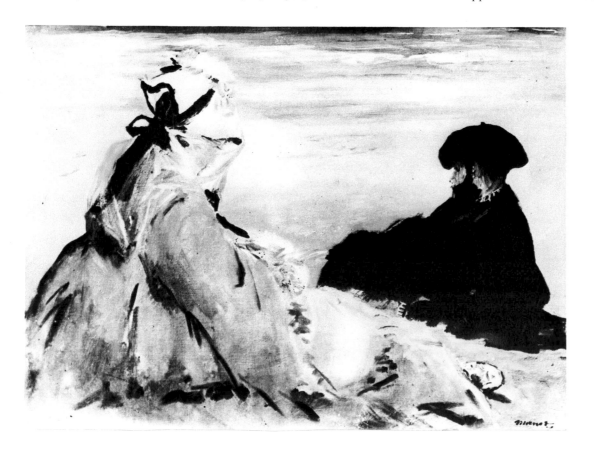

Edouard Manet. *On the Beach*.
1873. Oil on canvas,
22½ × 28⅜″.
Museum of Impressionism,
The Louvre, Paris

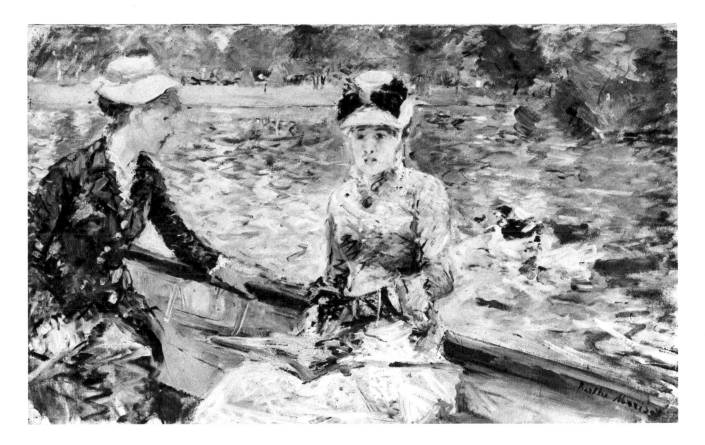

Berthe Morisot. *Eté (Summer)*. 1879.
Oil on canvas, 18⅛×29½".
National Gallery, London

below: Pierre-Auguste Renoir. *Woman Reading*. 1875–76.
Oil on canvas, 18½×15".
Museum of Impressionism, The Louvre, Paris

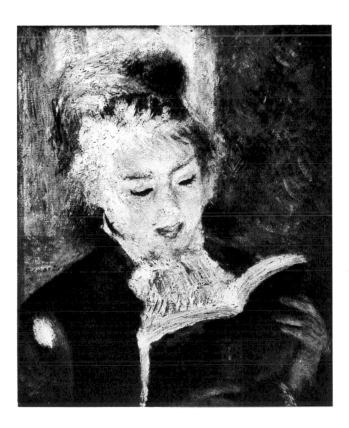

Claude Monet. *Unloading Coal*. 1872.
Oil on canvas, 21⅜×26".
Collection Durand-Ruel, Paris

of Delacroix and Turner, a horde of savages had set them-
selves up as artists! The nature by which they were
inspired no longer had the clear outlines of patiently
finished studio painting; it now lay everywhere. Lightly
evoked in a myriad of distinct or dissolving brush-
strokes, it became mist, sparkle, and brightness.

Henceforth the artist finishes a study; he does not fin-
ish a picture. He leaves the way open for further possi-
bilities. But declining to call himself the victor does not
mean that he has been defeated. On the contrary, the
sketch of an Impressionist often goes further than the
finished work of a traditionalist. All the artists of the
group share, if not absolute confidence in the feelings
they experience (this would be true of Monet but not
of Cézanne), at least a certain surrender to the uncertain,

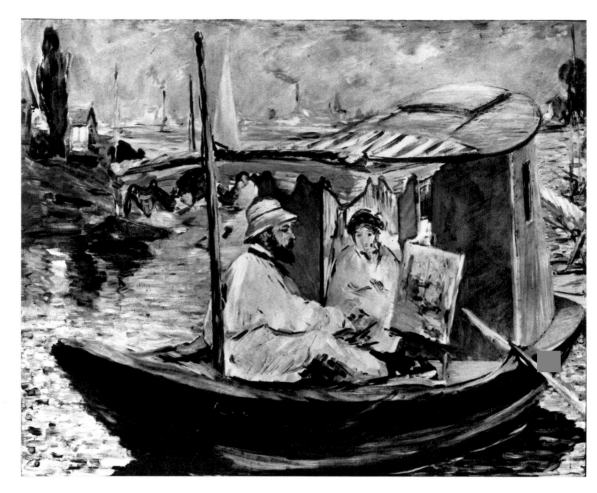

Edouard Manet.
*Claude Monet
in His Floating Studio
(Argenteuil).*
1874. Oil on canvas,
31½ ×38⅝″.
Neue Staatsgalerie,
Munich

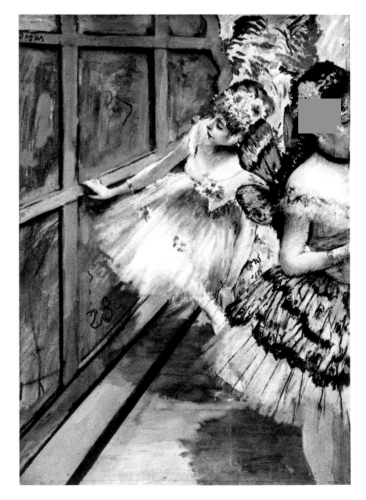

Winslow Homer. *Girl by the Seacoast.* 1888.
Oil on canvas, 23×15″. Courtesy Museum of Fine Arts,
Boston. Gift in part of Walston C. Findley, Jr.

Edgar Degas. *Dancers Behind Stage.* c. 1880.
Pastel, 27⅛ ×18⅞″.
Collection Mrs. H. Harris Jonas, New York

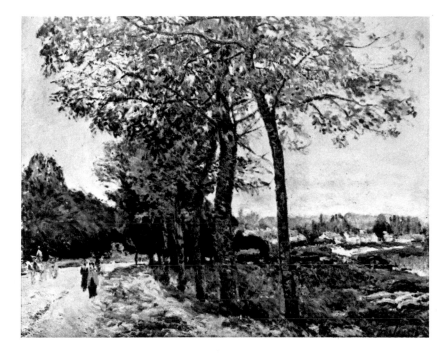

Alfred Sisley. *The Seine at Marly.*
1876. Oil on canvas,
23⅝ × 29⅛″. Musée des Beaux-Arts, Lyons

Paul Cézanne. *Quai de Bercy in Paris.*
1880. Oil on canvas, 23½ × 28½″.
Kunsthalle, Hamburg

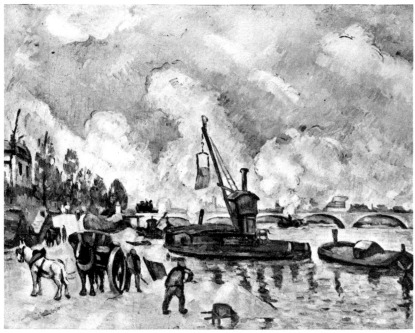

Georges Seurat.
Le Bec du Hoc, Grandcamp. 1885.
Oil on canvas, 25¾ × 32″.
Tate Gallery, London

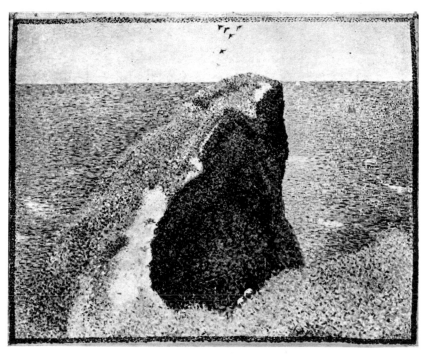

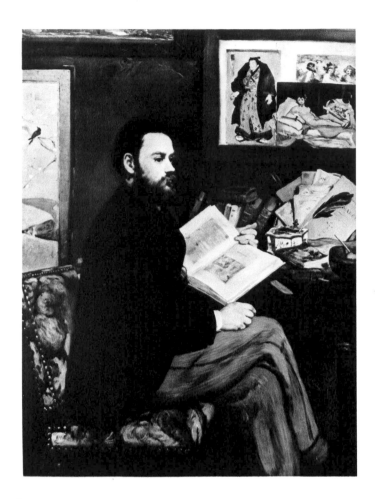

to the undefined, to the inspiration that impels the mind and guides the hand with warmth and sensitivity.

Form is effaced by color. The light has its shimmer, its continuous palpitation. Under the influence of Japanese prints, some painters (Monet, Degas, Lautrec, Van Gogh) arrange flat areas of color and cut their forms without regard to the picture's edge.

For once it was necessary for an artist to experience on his canvas the sound of the wind and the trembling of the leaves, to see the haze covering the landscape, the dancer transformed by the spotlight, the rays of the sun mottling the body of the nymph who had now become simply a bather.

> *Et tout . . .*
> *Semblait fourbi, clair, irisé.*
> *Le liquide enchâssait sa gloire*
> *Dans le rayon cristallisé.*[22]

> (And all . . .
> Seemed polished, bright, iridescent.
> The liquid enshrined its glory
> In the crystal ray.)

To show, in the "perpetual growth"[23] of his painting, a series of stages, of arrivals and departures, instead of repeating what his predecessors had done—this was the destiny of the Impressionist painter.

above:
Edouard Manet. *Emile Zola*. 1868.
Oil on canvas, 57 × 44⅞".
Museum of Impressionism,
The Louvre, Paris

Edgar Degas.
Amateur Jockeys near a Carriage.
c. 1877–80.
Oil on canvas, 26 × 32¼".
Museum of Impressionism,
The Louvre, Paris

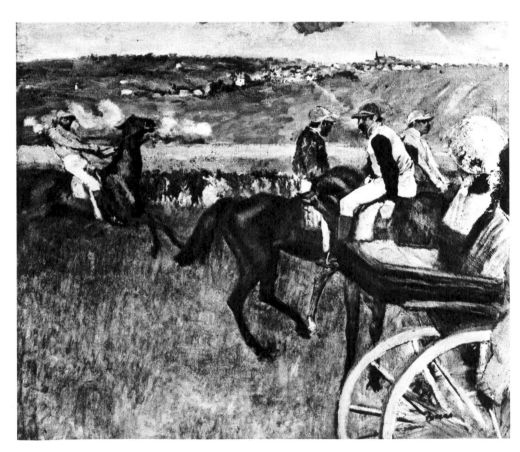

Also, little by little, tired of prolonging an attachment to the subject matter which acted only as a curb on their ardor for improvisation (Cézanne alone will be able to retain the point of departure from the real, and use it as a springboard), the Impressionists went on to substitute the reflection for physical nature, enchantment for reality. The most Impressionist of all will finally paint in series, and by thus incorporating his subject, knowing it "by heart," will discard still further the preoccupation with reproducing reality.

Under such conditions, what miraculous gift of Impressionism enabled it to go on representing persons? According to Meyer Schapiro, portrait painting could only survive with difficulty in the "Impressionist vision of the world." Was not the human countenance, in the eyes of the Impressionist painters, subject to the same play of color and improvisation as the sea and sky? Did it not then become "increasingly a phenomenon or surface, with little or no interior life"?[24] All that is true enough. But the Impressionists did not pretend to be psychologists, they were not interrogating the faces they painted. As we have seen, light was for them the principal attraction. In depicting man, all that interested them was his external aspect, imbued with the surround-

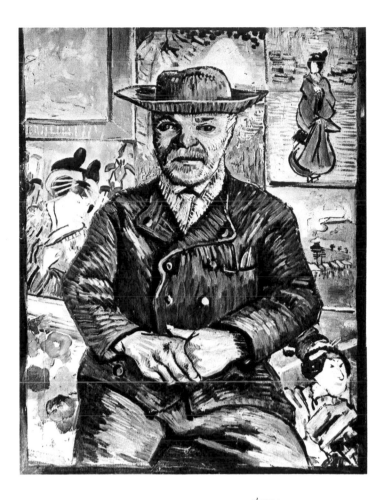

above:
Vincent van Gogh.
Portrait of Père Tanguy. 1887.
Oil on canvas, 25 × 19".
Collection Stavros S. Niarchos

Paul Cézanne.
Mont Sainte-Victoire Seen from Les Lauves. c. 1904–6.
Oil on canvas, 25 × 32⅝".
Kunsthaus, Zurich

27

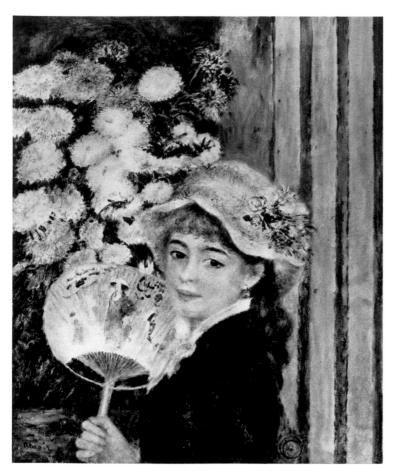

Pierre-Auguste Renoir. *Girl with a Fan*. 1881. Oil on canvas, 25½ × 21¼". Sterling and Francine Clark Art Institute, Williamstown, Mass.

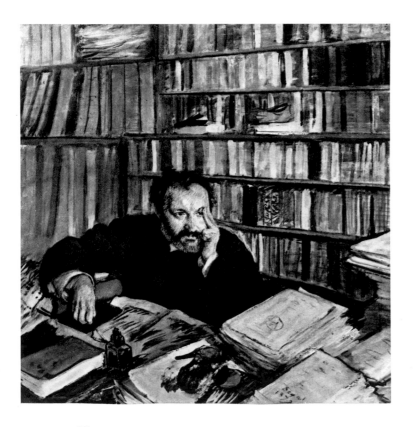

Edgar Degas. *Portrait of Duranty*. 1879.
Distemper, watercolor, and pastel on linen, 39¾ × 39½".
Glasgow Art Gallery and Museum. Burrell Collection

ing atmosphere. This fact may serve to allay certain objections.[25] The new age imposed on Renoir, who "put his contemporaries into pictures,"[26] a different conception from the portraits of Titian or Rembrandt. Renoir painted the whirl of the crowd in spots of color, groups of friends around cabaret tables, woman in her fleeting appearance and her ripe nudity. For him, the portrayal of a person was not a subject above others, and was not to be distinguished from a landscape or still life.

Much more than their predecessors, the Impressionists all painted the passing scene (strollers and carriages), the fleeting moment in nature (wind in the trees, clouds, haze, the flow of rivers), action unfolding in space (horse-races, dancers on the stage), the breath of life (a momentary glance, the torso of a girl bathing in the sunlight). All of them took these things in their natural aspect, and in so doing created a splendid unreality. As Robert de la Sizeranne wrote: "Under the pretext of better showing the light reflected by the monster, they concealed the monster."[27]

REPROACH AND SCANDAL

Naturally there was criticism. Fromentin accused the Impressionists of fragmenting reality. Duranty came to their defense, commending them to the author of *Les Maîtres d'autrefois* for seeking new subjects in the life of the present. Some reproached these colorists for their broad and motley technique, their "violettomania."[28] They were said to have lost the notion of green. They were accused of "cacophony," of haste, of "painting pictures that would make tram-horses rear up in fright."[29] People laughed at their saffron-colored portraits, at their sun-spotted nudes, at their scarlet seas, and denounced their "chameleon" palette. It was said that they did not carry the execution of their work beyond a first glance, that their landscapes had been viewed through the window of a train.[30] For them, "a factory was as good as a temple, a suit of clothes as good as a doublet, and a locomotive the equal of the horse of Phidias."[31]

Not content with attacking their art, the fastidious gentlemen of the Académie des Beaux-Arts regarded the Impressionists as *communards*, and outdid themselves to show that this revolution in painting coincided with the Paris insurrection of 1871. "A little more," says Geffroy, "and their paintings would have been handed over to the firing squads."[32]

CHEZ MM. LES PEINTRES INDÉPENDANTS, PAR DRANER.

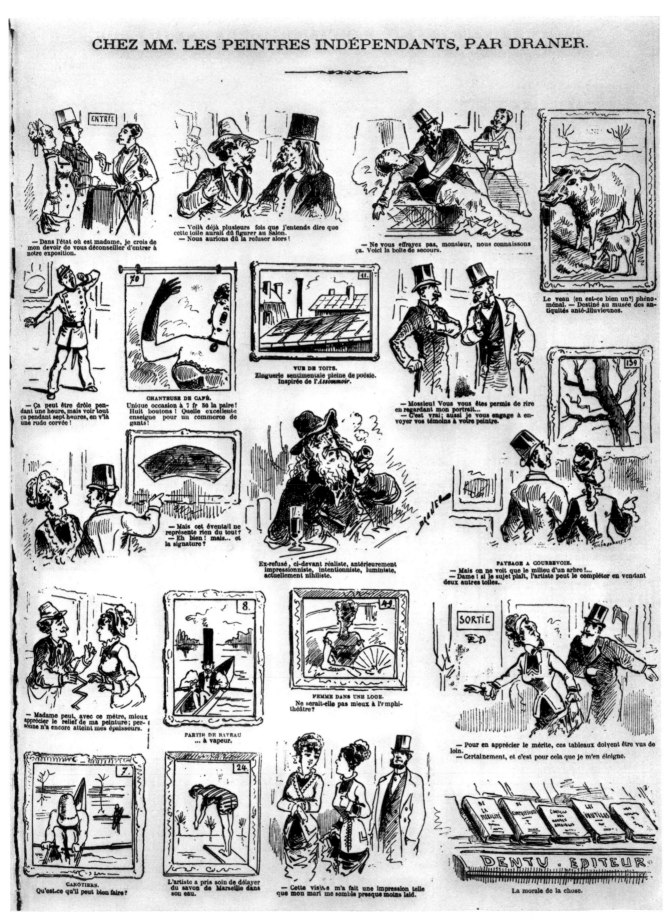

Caricature by Draner on the exhibition of the Impressionists. *Le Charivari*, April 23, 1879

What did the Institut and the Ecole des Beaux-Arts have to offer instead? Society genre painting in the manner of Meissonier, clusters of nudes by Bouguereau and Cabanel, the muddy portraits of Bonnat, the army scenes of Alphonse de Neuville, the medievalism of Jean-Paul Laurens.

In the changing climate of opinion, which little by little was operating in favor of Manet, of Monet, of Degas (of them all, Cézanne remained the least understood, the most attacked, the most abused by the critics and public), the hue and cry of the conservatives became more violent, more spiteful toward what they called "a bomb thrown in the face of the public." In 1878, the official jury of the Salon, which had not yet recovered from the horror aroused by the Paris Commune, rejected Delacroix, Millet, Théodore Rousseau, and, with still more reason, the Impressionists. On August 8, 1885, Camille Pissarro wrote to Eugène Murer, the pastry cook

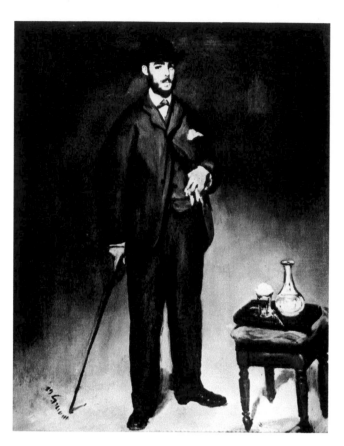

Edouard Manet. *Théodore Duret*. 1868.
Oil on canvas, $18 \times 13\frac{3}{4}''$.
Musée du Petit-Palais, Paris

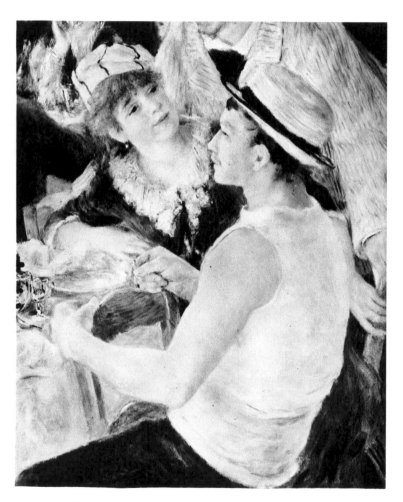

Pierre-Auguste Renoir. *Portrait of Caillebotte*. Detail from *Luncheon of the Boating Party*. 1881. Oil on canvas, $51 \times 68''$. The Phillips Collection, Washington, D.C.

and art collector: "Just think, here in Paris we are still outcasts, paupers. No, it is impossible for an art which upsets so many old convictions to achieve acceptance. . . . No, the bourgeois are the bourgeois from the tops of their heads to the tips of their toes."

Then there was the case of Caillebotte, the dilettante painter whom we see seated astride a chair in the foreground of Renoir's *Luncheon of the Boating Party*. Gustave Caillebotte had bought canvases by almost all the Impressionists. His collection included a good part of what now constitutes the Museum of Impressionism at the Jeu de Paume in Paris.[33]

In 1883, Caillebotte, "tired and a latecomer"[34] as a painter, drew up a will leaving sixty-five Impressionist works to the French nation. Foreseeing the difficulties that his gift could not fail to encounter at the hands of the authorities, the collector had stipulated a condition: the canvases were to be exhibited in Paris, at the Luxembourg Museum, and later at The Louvre.

The bequest was in danger of being refused. After Caillebotte's death in 1894, it took more than three years of negotiation with the administration of the Beaux-Arts before a compromise was reached. Thus twenty-seven of

these works, described at the time as "ordure," were returned to the artists or their heirs. Renoir's *Dancing at the Moulin de la Galette* owed its inclusion among the thirty-eight paintings retained by the State to the fact that a member of the Institut was one of the artist's models.

Finally, in 1900, at the Universal Exposition in the Grand Palais, where the Impressionists triumphed, there was the outburst by Gérôme, the smooth Philistine of the *Société des artistes français*. "Stop," he said to President Loubet, barring the entrance to a room filled with brightly colored canvases, "stop, *Monsieur le Président!* This is the shame of France."

Thinking of future interpreters of Impressionism, Théodore Duret, its first historian, emphasized the heroism of the painters and the courage of those men who took part in the movement. "One must say," he wrote, "that all of them, in love above all with their art, eager to extend it along new paths, thinking only of realizing the vision that arose within them, suffered constant mockery, abuse, and contempt, while holding themselves outside the channels where public favor and official encouragement are obtained. . . . Their valor should be held up as an example to all those who, in the service of a noble cause, will in their turn have to face poverty and persecution."[35]

The Impressionists

What were the Impressionists like as men and artists? What were the bonds that united them, the differences that separated them? How did they express their individual talents?

CLAUDE MONET

Monet's art, almost in itself, spans and crowns what is most significant in Impressionism. In "luminous waves," in "splashes of brilliance,"[36] he set down the moment on canvas. The *carpe lucem*. He was both the virtuoso of light and its willing subject. "When it gets dark," he confided to a friend, "I feel as though I'm dying."[37]

His portraits around the age of thirty-five show him with a well-kept beard and a determined, youthful look. Tabarant described him as "thickset, stocky, his shoulders on the defensive, his look piercing, but directed to the side the better to be on guard."

The figures that Monet assembles close up in his first canvases—in the Chailly woods where he works with Bazille—he will soon scatter and lose in the poppy fields, before eliminating them altogether. His eye has no equal in conveying the effects of luminous haze, rippling water, smoke, and crowds. Monet thus paints springtime landscapes, sunny winter scenes, rivers in summer, boulevards swarming with people, golden autumns. Duret saw him, brush in hand, "braving the wind and the heat of the sun, or standing in the snow. He puts a blank canvas on his easel, and begins abruptly

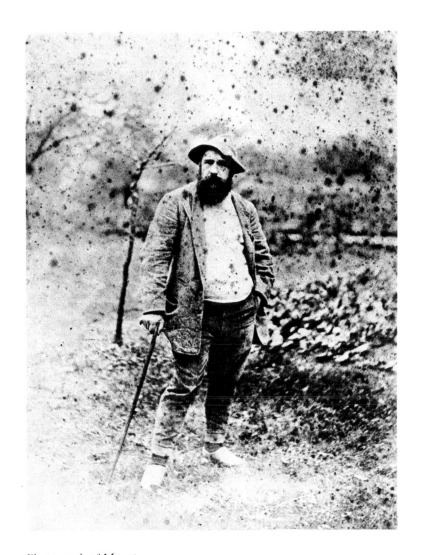

Photograph of Monet.
Musée Marmottan, Paris

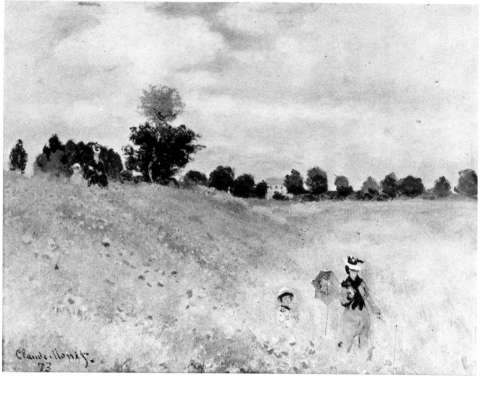

Claude Monet. *Wild Poppies.*
1873. Oil on canvas,
19⅝×25½".
Museum of Impressionism,
The Louvre, Paris

below:
Claude Monet. *Rouen Cathedral,
Portal, Gray Weather.* 1894.
Oil on canvas, 39⅜ × 25½".
Museum of Impressionism,
The Louvre, Paris

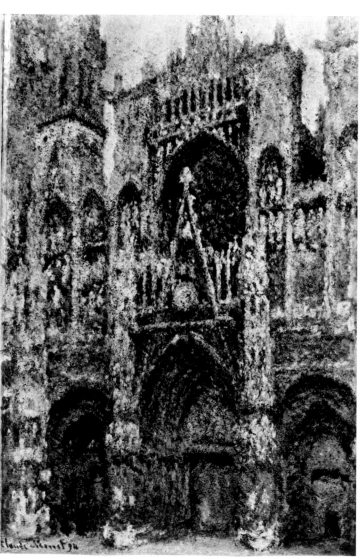

to cover it with patches of color. . . . Often during the first session, he achieves nothing but a rough sketch. Next day, returning to the site, he adds to his first sketch, and the details become sharp, the colors precise."[38]

Then everything became color, brilliant color, right up to the day when the painter begins his series of haystacks, of poplars, of cathedrals. However, the representation of objects still preoccupies him too much. His texture has something of nougat about it, something of pastry.

Finally, his eye, which "perceived to infinity the variegated particles of which an atom is formed,"[39] evoked his waterlilies over the reflection of a great liquid mirror. In the painter's studio, time slips away in innumerable variations on the play of atmosphere and flowers. On the shimmering surface of the water where the sky is reflected, all is illuminated, the light undulating and spreading like the diffusion of sound.

In his last paintings, which he called "flowering gardens," Monet dissolved substance and reality in light and color. We need not go along with Albert Aurier and say that he reached the point of "illuminating nothingness with sumptuous color," but the master of Giverny displays, shortly before his death, a technique of color and texture that renders the initial object unrecognizable. It is now simply a harmony of patches of color, of spaces, and tonalities, a *lyrical abstraction* which, at the time of its creation (1923–24), did not much please the Cubists and the strict abstractionists, but today is admired by partisans of a soft or "informal" style.

ALFRED SISLEY

Compared to Monet's many-sided gift, Alfred Sisley's seems frail. There is little variety in the scenes he painted: the banks of the Loing River drenched in dew, reflections on the water, village roads wet with rain, poplars on the banks of the Yonne where he had retired.

The son of wealthy parents ruined by the Franco-Prussian War in 1870, Sisley experienced continual poverty.[40] He found consolation and freedom in painting leaves, grass, shrubs, the morning sunlight on the fields.

His life as an Englishman born in Paris, where, despite his wish, he could not become a French national, was, like his art, without outward incident. Of all the first group of Impressionists, Sisley was the most scorned and ignored, the one whose work aroused the least comment. Perhaps he was too moderate for the more daring collectors, not enough so for the numerous lovers of small effects.

Nevertheless, by the age of thirty-five, Sisley, who was to die at sixty of cancer of the throat, had known splendid days. His light, active brush, appealingly expressive, brought forth unforgettable subdued landscapes, snow scenes, rivers in flood. His fresh, quick brushstrokes, with touches of lapis lazuli, of acid green, of tones sometimes almost indistinct yet resonant, catch the most delicate mobility of the moment in a continual vibration of light.

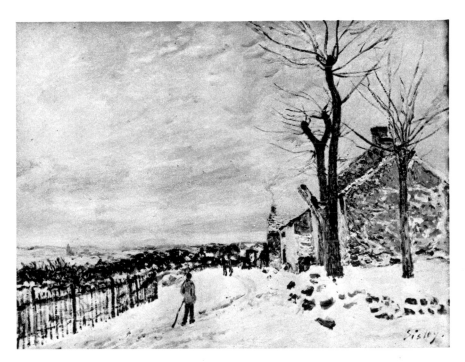

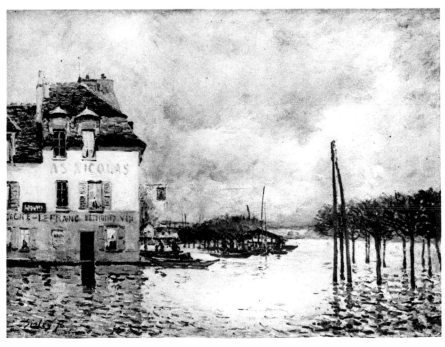

above: Photograph of Sisley
at the age of thirty-five. c. 1870–75.
Collection Durand-Ruel, Paris

above right: Alfred Sisley. *Snow at Veneux-Nadon.*
c. 1880. Oil on canvas, 21⅝ × 25½".
Museum of Impressionism, The Louvre, Paris

right: Alfred Sisley. *Flood at Port-Marly.*
1876. Oil on canvas, 23⅝ × 32".
Museum of Impressionism, The Louvre, Paris

CAMILLE PISSARRO

Pissarro was not treated much better than Sisley by the critics of his time. Some ridiculed his love for green, violet, and blue. Others disliked his radical beliefs. He was, however, at the beginning of Impressionism, although he did not claim what others denied him anyway —denied him and his companions, all younger than himself but whom he resembled—the credit for discovering it. Maurice Denis has described "the warm, dark, golden look on his brown face—Jewish, Spanish, Creole,"[41] adding that in "his soft, caressing voice [he] prophesied the society of the future."

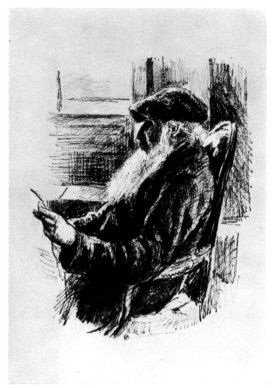

Maximilien Luce.
Pissarro, Portrait in Beret.
Bibliothèque Nationale, Paris

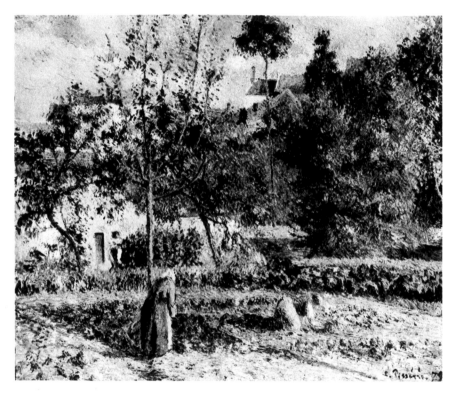

Camille Pissarro.
Vegetable Gardens at the Hermitage,
Pontoise. 1879. Oil on canvas,
21⅝ × 25¾".
Museum of Impressionism,
The Louvre, Paris

Camille Pissarro.
The Road, Rain Effect. 1870.
Oil on canvas, 15⅞ × 22¼".
Sterling and Francine Clark Art
Institute, Williamstown, Mass.

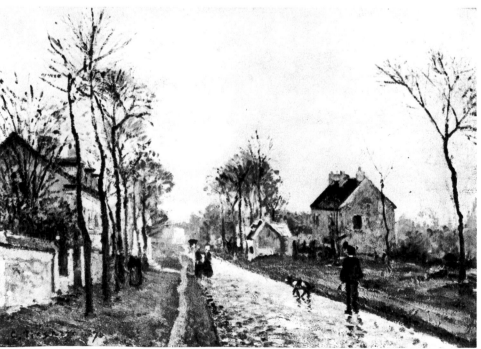

He was slow. But one must not forget that he turned Cézanne toward nature, and this was his brief and glorious adventure. It was he who pointed out "the wheat, the onion, and the apple."[42] *Field of Cabbages, Row of Cabbages, Cabbage Patch*—such were the titles of his "vegetable garden" paintings. In his work he raised the fresh charm of the countryside, and all the produce that is sold in vegetable markets, to the level of what Ingres had called the painting of history.

Like Millet, but with a secular religious feeling, Pissarro loved flocks of sheep, peasant women pushing barrows of potatoes, flowering cherry and apple trees, willow groves, women bathers in chemises on the banks of rivers. To all this, his frank and healthy approach imparted an urgency of softness and charm.

In our day, with the passage of time, Impressionism has lost the surprise of novelty. But the works of Pissarro take on an unexpected importance, savoring as they do of the earth and radiating an infinite love of nature.

This intimate understanding of the countryside alternates in Pissarro with a passion for Paris, which inspired

his views of the boulevards, of the Place du Théâtre Français, of the Pont Neuf, and those of the Quai Henri IV, where, a bearded patriarch, the painter ended his days.

These three Impressionist landscape painters were described by Armand Silvestre in 1873 in words that are still valid: "M. Monet is the most able and the most daring, M. Sisley the most harmonious and the most timid, M. Pissarro the most real and the most natural."[43]

PIERRE-AUGUSTE RENOIR

The metamorphosis to which Monet and his companions subjected the old conception of landscape was achieved by Pierre-Auguste Renoir for the human figure. An incomparable atmosphere surrounds his evocations of groups: Sunday couples waltzing in broad daylight under the diffused shadows of the Moulin de la Galette in Montmartre, or debarking at Bougival, at the bathing

Pierre-Auguste Renoir. *La Grenouillère.* 1868.
Oil on canvas, 26 × 32".
Nationalmuseum, Stockholm

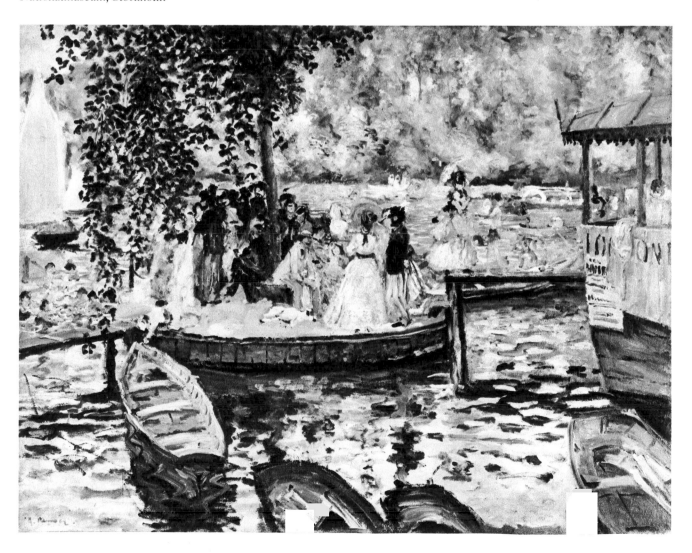

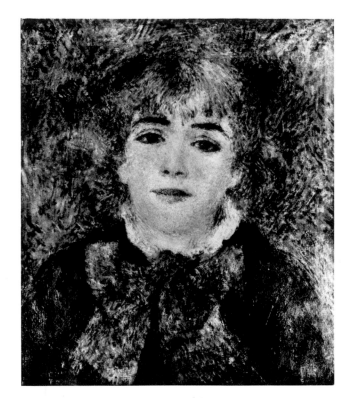

Pierre-Auguste Renoir. *Portrait of Jeanne Samary*. 1877.
Oil on canvas, 18⅛ × 17¼".
Collection Comédie-Française, Paris

establishment of La Grenouillère. Life is there, under the leaves, in a woman's look, the lighting of a cigarette, the turn of a waltz.

Taking some of the themes dear to Manet, Renoir broadens and exalts them, and surrounds them with a halo of light. He knew how to render the pinkness of a bosom under a muslin dress, the shape of a profile. In modeling the blondness of a child's head he has no peer, nor in imparting to the eyelashes of a Parisian girl that dark velvety accent one finds at the center of a poppy.

Unlike Claude Monet, Renoir had hardly gone beyond the canvases of his youth when, "tall, pallid, a little ungainly, an extreme mobility in his look,"[44] he was one of the group that met at the Café Guerbois.

His love of woman extends from the timid modesty of the adolescent girl to the full charm of the mature woman, from the healthy assurance of the pregnant woman to the generous bounty of motherhood. Certain of his female bathers, with the "strong thighs of goddesses," painted after 1900, are of a splendid carnality. All this with the gestures of hands splashing, arms raised over an abundant head of hair, Olympian poses in shimmering patches of sunlight. Where is the "old hag" whom Cézanne, taking a thousand precautions as a provincial being spied upon by his neighbors, used as

a model in Aix? Where is she beside these lips swollen with savage joy, this warm flesh which to our eyes seems as though it can never wither?

This man with shining eyes, wearing a round felt hat, his gaunt face elongated by a short beard, lived a life without misfortune until he was stricken with rheumatism.

Toward the end, at Cagnes, with his fingers deformed by his malady, his body twisted as an olive tree, he is the only image of "Renoir" whose features I can assemble. Otherwise, at the thought of his name, there appears before me, on a background of emerald green, the torso of a young girl.

Far from being, like Monet and Sisley, subject to the chronological stages of light (an exception being his cottony landscapes, which caused Degas to call their author "a cat playing with balls of yarn"), Renoir himself provides the occasion for his own painting. He invites us to an untold feast for the eyes, which he himself supplies.

His emblem could be the rose, which so often comes to mind when one speaks of him, the red rose of Aphrodite, and the blossoming rose, the rose as generatrix.

Let us therefore praise a man who, in bringing to light these marvels, succeeds in convincing us that everything on earth has preserved the clarity of a happy life, moreover without grandiloquence, without intellectuality, and even, it seems, without thought. Let us praise this faun who delights in flesh and greenery. All that moves and blossoms in time has taken on, under the touch of his hand, a henceforth timeless aura.

Renoir painting a nude in his studio in Cagnes.
Photograph by Sirot. Bibliothèque Nationale, Paris

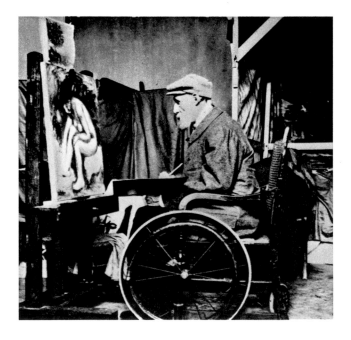

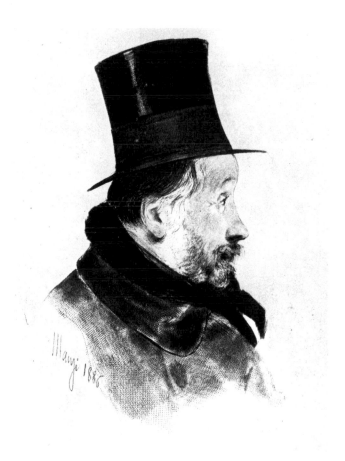

Manzi. *Degas in Profile*. 1886. Etching

EDGAR DEGAS

A mocker, his nose in the air, his look irresolute under
his drooping eyelids, Degas never sat for long at the
Café Guerbois, for a while the meeting place of the new
painters. Very cultivated, with classical tastes, this
"innovator of sorts, whose ironic modesty of manner
in life saved him from the hatreds that become attached
to the noisy ones,"[45] had a horror of Goncourt neolo-
gisms, and detested anything that he considered "Bou-
guereautized." On the whole, however, his work is darker
in tone than that of his companions. Along with Whistler,
that "rare gentleman, in some way a prince" (Mal-
larmé), Degas was not at all an Impressionist of sun-
light (of which little appears in his painting), but of the
artificial light of the theater and ballet.

One of his old models tells us that, after pushing aside
the platform, he had her make "difficult movements,"
take a "full-action pose in which you had to arch your
back and stretch your muscles to the tips of your fin-
gers,"[46] while he sat drinking herb tea. In this way he
made little clay studies for his numerous sculptures, in
which the movements are so natural.

Degas, who liked to sing arias in Italian from *Don
Giovanni*, did not paint the "smooth nude flesh of god-

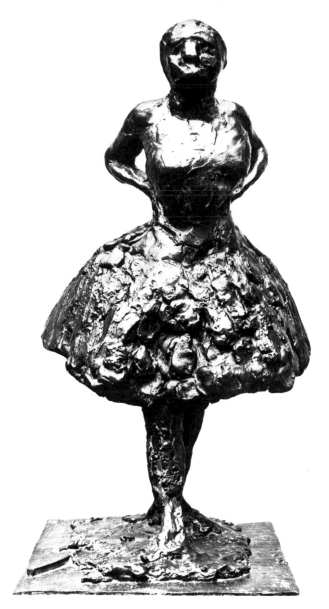

Edgar Degas. *Dancer Clothed*. 1880–81. Bronze, height 38½".
Museum of Impressionism, The Louvre, Paris

desses," but "flesh at the moment of its ablutions,"[47]
the contours of which he followed with eyes half-closed
behind his glasses.

We know from his niece that Degas was never totally
blind. He had lost the use of one eye, and saw imperfectly
with the other.[48] He tried to console himself with the
mechanical eye of photography, but had few illusions
about it.

His nickname was "the grizzly bear." His next-to-last
studio was in the Rue Victor-Massé, and there he lived
in a dusty litter of boxes and frames, dozing in his arm-
chair, across from the Bal Tabarin which he was hence-
forth forbidden to enter. His housekeeper, Zoé Closier,
read to him from *La Libre Parole*, Drumont's anti-
Semitic newspaper.

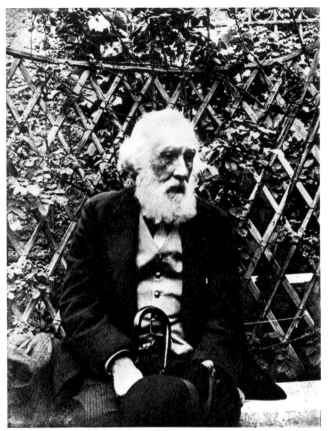

Degas in old age. Photograph by Bartholomé.
Bibliothèque Nationale, Paris

At the end, an old, isolated bachelor, hardly seeing at all, tormented by a disease of the bladder, he seldom spoke. "Painting no longer interests me," he said to the admirers who presented themselves at 6 Boulevard de Clichy, the new studio where he had virtually ceased to work. Robert de la Sizeranne reports seeing him there, walking back and forth in the room. "Sometimes he interrupted his pacing and his silence to ask all of a sudden: 'And So-and-so?' 'Dead,' one was most often obliged to reply. 'Ah!' And he resumed his walking. It was said that he was counting those who had departed and waiting for a certain mysterious number before joining them."[49]

BERTHE MORISOT

A woman provides the link between Manet, who was her adviser (she was nine years his junior), and the Impressionist group. At first a pupil of Corot, she awaits the appearance of Claude Monet before taking up, with an exceptional sensibility, the technique of seeming improvisation.

Berthe Morisot knew how to preserve and display her feminine qualities in all things. The happy prisoner of her family, she transformed the everyday life around her. See how she approaches her fellow creature: "By that

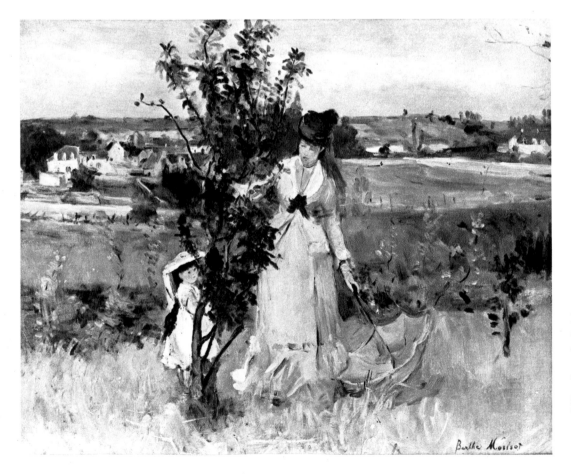

Berthe Morisot.
Cache-cache. 1873.
Oil on canvas,
17¾ × 21¾".
Collection Mr. and Mrs.
John Hay Whitney,
New York

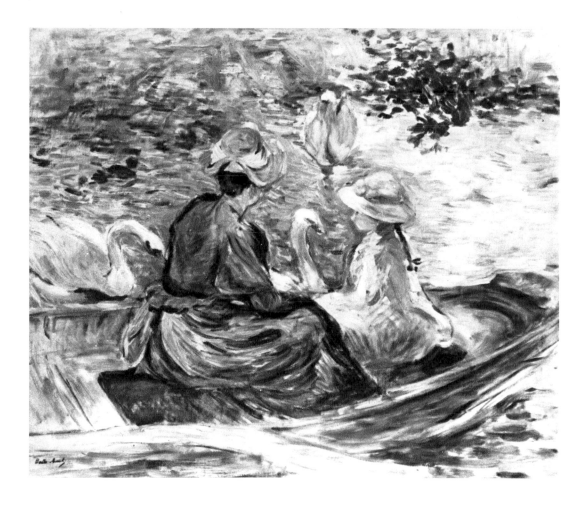

Berthe Morisot.
On the Lake. 1889.
Oil on canvas,
23¼ × 28¾".
Collection
Mr. Prentis Cobb Hale,
San Francisco

below:
Edouard Manet.
Berthe Morisot.
1872. Etching

clearsightedness, she was wonderfully restored, the satin coming to life by the contact of skin, the luster of pearls by the atmosphere."[50]

To a much greater degree than Mary Cassatt, the American friend whom she received in her home in the Rue Weber near the Porte Dauphine, and who painted solid maternal figures, Berthe Morisot conveyed charming impressions, even in her most sketchy notations in oil, watercolor, and pastel.

One likes this universe she painted, where children play in the shrubbery dappled with sun and shadow, where the swans in the Bois de Boulogne glide among the boats, where faces are turned in profile toward the sea. Everything in Berthe Morisot makes us pause and binds us to her touch, her colors, the astonishing freedom of her style.

Despite the praises of Mallarmé and Valéry, I do not think that the worth of this woman has been sufficiently recognized. This may be due to the fact that her work is not adequately represented in The Louvre and other museums of France.

In the numerous portraits that Edouard Manet left of her, we see her by turns restless and calm, hidden behind a fan, or else full face, her serious and penetrating gaze perhaps heightened by a secret.

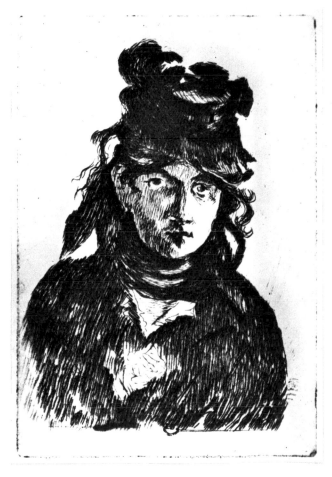

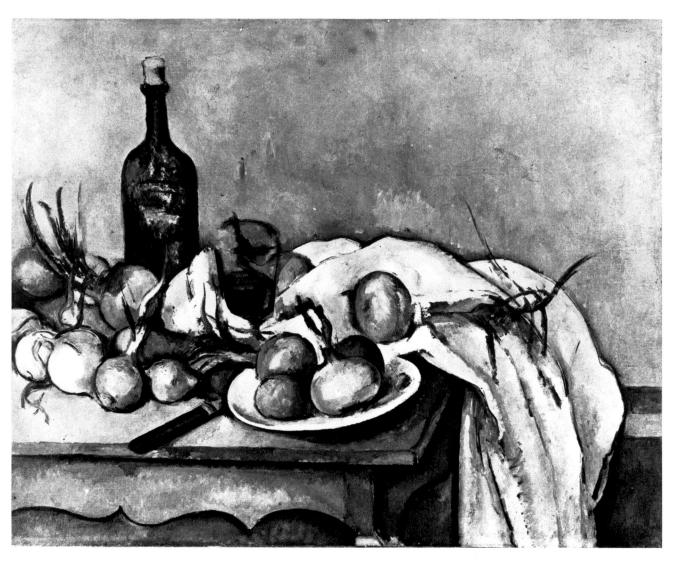

Paul Cézanne. *Still-Life with Onions.* 1895–1900. Oil on canvas, 26 × 31 ⅞″. Museum of Impressionism, The Louvre, Paris

PAUL CÉZANNE

Of the Impressionist group, Paul Cézanne was the only one to be distrustful of haste and the impulse toward color, still to be seen in the early paintings that he called his "orgies," and which are marked by a schoolboy eroticism. "It's beautiful," said Sérusier of an apple painted by this exacting artist. "No one would dare to peel it, they'd want to copy it."[51]

Art for Cézanne was a means of knowledge. The torment of identity, the search for a higher state to be reached step by step, for him took the place of the purely pictorial pleasure that seems to have sufficed for his companions. This produced his restlessness and the pain of being unable to fulfill himself.

He could not be content with a *view*; he aspired to a *vision*. Likewise, if he wished to "interest himself in a picturesque old street," "the flesh made him dizzy." The higher harmony to which he aspired drove him to

distort physical reality in order to tone it down. "Frenhofer," he said one day to Joachim Gasquet, pointing to himself.[52]

Cézanne, however, did not disavow his ties with Impressionism. "I do not hide it," he said, "I too have been an Impressionist. Pissarro had an enormous influence on me. But I wanted to make of Impressionism something solid and lasting like the art in museums."[53]

Soon the artist who would have liked "to wed the curves of women to the slopes of hills,"[54] does not hesitate to find Pissarro, his senior by eight years and with whom he had painted at Pontoise in 1873, a little too "earthy." Likewise, he recognized the uniformity of expression of Guillaumin, who had taught him engraving at Dr. Gachet's house in Auvers-sur-Oise. He saw Renoir as no more than "skillful," and preferred Lautrec to Degas. Only Claude Monet, whose art, however, was direct, immediate in its effect, and entirely the opposite of his own, escaped his reservations. In

him he admired "the finest painter's eye that has ever existed."[55]

If the nature of Cézanne's art sets him apart from the others, he has nevertheless two characteristics that make him an Impressionist. First of all, the *plein air*, his attachment to external reality (was he not trying to "re-do Poussin on the basis of nature"?). Then, color, which for him was inseparable from light. He ranked color above everything, to the point of remarking: "When the color is rich, the form is at its fullest."[56]

Timid and violent, emotional to the highest degree, Cézanne was an unusual combination of mysticism and positive reality. "We are nothing but a little bit of solar heat stored up and organized, a reminder of the sun, a little phosphorus burning in the meninges of the world,"[57] he said on reading Lucretius. But his intelligence was not content to be deductive; it passed over the things of this world and, strengthened by intuition, arrived at the Christian faith. Gasquet recalls seeing him at Le Tholonet, "after Vespers, his head bare, magnificent in the sunlight, around him a large circle of respectful young people, walking behind the canopy in the procession of Rogations,[58] and kneeling along the way at the edge of the fields with tears in his eyes."[59]

For him, everything came from inner conflict. "An art that does not have its source in emotion is not an art," he liked to say. But his work does not have the quick accents of Monet, Sisley, or Morisot; it is, on the contrary, patient and deliberate. "How does he do it?" Renoir wondered. "He puts two brushstrokes of color on a canvas and it's already something good."[60]

At Aix, merged with his corner of earth, he did not take his eyes from it until nightfall, in his effort to put "the flow of the world into an inch of matter."[61] Educated in all things, spewing up what he called the "Ecole des *Bozards*," he conceived the course of humanity from the bisons and deer engraved on the walls of caves up to the steam-filled railway stations of Monet. "We see in painting," he said, "everything that man has seen, everything he has wished to see. We are the same man." And he confessed: "I shall add a link to this chain of color."[62]

"He was a little round-shouldered, and had a swarthy complexion marked by reddish tones, a high forehead, long dishevelled wisps of white hair, the small piercing eyes of a ferret, a rather red Bourbon nose, a short drooping mustache, and a military goatee," wrote Edmond Jaloux, to whom we owe this portrait. "I can hear his heavy way of speaking, nasal, slow, and meticulous, with something careful and caressing about it."[63]

This great clarifier, whose life alternated between enthusiasm and despondency, ended his days at Aix in a kind of disgust with himself and his work. "His most

Paul Cézanne. *House of Dr. Gachet at Auvers*. c. 1873.
Oil on canvas, 18⅛ × 15″.
Museum of Impressionism, The Louvre, Paris

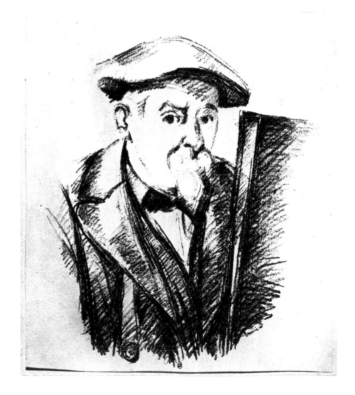

Paul Cézanne. *Self-Portrait in Beret*. Lithograph

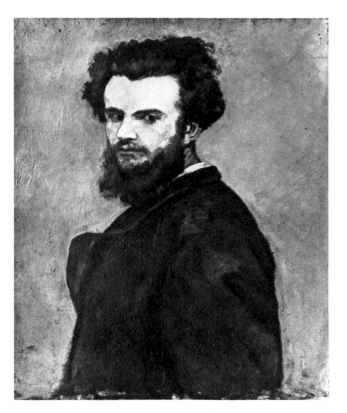

beautiful canvases," says Gasquet, "lay about on the floor, and he walked over them. He left them out in the fields, or let them rot in the studio." Cézanne foresaw at the time the advent of future artists who would treat nature "as cylinder, sphere, and cone."[64]

Although he was undergoing treatment for diabetes, he still insisted on his bottle of wine. But his legs became swollen. His eyes watered and he began to doze. "The Mass and a shower," he said, "are all that keep me on my feet."[65]

Maurice Merleau-Ponty professed to see "the fear of life and the fear of death" in Cézanne's practice of religion. "He believed himself to be impotent because he was not omnipotent, because he was not God."[66] This is to misjudge one whose spirit of exile felt the need to reascend to the sources of life. Is not despair the transitory feeling of all creators, believers and non-believers alike, who are not overtaken by foolish pride in perceiving their own limits?

Armand Guillaumin. *Self-Portrait.* c. 1873. Oil on canvas, 28¾ × 23⅝″. Museum of Impressionism, The Louvre, Paris

Armand Guillaumin.
Quai de Seine. 1874.
Oil on canvas,
15 × 17⅞″.
Collection
Count Arnauld Doria,
Paris

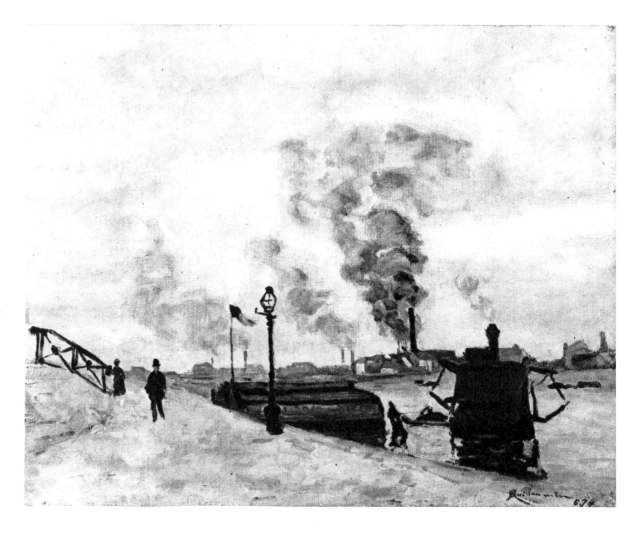

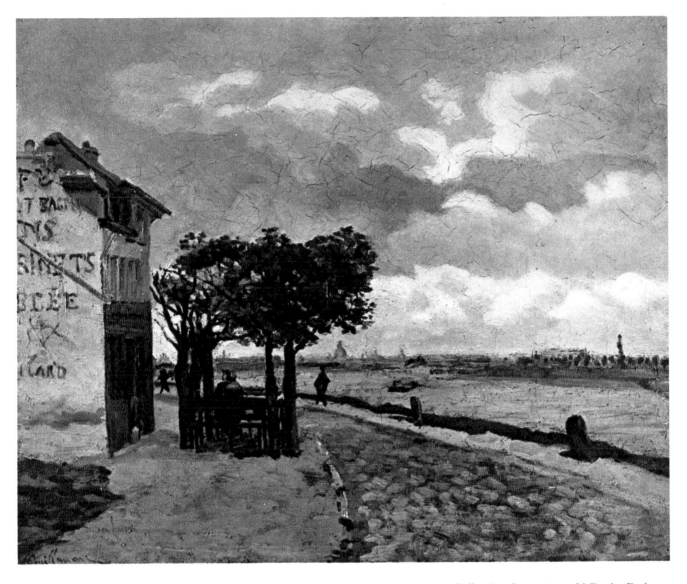

Armand Guillaumin. *Tavern at Bercy on the Seine.* 1873. Oil on canvas, 21¼ × 25⅝″. Collection Count Arnauld Doria, Paris

ARMAND GUILLAUMIN

Armand Guillaumin was for many years a Sunday painter. At first a shop assistant, he then worked for the Orléans railroad company, and later for the Paris municipality in the Department of Bridges and Roads. All of his free time was devoted to painting. But this double existence[67] hindered him from joining his companions, whose meeting place at the time was the Café de la Nouvelle Athènes in Place Pigalle.

Unsociable, irascible, with rather sharp features, Guillaumin had a pallid face set off by thick, dark hair and a beard. At the time when he paints his self-portrait (1873), now in The Louvre, he claims to be one of the Impressionists, and links himself to Claude Monet, who does not much care for this "nature painter," full of Baudelaire and now defended by Fénéon.

At the end of 1891, Guillaumin had the good fortune (or misfortune!) to win 100,000 francs in a lottery of the Crédit Foncier, and this allowed him to give up his job and devote himself entirely to painting. At the age of fifty, he returns to the scenes of his dreams—the red rocks of Aguay, the country around Crozant.

Then Guillaumin, who, in the difficult years, after painting the houses and quais of Paris (some in the Divisionist technique), had freely employed the Impressionist palette, painted his gloomy series of landscapes of La Creuse. Cut off from his friends of other times, with whom he however continues to exhibit, he loses his way. His technique becomes bogged down in the "violettomania" and jaundice yellow of sunken paths, moss-covered beech trees, and winding streams.

The Neo- and the Post-Impressionists

GEORGES SEURAT

Around 1883, the Impressionist group began to break up.[68] Almost all of them now lived far from Paris: Cézanne at Aix, Sisley at Moret, Monet at Giverny, Pissarro at Eragny, Renoir at Cagnes.

At that time there appeared on the scene those painters who have been called by turns Pointillists, Confettists, Divisionists, Neo-Impressionists, and whom Georges Seurat, the initiator of the new technique, called Chromo-Luminarists. These artists, less spontaneous than their predecessors, no longer separated the colors in their paintings instinctively. Returning, at least partially, to working in the studio, they proved to be much more methodical and even scientific.

Immersing himself in the study of the colors of the spectrum and the theories of Helmholtz and Chevreul, Seurat began to juxtapose pure colors directly on his canvas, without first mixing them on his palette, so that the viewer had the optical illusion of their blending. He was also to be concerned with the significance of line according to its position and direction in the composition.

Degas called him "the notary," because of his conserv-

Georges Seurat. *The Channel at Gravelines, Evening.* 1890. Oil on canvas, 25¾ × 32¼". Collection Mr. and Mrs. William A. M. Burden, New York

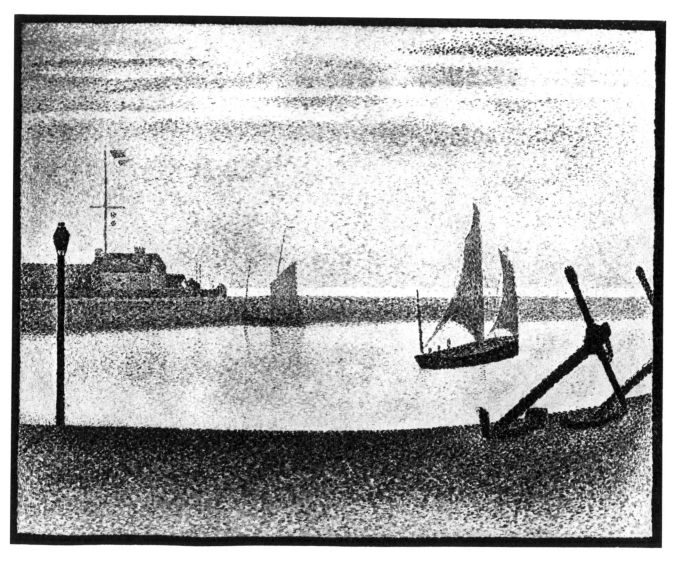

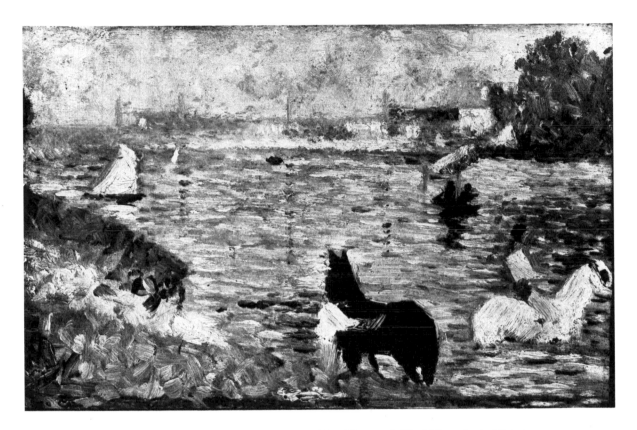

Georges Seurat. *Cheval Blanc et Cheval Noir dans l'eau* (*White Horse and Black Horse in the Water*),
Study for *Une Baignade*. 1883–84. Oil on wood, $6 \times 9\frac{3}{4}$″. Collection Christabel Lady Aberconway, London

ative way of dressing. Pissarro blamed him for having been a pupil at the Ecole des Beaux-Arts,[69] and accused him of being an official in disguise. The reproach is unjust. The revolution accomplished by Seurat—even if at the beginning it owes something to tradition—is of an extreme audacity. With Seurat, who was moreover one of the most incomparable draftsmen of all time, the deliquescence of color is reversed (in a manner quite different from that of Cézanne) in the direction of a return to contemplated form.

This didactic tendency did not, however, impair the fresh, vibrant luminosity of the three great canvases that sum up Seurat's work: *Une Baignade*, *A Sunday Afternoon on the Island of La Grande Jatte*, and *The Models*. The artist left a great number of preparatory sketches for these vast compositions. They are all part of that eternal summer with which Seurat's work is saturated.

Light also envelops the landscapes painted at Honfleur, Port-en-Bessin, and Gravelines (Seurat went there in the summer to clear his eyes of the dust of Paris). The sun and the sand of the beaches make themselves felt—a "terrain white as the carcass of a squid."[70] Only in its last years does this daring palette grow colder, in the acetylene sparkle of his nocturnes of the circus.

In its entirety, the work of this "big, timid, stubborn boy who concealed the sweetness of a girl behind his apostle's beard" (he was not yet thirty-two when he died) is the taking possession of space by a swarm of

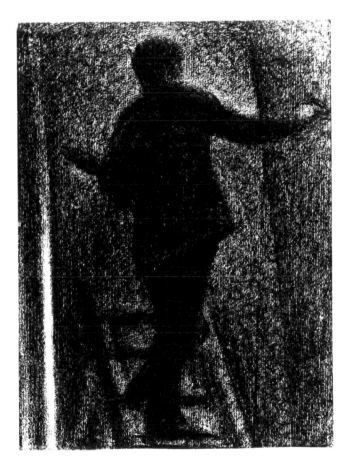

Georges Seurat. *The Artist in His Studio*. c. 1884.
Black conté crayon, $12\frac{1}{2} \times 9$″.
Philadelphia Museum of Art. A. E. Gallatin Collection

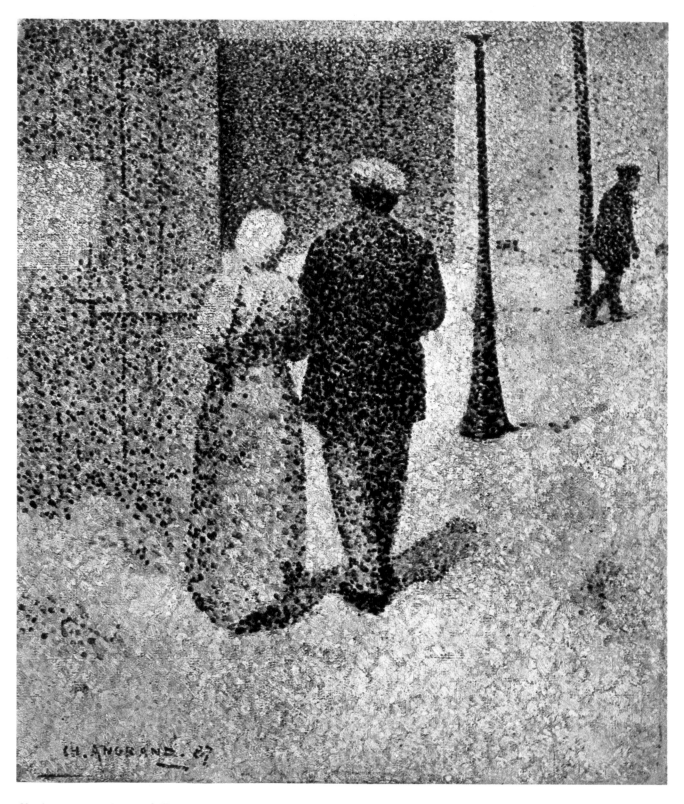

Charles Angrand. *Man and Woman in the Street.* 1887.
Oil on canvas, 15 × 13″. Musée National d'Art Moderne, Paris

Pointillist dots, dense in form, continuous, and seemingly haloed. The vertical is repeated like a leitmotiv, to the point where Seurat's figures remind one of those children to whom one always says: "Stand up straight!"

Perhaps at first sight such painting seems to have a kind of affected simplicity. But it soon comes to life, and reveals its surprises, its solidity, its complexity of structure, its contrasting tonalities, showing its author to be a precursor of the Cubists and Constructivists, and a unique and irreplaceable artist.

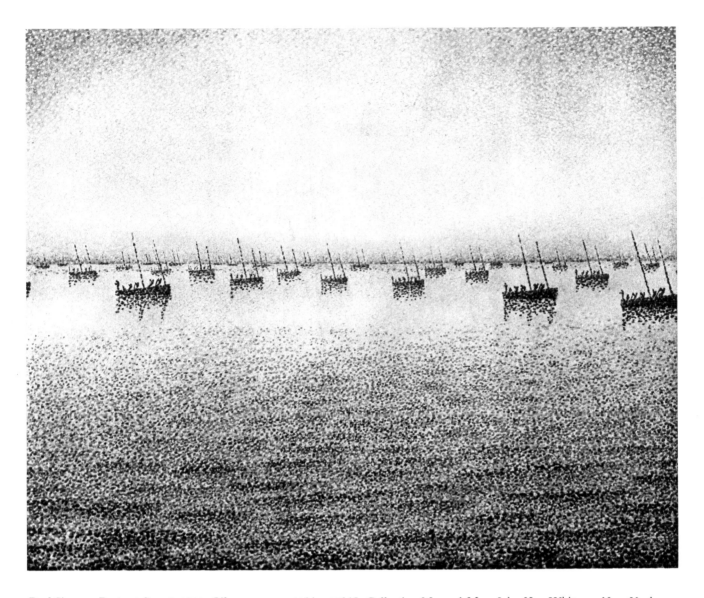

Paul Signac. *Boats at Sunset.* 1891. Oil on canvas, 24½ × 30¾". Collection Mr. and Mrs. John Hay Whitney, New York

SIGNAC, LUCE, DUBOIS-PILLET, CROSS, HAYET, ANGRAND

As the leading Neo-Impressionist, Seurat was joined by several other Pointillists, led by Paul Signac, who worked his canvases like mosaics of disparate spots, and brought to the young movement, according to Arsène Alexandre, "the strength of a precise intelligence and a rigorous will." "Social justice, artistic harmony—the same thing," this revolutionary liked to say. As a young man he had been a friend of Vallès, Van Gogh, and Verhaeren, and an admirer of Zola. He wrote for *Le Cri du Peuple* and wished to "sublimate in painting the 'tentacular towns,' the suburbs and gas tanks."[71]

If the original Impressionists, except for Degas and Renoir, had somewhat socialist ideas, those who are familiarly called *"les Néos"* were instead anarchists. Signac was, however, opposed to absolute socialism of the Proudhon variety, and felt that the artist should remain free in his choice of subject.[72] Moreover the toil of the workers hardly tempted his brush.

The introduction of this theme fell to Maximilien Luce, proletarian artist in a battered hat. "Wearing blue trousers, and washing his face with his hands in a red basin,"[73] this son of a *communard* railroad worker was a militant.[74] He read *La Révolte,* collaborated with *père* Peinard, and made lithographs for Jules Vallès's album on the anarchists confined with Fénéon in the Mazas prison.[75]

By adopting a monocle and a loose, flowing necktie, Dubois-Pillet tried to make his friends forget that he wore the uniform of the Republican Guard. In his studio at 19 Quai Saint-Michel (the house of Vanier, publisher of the decadent poets), he introduced into his painting a Divisionism even more complicated than that of Seurat. As for Cross (he had taken this surname out of modesty, Anglicizing his real name, which was Delacroix), he was enraptured by the "luminous pullulation"[76] of Le

Maximilien Luce. *Industrial Valley of the Sambre.* c. 1898–99.
Oil on canvas mounted on cardboard, 12⅝ × 16¼″.
Collection Count Arnauld Doria, Paris

right: Albert Dubois-Pillet. *Saint-Michel-d'Aquilhe in the Snow.*
1890. Oil on canvas, 25⅝ × 14⅜″. Musée Crozatier, Le Puy

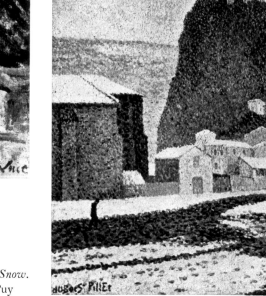

Henri-Edmond Cross. *Grape Harvest.* c. 1892. Oil on canvas, 37½ × 55″. Collection Mr. and Mrs. John Hay Whitney, New York

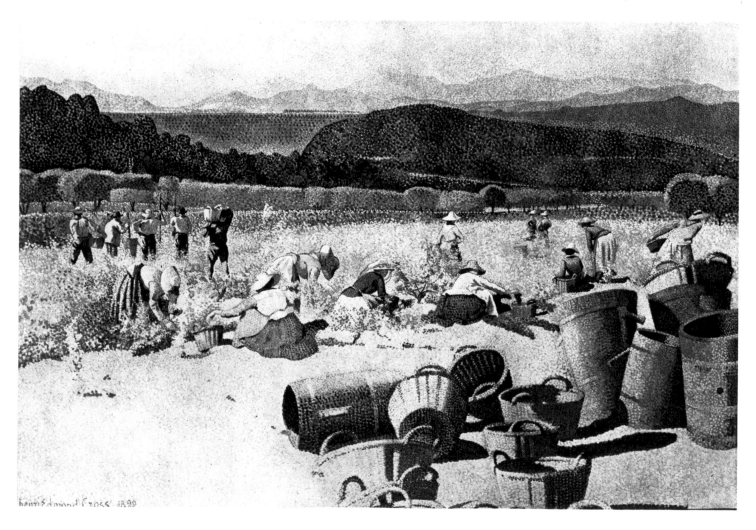

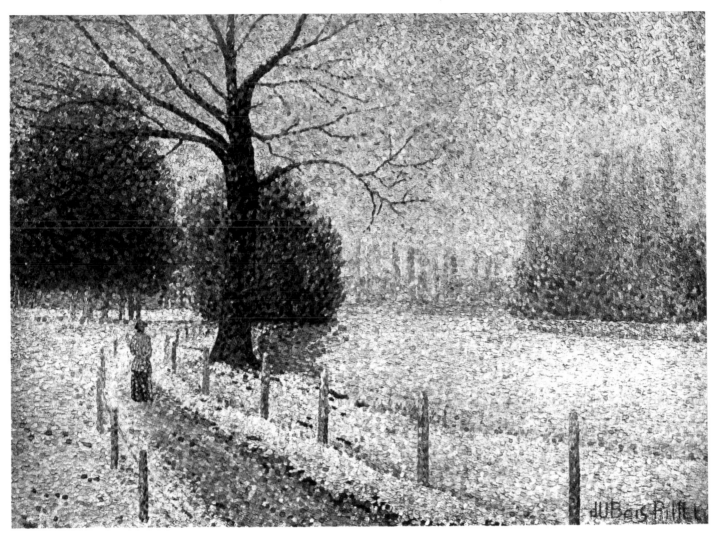

Albert Dubois-Pillet. *Riverbank in Winter*. 1889. Oil on canvas, 14⅞ × 19⅝. Collection Mr. and Mrs. Arthur G. Altschul, New York

Maximilien Luce. *View of the Seine Toward the Pont-Neuf.* 1900. Oil on wood, 5¼ × 8″. Collection Count Arnauld Doria, Paris

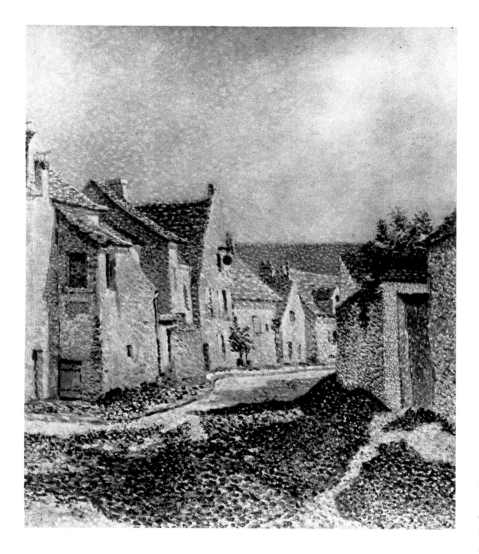

Henri-Edmond Cross. *Village Street.*
c. 1892. Oil on canvas, 18¾ × 16½″.
Collection The Ritter Foundation, Inc.,
New York

below:
Louis Hayet. *Vegetable Market.*
1889. Encaustic on paper over
canvas, 7¼ × 10½″.
Collection Mr. and Mrs.
Arthur G. Altschul, New York

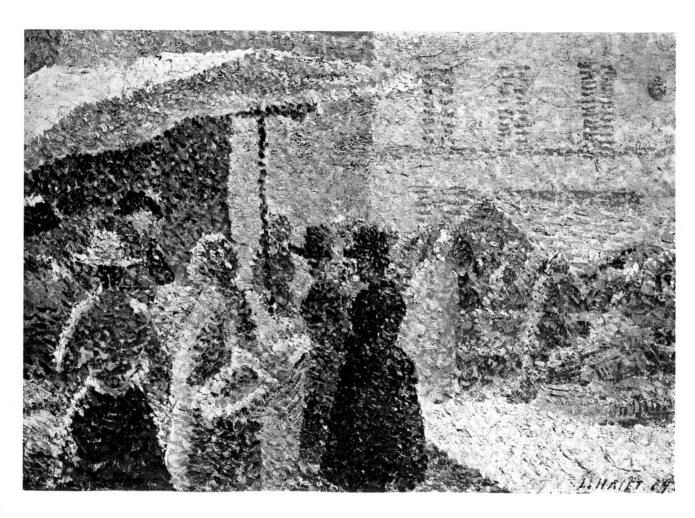

Lavandou on the Mediterranean coast. There was also Hayet, a big bearded man with a phlegmatic look, lover of the music of Fauré.

Of this last group, Charles Angrand, today forgotten, is perhaps the most interesting. He was an intimate friend of Seurat, and accompanied him to paint on the island of La Grande Jatte. "More a thinker than a creator," Signac said of him. He adopted the Pointillist technique after painting a number of delightful farm scenes. Retiring finally to upper Normandy, he there painted the clear space, the luminous haze in which objects have a sparkling evanescence, and covered sheets of paper with gray, scarcely perceptible waves.

THE NEO-IMPRESSIONISTS AND THE SOCIÉTÉ DES ARTISTES INDÉPENDANTS

The Neo-Impressionists, unlike their immediate predecessors, did not hold exhibitions limited to their own group, but they did contribute to the founding of a Salon that was more or less theirs: the Société des Artistes Indépendants. The first of these exhibitions, which dispensed with both jury and awards, took place in December, 1884, after an initial open exhibition, which began on May 15 in a barrack set up in the Tuileries.[77]

If the value of many of the works displayed was questionable, one dazzling room contained the entries of Seurat, Signac, Dubois-Pillet, Angrand, Cross, as well as those of Guillaumin and Odilon Redon. The group was henceforth to open its annual exhibition to those artists who would have more appeal in the future than at present for the great bulk of visitors. This was to be the case, among others, of the only truly Impressionist sculptor, the Italian Medardo Rosso, "painter without brushes, painter with a chisel," whose sensitive touch brought forth forms of an almost misty smoothness from the wax or clay.

Almost all the Neo-Impressionists were similar in appearance—hair cut short, pointed goatee, silk top hat. They were brothers of the Symbolist and decadent poets,[78] with whom they rubbed shoulders at the Brasserie Gambrinus in the middle of the Luxembourg Gardens, where they had founded *La Vogue* and *La Revue indépendante*; together they were the targets of derision or the victims of indifference. They asked the State not to bother with them, the Institut to close its doors,[79] the tinkers and tailors to keep their medals and decorations to themselves.

They all sought to discover the unperceived aspects of nature. Seurat's friend Gustave Kahn, editor of *La Vogue* and an exponent of free verse, speaks of a dinner at

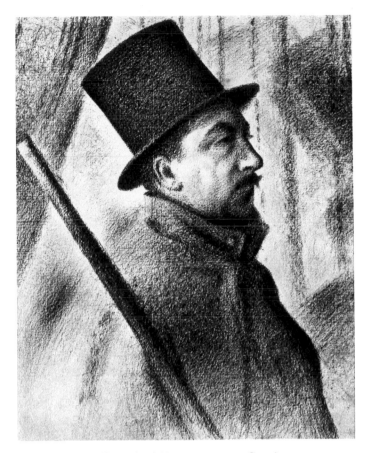

Georges Seurat. *Portrait of Signac*. 1889–90. Conté crayon, 13½ × 11″. Collection Mme Ginette Signac, Paris

Medardo Rosso. *The Golden Age (L'Età d'Oro)*. 1886. Wax over plaster, height 17″. Hirschhorn Museum and Sculpture Garden, Smithsonian Institution, Washington, D.C.

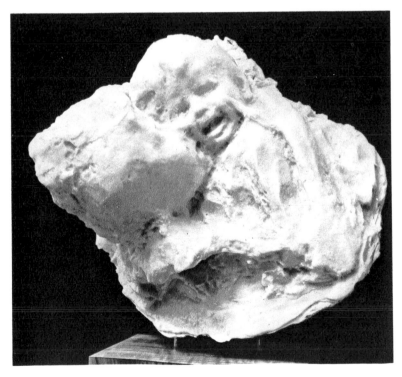

51

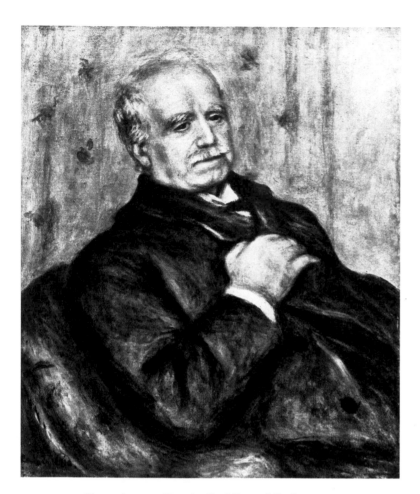

Pierre-Auguste Renoir. *Paul Durand-Ruel*. 1910.
Oil on canvas, 25¾ × 21½".
Collection Durand-Ruel, Paris

We now come to those who only passed through Impressionism, or who, in their artistry, became its consecration.

In the beginning, Gauguin underwent the influence of Camille Pissarro, even to the point of painting fan-shaped pictures. "Worship of Pissarro," said Huysmans of the first landscapes by the painter who would attempt on the surface what Cézanne achieved in depth. "Tell Gauguin," Pissarro wrote to Murer on August 8, 1884, at the time when the future painter of the *Yellow Christ* had left his bank job, "that after thirty years of painting . . . I'm flat broke. These young people should remember that!"

Gauguin, however, persevered. And soon, during his visits to Brittany, which were interrupted by a trip to Martinique, his Impressionist touch will disappear. "I am an Impressionist," he nevertheless told Taboureaux in an interview, "but I very rarely see any of my colleagues, either men or women. The little church has

Paul Gauguin.
Portrait of the Artist. c. 1890–91.
Oil on canvas, 16 × 12¾".
Collection Mr. and Mrs. Paul Mellon,
Upperville, Va.

which an effort was made to gather the whole group of Neo-Impressionists at the Saint-Fargeau restaurant in Belleville, beside an artificial lake created by the Dhuis reservoirs, where group banquets were held. Among others present were Seurat, Signac, Pissarro, Guillaumin, and Gauguin. The guests ate outdoors under Chinese lanterns. "Couples passed alongside our table," Kahn writes, "young girls in pink or white starched cotton dresses. It all seemed like a Sunday outing. Brushing against us were the models of Degas, of Renoir."[80]

In 1897, Paul Durand-Ruel had the idea of displaying the two Impressionist styles, the "old" and the "new," together in his gallery. On that occasion, Signac noted in his journal: "When one goes from our rooms to those where Manet and the Impressionists are hung, one is struck by the juicy and 'museum' look of these works, which twenty years ago produced the same effect in relation to their predecessors."[81] But soon the same would be true of Pointillism, which, as Seurat recognized, would lose the charm of novelty when everyone practiced it.

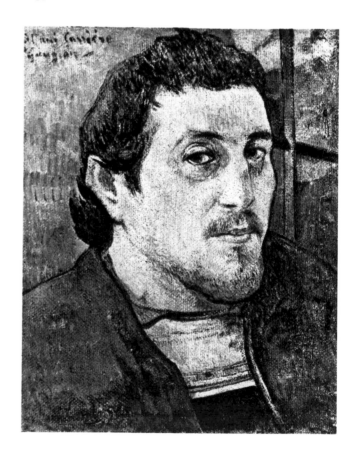

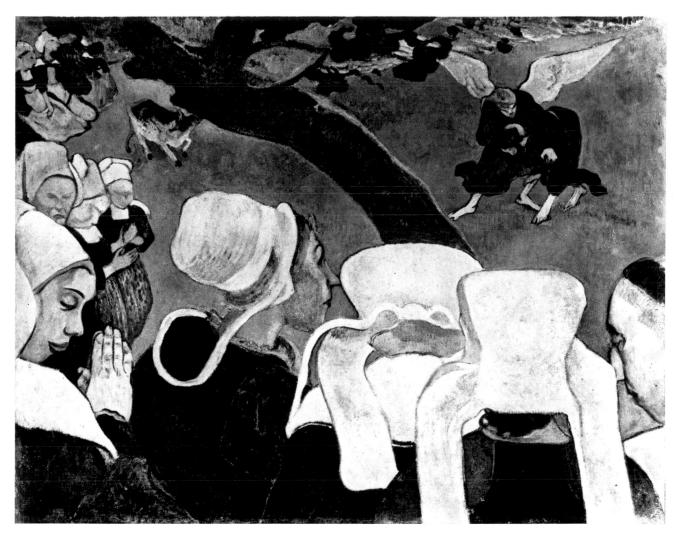

Paul Gauguin. *The Vision after the Sermon (Jacob Wrestling with the Angel)*. 1888.
Oil on canvas, 28¾ × 36¼". National Gallery of Scotland, Edinburgh

become a banal school that opens its doors to the first
dauber who comes along."

After the surprising and violent coloring of *Jacob
Wrestling with the Angel*—which foreshadows the
Fauves—there will be, along with the search for a
primitive paradise and esoteric magic, that decoration
oriented toward symbolism and Swedenborgian idealism
that the artist called *"Saintaize."*[82] Gauguin, whom
Helleu with some jealousy called "a magus," and who
seemed to have escaped from the pages of Schuré's *Les
Grands Initiés*, deserves credit for bringing back some-
thing of the monumental to the scattered effects of the
Impressionists, who, in his opinion, tried "to seek too
much around the eye."

Gauguin returned to Tahiti, never to come back,
"never to be seen again in Montparnasse, with his blue
frock coat with mother-of-pearl buttons, his Breton
vest, his beige trousers, his wooden shoes, and the pearl-
handled stick that he himself had carved."[83]

VINCENT VAN GOGH

Van Gogh takes his place at the outset of another branch
of Fauvism, leading to the exacerbated technique of
Soutine. He had and this is too often forgotten—a
profoundly religious mind. "I want to paint men and
women with that something of the eternal which the
halo used to symbolize, and which we now seek to give
by the actual radiance and vibrancy of our colorings."[84]
His strict Christianity as a Protestant and socialist col-
lapsed as he sank into what he himself called "the
malady of the sunflower," that is to say, of the sun. But
to the very end Van Gogh sustained in himself that
sacred feeling for his art which was central to his life.

"This true and robust artist, highly refined, with the
brutal hands of a giant, the nerves of an hysterical woman,
the soul of a mystic,"[85] had little contact with the Im-
pressionists, the fleeting sensations of whose painting he

wished to get rid of in his own. During his stay in Paris, at the age of thirty-three, he hardly saw more than two or three of them. "What disturbed him," says Emile Bernard, "was to see Pissarro, Guillaumin, and Gauguin in financial difficulties that compromised their work and paralyzed their plans."[86] In Montmartre, where he experimented with Pointillism on some of his canvases, Van Gogh was already in the grip of an excitation that alarmed his comrades.

Van Gogh adopted Monet's technique to a greater degree than Gauguin did Pissarro's, and enlarged on it right down to the thick strokes and sparks in the *Wheatfield with Crows*, which he painted at Auvers before fatally shooting himself.

Vincent van Gogh.
Interior of a Restaurant.
1887. Oil on canvas,
17¾ × 21¼".
Rijksmuseum Kröller-Müller,
Otterlo

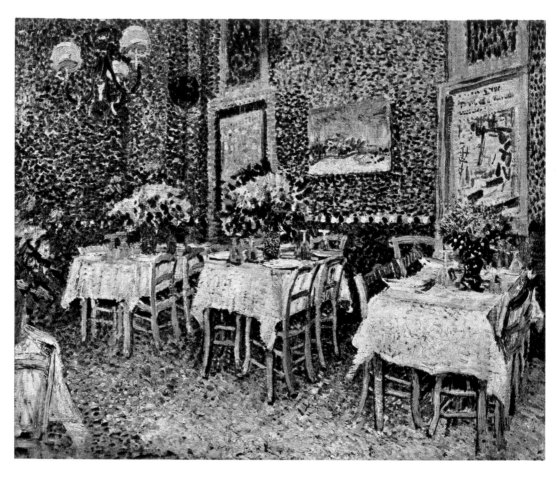

below:
Vincent van Gogh.
The Plain of Auvers. 1890.
Oil on canvas, 19¾ × 39½".
Kunsthistorisches Museum, Vienna

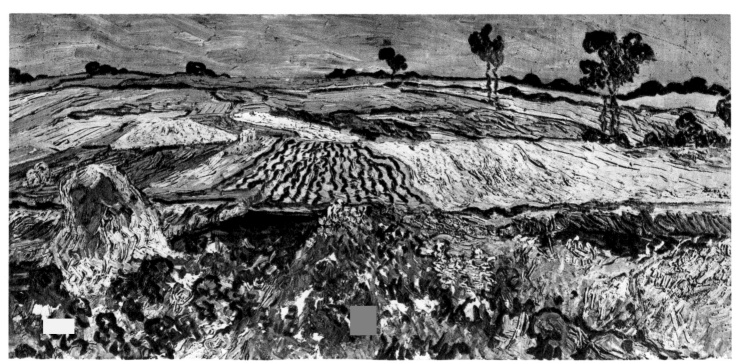

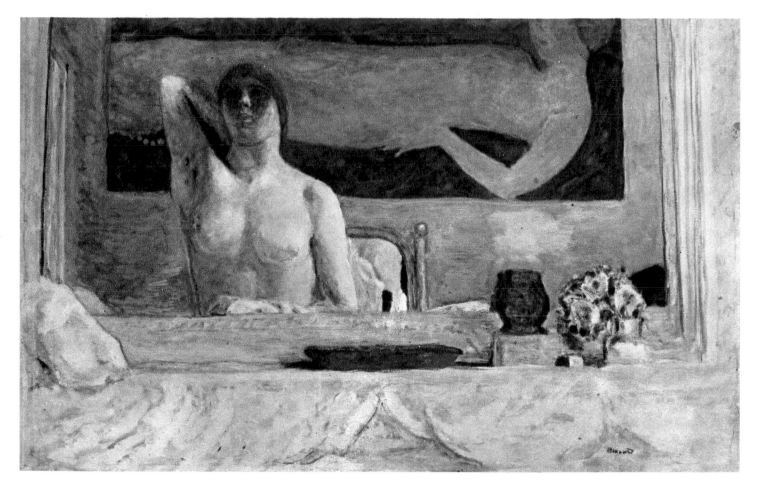

PIERRE BONNARD

Painter of women, of flowers, and of intimacy, Pierre Bonnard seems to respond as from a distance to the wonders of Turner. Under his enchanted brush, female nudes stand out temptingly in the doorways. He also portrays Marthe, the model whom he will later marry, in the intimacy of darkened rooms, or in the evening:

> Le foyer, la lueur étroite de la lampe
> La rêverie avec le doigt contre la tempe.

(The hearth, the narrow glimmer of the lamp
Reverie with a finger against the temple.)

In Bonnard's paintings, water sparkles under the palm trees, light shines on the pearly whiteness of the tablecloth at a children's afternoon party, the enchantment of the ordinary radiates from the whole length of the indolent woman in the blue bathtub.

In his style of a naive intellectual, Bonnard expressed himself in a way parallel to Claude Monet, who, in his most delicate aspects, comes back to the "peacock tail" style of the beginning of the century. His major works, all imbued with sensibility, are those of a poet whose inspiration is visual. Contrary to what we see in Degas, the most trivial motif assumes in his painting the revolving and sparkling splendor of a diamond.

Pierre Bonnard. *Woman's Torso in a Mirror*. 1916.
Oil on canvas, $31\frac{7}{8} \times 43\frac{3}{4}''$.
Collection Bernheim-Jeune, Paris

below: Pierre Bonnard. *Self-Portrait*. Undated.
India ink, $6 \times 6\frac{1}{8}''$. Museum of Fine Arts, Budapest

SUMMARY

Now that we have seen Impressionism as manifested by its last exponents—Raffaëlli, Lebourg, Pégurier, Maufra, Loiseau in the first style; Petitjean, Van Rysselberghe, Georges Lemmen in the second—let us try to recapitulate the outside events that mark the stages of its course. But first we should make special mention of the American Maurice Prendergast, an independent painter whose ebullience of form and style, and lustrous brilliance of color, are particularly significant.

What do we see during that long period that falls between the first Paris performance of *Tannhäuser* and Lindbergh's flight across the Atlantic? The end of the Second Empire, the Paris Commune, the anarchist movement, the Dreyfus case, the triumph of Sarah Bernhardt, Yvette Guilbert's black gloves, La Goulue's buffoonery, the scandals of adventuresses. It was also the time of Meliès and the first cinema, and of Clemenceau, Monet's protector. And there was the First World War.

In music, after Chabrier—who held the dying Manet in his arms—Debussy composes the dissonant chords of his *Jardins sous la pluie*, Fauré writes his resonant and luminous works. Ravel's *Mother Goose Suite* seems like a musical commentary to Monet's *Waterlilies*.

After the poetry of Verlaine, Laforgue, and Mallarmé, after Bergson's delicate philosophy, come the subtle and varied recollections of Marcel Proust's *mémoire involontaire*.

And did not Impressionism also give rise to Gallé, to the posters of Chéret, and the serpentine dance of Loie Fuller?

One last question can be raised. What would be the inclination of Impressionism with respect to human behavior, in particular that of the creative artist? Some have professed to see in it a kind of depersonalization of

Maurice Prendergast. *Afternoon, Pincian Hill.* 1898.
Watercolor, 21 × 27". The Phillips Collection, Washington, D.C.

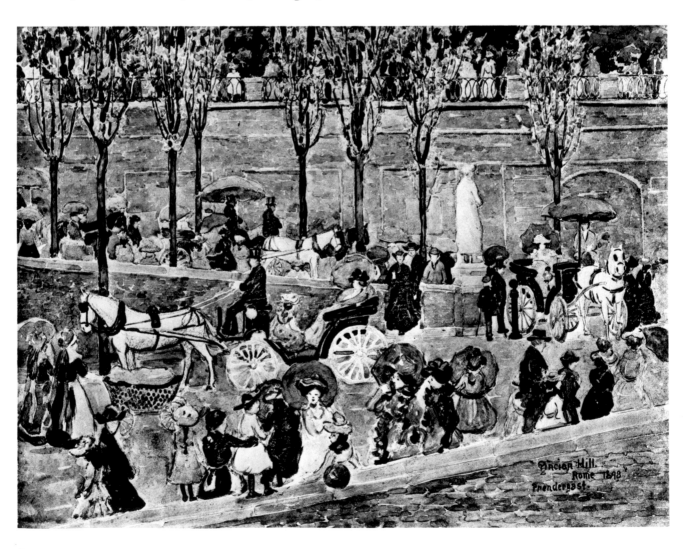

Paul Cézanne. *Bathers.* c. 1895–1900. Oil on canvas,
28¾ × 36¼". The Ny Carlsberg Glyptothek, Copenhagen

the artist, who thus becomes no more than the receiver of uncontrolled perceptions.

But there is nothing to show that he who receives the sensations, letting himself at first be overrun by them, cannot have a spontaneous and even unconscious reaction that guides and marks his creation as his own. If one were to accept Herman Bahr's contention that the eye of the Impressionist loses itself in some kind of "vague fascination," becoming "passive like an echo of nature,"[87] would not that be a condemnation of the poetic state of receptivity, a denial of the creative intuition of the artist?

Now, far from being passive, the Impressionists each had an undeniably individual personality in their ways of spiritualizing matter or, at the very least, imparting to it their own character. Unlike their Barbizon predecessors, they never allowed themselves to be overcome and submerged by nature. On the contrary, they always resisted imitation and monotony. How different they all are! And how well they accomplished, for once and for all, what had to be done, imbued with the ideas and feelings of their century!

The history of art has constructed in time a series of pyramids, of which each with its expression, its style, its originality, has its moments of grandeur and of decadence. The one raised by Impressionism, by not being a monument of granite but a workshop of transparent crystal, is not the least fascinating.

SELECTED GRAPHIC WORKS

Paul Cézanne. *Head of a Young Girl.* 1873. Etching

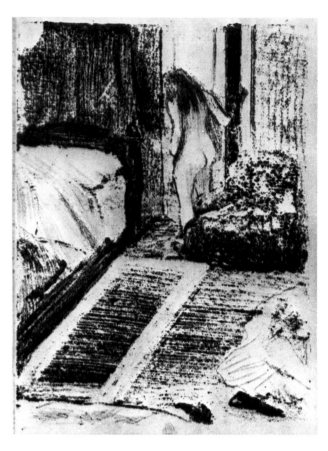

Edgar Degas. *Nude at the Door of Her Room.* Lithograph, 6⅜ × 4¾"

Edouard Manet. *Races at Longchamp.* 1864. Lithograph, 14⅜ × 20¼"

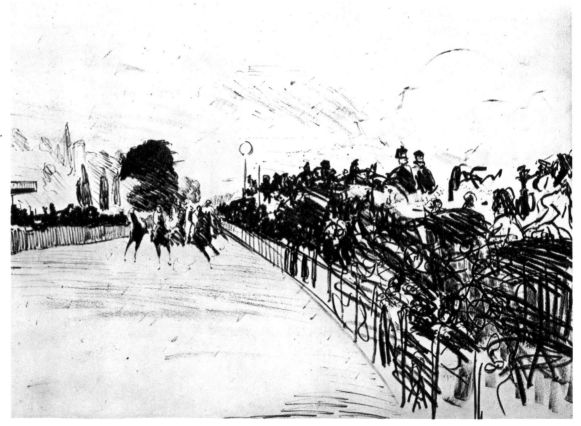

Alfred Sisley. *Banks of the Loing, the Cart.* 1890.
Etching, $5\frac{3}{4} \times 8\frac{7}{8}''$

Eugène Boudin. *Marine.* 1899. Etching

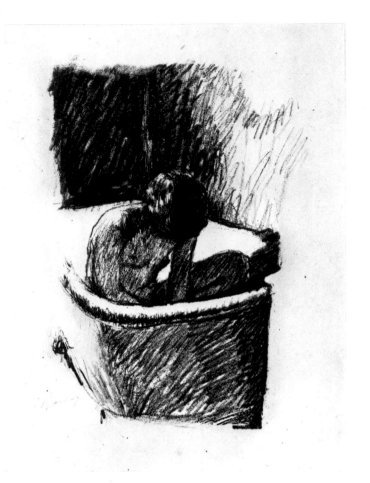

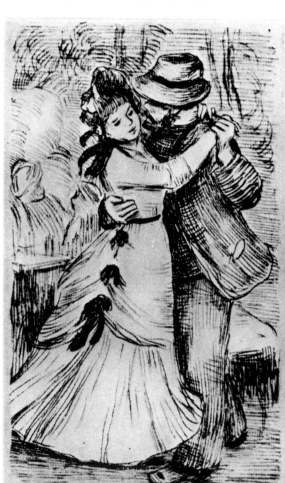

Pierre Bonnard. *The Bath*. 1925. Lithograph, 13 × 8 7/8″

Paul Gauguin. *Eve*. c. 1895–1903. Woodcut

Mary Cassatt. *In the Omnibus*. 1891.
Color etching, 14 1/4 × 10 1/2″

Pierre-Auguste Renoir. *The Dance at Bougival*.
c. 1890. Soft-ground etching, 8 5/8 × 5 3/8″

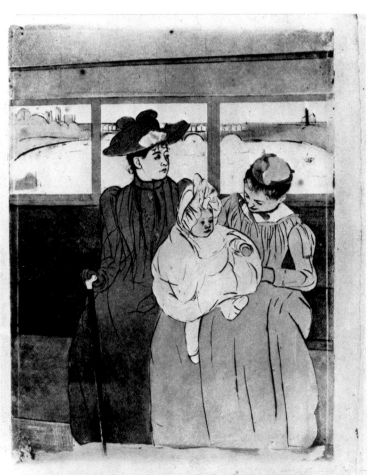

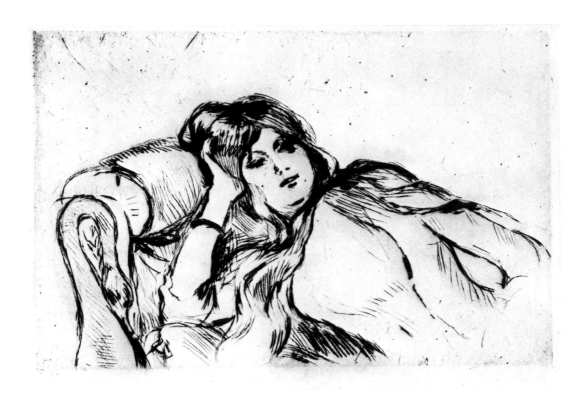

Berthe Morisot.
*Young Girl Leaning on
Her Elbow.*
c. 1887. Drypoint

Camille Pissarro. *The Port of Rouen.* 1885. Etching, 3rd state, 5⅞ × 6¾″

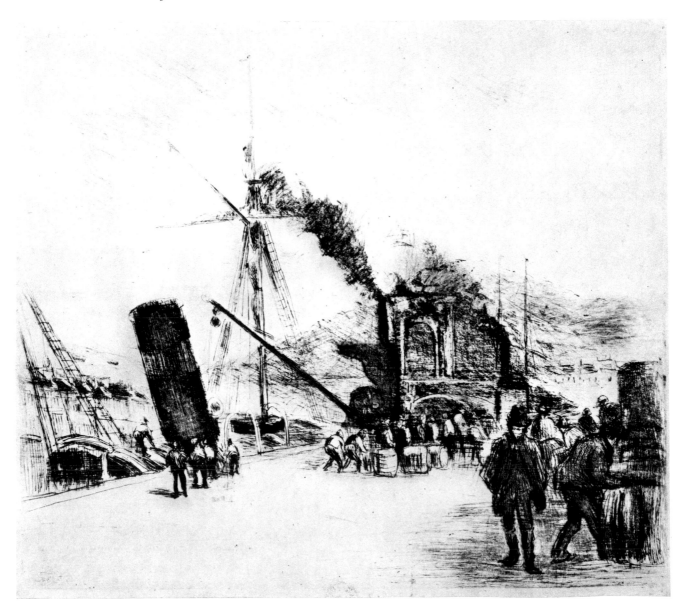

Paul Cézanne. *Barges on the Seine at Bercy*. 1873. Etching

Louis Hayet. *Portrait of Verlaine*. 1892.
Frontispiece for *Liturgies intimes*

Maximilien Luce. *Woman Arranging Her Hair*.
1894. Lithograph

NOTES

1 A. Dubuisson, *Les Echos du bois sacré: Souvenirs d'un peintre*, Paris, 1924.

2 Emile Montégut, *Nos Morts contemporains*, 2nd series, Paris, 1884.

3 Charles Clément, *Artistes anciens et modernes*, Paris, 1876.

4 Gleyre, however, did not wish to be the head of the school of Neo-Greeks, which was ridiculed by Gérôme.

5 Gustave Geffroy, *Histoire de l'Impressionnisme—La vie artistique*, 3rd series, Paris, 1894.

6 André Pératé, "Un Siècle d'art," *La Quinzaine*, December 16, 1899.

7 See Erich Koehler, *Edmond und Jules de Goncourt, die Begründer des Impressionismus*, Leipzig, 1912.

8 Nadar had just moved out, vacating the premises.

9 The address of the Society was 9 Rue Vincent-Compoint, in the Clignancourt quarter, as shown at the head of a letter from Degas to Bracquemont, written in 1874 (Bibliothèque Nationale, n.a.f. 24830).

10 For the reactions of the press to this exhibition, see Jacques Lethève, *Impressionnistes et Symbolistes devant la presse*, Paris, 1959.

11 The expression *("école des yeux")* was coined by Marc de Montifaud, in *L'Artiste*, to describe the new group.

12 Courbet, sentenced to pay for the restoration of the Vendôme column, which had been demolished by the Commune, took refuge in Switzerland.

13 Albert Aurier, *Oeuvres posthumes*, Paris, 1893.

14 Arsène Alexandre, *La Collection Canonne: Une Histoire en action de l'Impressionnisme*, Paris, 1930.

15 Before the two seascapes exhibited by his near-namesake at the Salon of 1865, Manet said, "Bah, people look at them because they think they're by me."

16 Théodore Duret, "Les Impressionnistes," in *Critique d'avant-garde*, Paris, 1885.

17 There are no Italian Impressionists, except perhaps De Nittis, and even that is doubtful. In Germany, except for a few unrepresentative canvases by Corinth and Slevogt, we find hardly anyone but Max Liebermann, who moved in this direction fairly late.

18 Richard Hamann and Jost Hermand, *Impressionismus*, Berlin, 1960.

19 See Pierre Courthion, *Raoul Dufy*, Geneva, 1951.

20 Michel Belloncle, "Les Peintres d'Etretat," *Jardin des Arts*, May, 1967.

21 Guy de Maupassant, "La Vie d'un paysagiste," *Gil Blas*, September 28, 1886 (in the form of a letter dated from Etretat, September). De Maupassant writes of having seen Monet paint in this way the previous year, i.e., 1885.

22 Albert Aurier, op. cit.

23 Gustave Geffroy, op. cit.

24 Meyer Schapiro, *Van Gogh*, New York, 1950.

25 Among others, those of Robert de la Sizeranne and Werner Weisbach.

26 Roger Marx, *Maîtres d'hier et d'aujourd'hui*, Paris, 1914.

27 Robert de la Sizeranne, *Les Questions esthétiques contemporaines*, Paris, 1904.

28 Oscar Reutersvärd, "The 'Violettomania' of the Impressionists," *Journal of Aesthetics and Art Criticism*, Vol. IX, No. 2, December, 1950.

29 Francis Jourdain, *L'Impressionnisme, origines, conséquences*, Paris, n.d.

30 F. A. Bridgman, *L'Anarchie dans l'art*, Paris, n.d.

31 Robert de la Sizeranne, op. cit.

32 Gustave Geffroy, op. cit. Can one see an analogy between the political radicalism of the period after the Paris Commune and the revolutionary experiments of the Impressionists? I do not think so. If Camille Pissarro and Luce were anarchists who read Kropotkin and admired Blanqui and Fénéon, Renoir was a moderate socialist, Degas like Manet a distinguished bourgeois, and Berthe Morisot the daughter of a well to do family. As for Monet, his radicalism was of the Clemenceau variety. It was by their experiments that these painters set themselves against the Establishment of their time: Monet by his study of light phenomena, Pissarro by his love of the rural life, Sisley by his wounded sensibility, Degas by his picture of the customs and diversions of the time, Cézanne by his need to distort reality in accordance with a transcendental conception.

33 Included in the Caillebotte Collection were Manet's *Balcony*, Renoir's *Dancing at the Moulin de la Galette* and *La Balançoire*, a *Gare Saint-Lazare* by Monet, Degas's *L'Etoile*, Pissarro's *Orchard and Flowering Trees, Spring*, Sisley's *Boat Races at Molesey*, Cézanne's *Farmyard at Auvers*.

34 Félix Fénéon.

35 Théodore Duret, "Quelques Lettres de Manet et de Sisley," *Revue Blanche*, March 15, 1899.

36 Georges Clemenceau, "Révolution de cathédrales," *La Justice*, May 20, 1895.

37 Reported by Wilhelm Uhde, *The Impressionists*, Vienna, New York, 1937.

38 Théodore Duret, *Le Peintre Claude Monet*, a note on his work, followed by the catalogue of the paintings exhibited at the gallery of the illustrated journal *La Vie Moderne*, 7 Boulevard des Italiens, June 7, 1880, with a portrait by Edouard Manet, Paris, Charpentier.

39 André Fontainas, "Claude Monet," *Mercure de France*, July, 1898.

40 About 1878–79, Sisley wrote to Théodore Duret asking him to find him a buyer who would pay five hundred francs a month over a period of six months for thirty canvases, "which means one hundred francs a picture" (Duret, "Quelques Lettres de Manet et de Sisley," op. cit.).

41 Maurice Denis, *Du Symbolisme au Classicisme, théories*, Paris, 1949.

42 Charles Morice, "Pissarro," *Mercure de France*, April, 1904.

43 Armand Silvestre, Preface to the exhibition *Recueil d'Estampes*, Galerie Durand-Ruel, Paris, 1873.

44 Armand Silvestre, *Au Pays du souvenir*, Paris, 1892.

45 Ibid.

46 Alice Michel, "Degas et son modèle," *Mercure de France*, February 16, 1919.

47 J.-K. Huysmans, *Certains*, Paris, 1889.

48 Jeanne Fèvre, *Mon Oncle Degas*, Geneva, 1949.

49 Robert de la Sizeranne, "Degas et l'Impressionnisme," *Revue des Deux Mondes*, November 1, 1917.

50 Stéphane Mallarmé, *Divagations*, Geneva, 1943.

51 Joachim Gasquet, *Cézanne*, Paris, 1921.

52 Frenhofer is the painter depicted by Balzac in *Le Chef-d'oeuvre inconnu* as a kind of pioneer of non-imitative art.

53 Joachim Gasquet, op. cit.

54 Ibid.

55 Ibid.

56 Ibid.

57 Ibid.

58 Rogations, in the Catholic liturgy, are solemn processions of penitence on the day before Ascension, a prayer to obtain God's blessing on the year's harvest.

59 Joachim Gasquet, op. cit.

60 Maurice Denis, op. cit.

61 Joachim Gasquet, op. cit.

62 Ibid.

63 Edmond Jaloux, *Fumées dans la campagne*, Paris, 1918.

64 Letter to Emile Bernard, April 15, 1904.

65 Joachim Gasquet, op. cit.

66 Maurice Merleau-Ponty, "Le Doute de Cézanne," *Fontaine*, No. 47, December, 1945.

67 Camille Pissarro reproached Guillaumin, whom he had met in 1868 at *père* Suisse's free academy, for not having the courage to devote himself exclusively to painting.

68 For the relations of the Impressionists with their dealer Paul Durand-Ruel, see the two volumes of Lionello Venturi, *Les Archives de l'Impressionnisme*, Paris, New York, 1939.

69 At the Ecole des Beaux-Arts, Georges Seurat was the pupil of Lehmann, a painter to whom we owe portraits of Liszt and some cold nudes.

70 Charles Angrand, letter to Lucie Cousturier, July 4, 1912, published in *La Vie*, October 1, 1936.

71 Françoise Cachin, Introduction to Paul Signac, *D'Eugène Delacroix au Néo-Impressionnisme*, Paris, 1964.

72 "The anarchist painter," he wrote, "is not the one who depicts anarchist scenes, but the one who without concern for gain, with no desire for compensation, struggles with all his individuality against bourgeois and official conventions to make his personal contribution." (See Robert L. and Eugenia W. Herbert, "Artists and Anarchism: Unpublished Letters of Pissarro, Signac, and Others," *Burlington Magazine*, Vol. CII, November and December, 1960.)

73 Jules Christophe, "Luce," *Les Hommes d'aujourd'hui*, 1890.

74 Luce painted the *Death of Varlin* and episodes of the Paris Commune.

75 Jules Vallès, *Mazas*, Paris, n.d., edition of 250 copies with ten lithographs by Maximilien Luce. Following the arrest of the terrorist Emile Henry, bachelor of science and student at the Polytechnic (1894), Fénéon and other acquaintances of the anarchist were arrested, confined in Mazas, and brought to trial. Henry had thrown a bomb on February 12 into the crowd seated at the Café Terminus. For Félix Fénéon, arrested on April 26, such assaults had done more to propagate anarchist ideas than the books, of Reclus and Kropotkin. Fénéon expounds the logic of these attempts—by Gallo against the Bourse, by Ravachol against the courts and the army (Lobeau barracks), by Vaillant against the Chamber of Deputies, by Emile Henry against the voters, by Caserio against the President of the Republic ("Extraits du journal inédit de Paul Signac," II, 1897–98, introduction and notes by John Rewald, *Gazette des Beaux-Arts*, April, 1952).

76 Maurice Denis, Preface to the retrospective exhibition of Cross at Bernheim-Jeune, April, 1937.

77 At this initial exhibition, Seurat showed *Une Baignade*, and Dubois-Pillet a *Dead Child* that Zola was to describe in *L'Oeuvre*.

78 Among the latter were such different men as Jean Moréas, Paul Adam, Mallarmé, Jules Laforgue, Verhaeren. There was also Maurice Beaubourg, the novelist admired by Seurat.

79 See Jules Laforgue, *Oeuvres complètes, Mélanges posthumes*, Paris, 1903.

80 Gustave Kahn, "Au Temps du Pointillisme," *Mercure de France*, April, 1924.

81 "Extraits du journal inédit de Paul Signac," III, 1898–99, introduction and notes by John Rewald, *Gazette des Beaux-Arts*, July-August, 1953.

82 The word is untranslatable. It plays simultaneously on *synthèse* (synthesis) and *sainteté* (sanctity).

83 Gustave Kahn, "Paul Gauguin," *L'Art et les Artistes*, November, 1925.

84 Quoted by Meyer Schapiro, op. cit.

85 Albert Aurier, op. cit.

86 Emile Bernard, "Vincent van Gogh," *Les Hommes d'aujourd'hui*, 1890.

87 Quoted by Luise Thon, *Impressionismus als Kunst der Passivität*, Munich, 1927.

CHRONOLOGY OF EVENTS AND EXHIBITIONS

THE IMPRESSIONISTS

1857 Camille Pissarro is the first to paint at the free academy of *père* Suisse, on the Quai des Orfèvres in Paris; in the following years he will be joined by Claude Monet, Armand Guillaumin, and Cézanne.

1858 Eugène Boudin meets an eighteen-year-old painter, Claude Monet, in Le Havre, and advises the young man "to be extremely stubborn" and "to stand by the first impression, which is the good one." The two artists paint outdoors together at Rouelles.

1861 First Parisian performance of Wagner's *Tannhäuser*, at a time when Offenbach's popularity is at its height.

1862 Monet, Renoir, Sisley, and Bazille work together in Gleyre's studio.

1863 Edouard Manet's *Déjeuner sur l'herbe* creates a scandal at the Salon des Refusés. The younger generation of painters groups itself around Manet.

1864 The Goncourts publish *Renée Mauperin*, inaugurating the Impressionist style in writing, which will be more pronounced in *Manette Salomon* (1867).

1865 Manet's *Olympia* is greeted by jeers and derision at the Salon.

1866 Monet, at Chailly-en-Bière with Bazille, paints a *Déjeuner sur l'herbe* in the open air. In the following year, his *Women in the Garden* will be rejected by the Salon.

1869 Monet and Renoir each paint *La Grenouillère*. Most of the Impressionist group joins the writers meeting at the Café Guerbois, Avenue de Clichy.

1870 The Republic is proclaimed on September 4.

1871 On March 18, the government of the Paris Commune is overthrown by the army of the Thiers government.

1874 *The first exhibition of those artists soon to be known as Impressionists is held from April 15 to May 15 in the studios of Nadar the photographer (he having just vacated the premises), Boulevard des Capucines. They have organized themselves as the* Société *anonyme coopérative d'artistes peintres, sculpteurs, graveurs, etc. . . . with headquarters at 9 Rue Vincent-Compoint in the eighteenth* arrondissement.

1875 Auction of paintings by Monet, Renoir, Sisley, and Berthe Morisot, at the Hôtel Drouot, March 24. Preface to the catalogue by Philippe Burty. Prices: Monet, 165 to 325 francs; Renoir, 100 to 300; Sisley, 50 to 300; Morisot, 80 to 480.

 The first performance of Bizet's *Carmen* is given at the Opéra Comique.

1876 *Second Impressionist exhibition is held in April at 11 Rue Le Peletier. The eighteen participants include* Boudin, Cals, Monet, Berthe Morisot, Camille Pissarro, Renoir, Sisley, and Degas.

 Edmond Duranty publishes *La Nouvelle Peinture*, in which he defends the new aesthetic.

1877 *Third Impressionist exhibition is held in April at 6 Rue Le Peletier. Eighteen participants, notably Calsa, Cézanne, Guillaumin, Monet, Berthe Morisot, Camille Pissarro, Sisley, and Degas.*

 On May 28, at the Hôtel Drouot, sale of forty-five paintings by Pissarro, Renoir, and Sisley. Prices about the same as before.

 The Impressionists gather at the Café de la Nouvelle Athènes, Place Pigalle.

1878 Théodore Duret publishes *Les Peintres Impressionnistes*. The demand for their pictures is very slight.

1879 *Fourth Impressionist exhibition, April 10–May 11, 28 Avenue de l'Opéra. Among those exhibiting are Cals, Mary Cassatt, Degas, Lebourg, Monet, and Pissarro. Each of the fifteen participants makes a net profit of 439 francs.*

 The publisher Gustave Charpentier launches *La Vie moderne*, a weekly in support of the new artistic and literary trends.

1880 *Fifth Impressionist exhibition, April 1–30, 10 Rue des Pyramides. Eighteen participants, including Mary Cassatt, Degas, Gauguin, Pissarro, Guillaumin, Lebourg, Berthe Morisot, and Raffaëlli.*

 In June, Claude Monet holds a one-man show at the gallery of the weekly *La Vie moderne*, 7 Boulevard des Italiens. There are eighteen entries in the catalogue, preface by Théodore Duret. Among others: *Ice-floes, Winter* (1879), *Rue Montorgueil Decked with Flags* (1878).

1881 *Sixth Impressionist exhibition, April 2–May 1, 35 Boulevard des Capucines. The participants, fewer than before, include Mary Cassatt, Degas, Berthe Morisot, Pissarro, Renoir, and Sisley. Monet not represented.*

 Gustave Geffroy defends the Impressionists in *La Justice*, the new journal founded by Clemenceau.

1882 *Seventh Impressionist exhibition, March 1–31, 251 Rue Saint-Honoré. Among the participants are Gauguin, Guillaumin, Claude Monet, Berthe Morisot, Camille Pissarro, Renoir, and Sisley.*

1883 Between March and June a series of one-man shows is held in an apartment at 9 Boulevard de la Madeleine, offering works by Boudin, Monet, Pissarro, Renoir, and Sisley.

 Durand-Ruel organizes Impressionist exhibitions in Holland, England, Germany, and the United States. Huysmans publishes *L'Art moderne*.

 First performance of Chabrier's *España* is given at the Lamoureux concerts.

1884 The Société des XX is founded in Brussels. It will be highly receptive to contemporary art. In Paris the Société des Artistes Indépendants opens its first Salon, dispensing with both jury and awards. The "Independents" will be one of the principal showcases for the Neo-Impressionists.

Félix Fénéon becomes editor of the *Revue indépendante*.

1886 *Eighth and last Impressionist exhibition, after which the group disperses. It is held at 1 Rue Laffitte from May 15 to June 15. Among the participants are Degas, Berthe Morisot, Gauguin, Guillaumin, Mary Cassatt, Camille Pissarro, and Seurat.*

After years of difficulty, Durand-Ruel, the dealer who had backed the Impressionist movement, achieves his first success in the United States. With the American Art Association he organizes an exhibition, *The Impressionists of Paris*, which is held in New York from April 10 to May 25.

Zola publishes *L'Oeuvre*, in which at first he presents the Impressionists in a heroic light, then finally in an atmosphere of despair. Fénéon publishes *Les Impressionnistes en 1886*.

1887 An international exhibition of painting and sculpture opens at the Galerie Georges Petit, Rue de Sèze; among others shown are Monet, Pissarro, Sisley, Renoir, and Berthe Morisot.

1889 Exhibition of Impressionist painters, Galerie Durand-Ruel, Paris, April 10–20. Monet–Rodin exhibition at the Galerie Georges Petit, Rue de Sèze. Almost all aspects of Claude Monet's work are represented. Catalogue preface by Octave Mirbeau.

"Twenty years of struggle and patience," says Gustave Geffroy, who places the moment between 1887 and 1889 when the outcry against the Impressionists began to lull.

In his *Nocturnes* ("Nuages," "Fêtes," "Sirênes"), Debussy expresses his musical Impressionism. In the same year, Henri Bergson publishes his *Essai sur les données immédiates de la conscience*.

Death of Chevreul.

1890 Pissarro exhibits at Boussod et Valadon, Boulevard Montmartre.

1891 In May, Claude Monet shows his series of *Haystacks* at Durand-Ruel.

1892 Monet exhibits his *Poplar* series at the same gallery. Large retrospective exhibition of Pissarro's works; catalogue preface by Georges Lecomte. In May, Renoir has a one-man show at the same gallery, with 110 entries in the catalogue and preface by Arsène Alexandre.

1893 Durand-Ruel shows a series of landscapes by Degas; in November, a Mary Cassatt exhibition.

1894 Armand Guillaumin exhibition at Durand-Ruel.

1900 On April 14, thanks to the efforts of Roger Marx, the Impressionists are prominently and numerously represented with an entire room at the Universal Exposition. Paintings shown include fourteen by Monet, seven by Degas, eight by Sisley, seven by Pissarro, four by Berthe Morisot, three by Cézanne, as well as Gauguins, Seurats, etc. This prompts a furious outburst by Gérôme, who tries to prevent the President of the Republic from entering the room. It is the consecration.

The following exhibitions took place in the present century:

1904 *Exposition de peinture Impressionniste*. February–March. Libre esthétique, Brussels. (195 entries, catalogue preface by Octave Mirbeau.)

1905 *A selection from the pictures by Boudin, Cézanne, Degas, Manet, Monet, Morisot, Pissarro, Renoir, Sisley, exhibited by Messrs. Durand-Ruel & Sons of Paris . . .* Grafton Galleries, London.

1908 *Impressionnistes français*. October–November. Kunsthaus, Zurich.

1921 *Impressionists and Post-Impressionists*. May–September. Metropolitan Museum, New York.

1924 *Französische Impressionisten*. Galerie Flechtheim, Berlin.

1927 *French Impressionists*. Galerie Goupil, London.

1934 *French Impressionists and Post-Impressionists*. Museum of Art, Toledo.

1935 *L'Impressionnisme*. Palais des Beaux-Arts, Brussels.

1935–36 *The Master Impressionists*. November–June. Museum of Art, Baltimore.

1936 *French Master Impressionists*. October. Institute of History and Art, Albany.

Exhibition of Master Impressionists. November. Museum of Fine Arts, Washington, D.C.

1937 *Présentation des Impressionnistes* (permanent collection). Museum of Impressionism, The Louvre, Paris.

1948 *Les Impressionnistes*. Biennale, Venice.

1949 *Les Impressionnistes*. Kunsthalle, Basel.

1953 *The Impressionists*. Vancouver.

THE NEO-IMPRESSIONISTS

1892–93 *Exposition des peintres Néo-Impressionnistes*. December 2–January 8. Hôtel de Brébant, Paris.

1921 *Impressionists and Post-Impressionists*. May–September. Metropolitan Museum, New York.

1932 *Le Néo-Impressionnisme*. Galerie Braun, Rue Louis-le-Grand, Paris.

1933–34 *Seurat et ses amis*. December–January. Galerie Beaux-Arts, 126 Rue du Faubourg Saint-Honoré, Paris.

1934 *French Impressionists and Post-Impressionists*. Museum of Art, Toledo.

1936–37 *Die Divisionisten*. December–January. Boymans Museum, Rotterdam.

1942–43 *Le Néo-Impressionnisme*. December–January. Galerie de France, Rue du Faubourg Saint-Honoré, Paris.

1952 *Il Divisionismo*. Biennale, Venice. (Catalogue preface by Raymond Cogniat.)

COLORPLATES

JAMES ABBOTT McNEILL WHISTLER (1834–1903)

Painted about 1870–75

Old Battersea Bridge: Nocturne—Blue and Gold

Oil on canvas, 26¼ × 19¾"
Tate Gallery, London

The *Old Battersea Bridge* counts among those works that I have called nocturnal Impressionism. It has a little of the enchantment of Turner, nourished by a sense of reality that Whistler could have seen in Courbet at the time of their meeting in Trouville in 1866. With that fastidious mind that was peculiarly his own, this subtle harmonizer subtitled his picture *Nocturne—Blue and Gold*. It is a fluid, fantastic, and melancholy painting. The great T-shape stands out in a ghostly way against the illumination of the sky and the boats on the Thames, while the night fog covers the river with a silvery veil.

A strange type, this Whistler. Gustave Geffroy describes him as "absolutely like one of the people he painted, all in shadow, the face and hands faintly lighted.

Small, with black hair, a white tuft at the center of his forehead." And Charles Morice recalls the arrival of this eccentric, who always wore formal dress and a high collar but without a necktie, at a deluxe hotel at the hour of tea: "Everyone was already at the table, the men in evening clothes, the ladies with bare shoulders, when all of a sudden they heard the deep growl of a tiger. All heads turned at once toward the door, but they turned back listlessly with neither fright nor amusement. 'It's Whistler,' someone said quietly, and conversation was resumed. It was indeed Whistler, impassive himself, dressed in a delightfully unusual way, and escorted by a whole entourage" ("Deux morts: Whistler et Pissarro," *Mercure de France*, April, 1904).

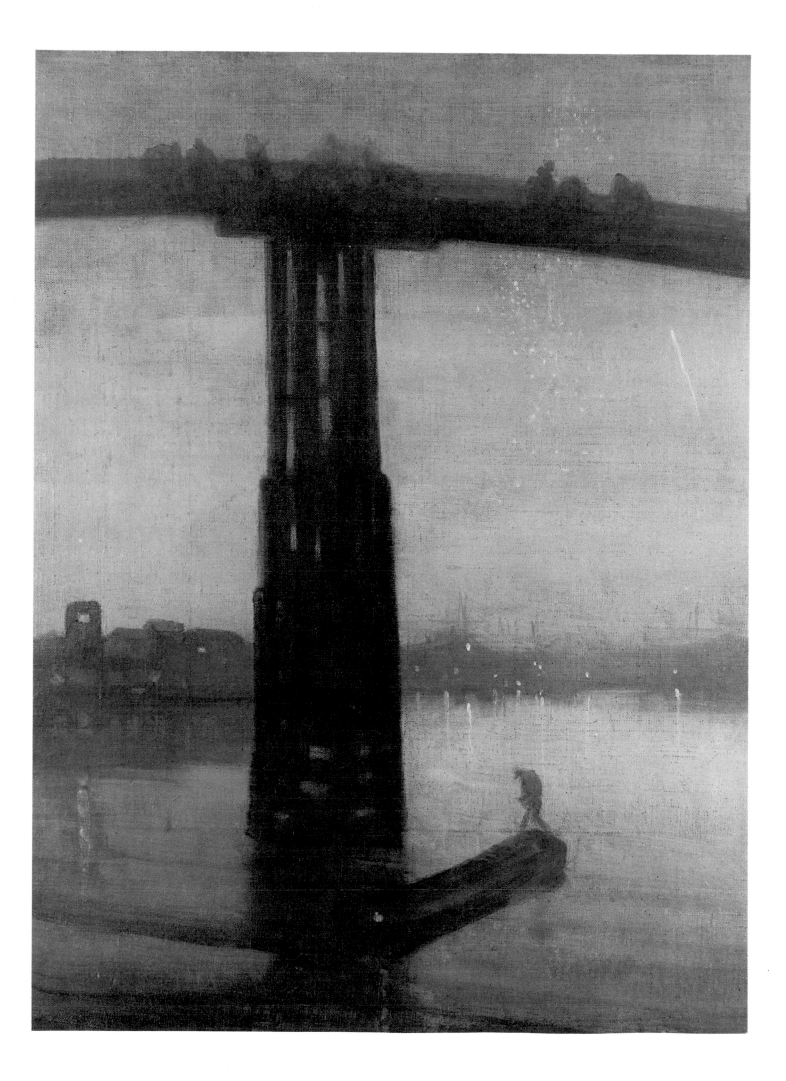

EDOUARD MANET (1832–1883)

Painted in 1862

Lola de Valence

Oil on canvas, 48⅜ × 36¼"
Museum of Impressionism, The Louvre, Paris

For its coloring, I do not think that Manet ever surpassed the richness of this painting. The dancer from the Spanish troupe that appeared at the Paris Hippodrome is depicted with an assurance, a fleshly sensuality, an art of supreme distinction. Here already is Manet's palette with its resonant blacks, its differentiated whites, its striking medley of color, its touches of cerulean blue.

This picture inspired in Baudelaire the celebrated quatrain which he subtitled *Inscription pour le tableau d'Edouard Manet*:

> *Entre tant de beautés que partout on peut voir,*
> *Je comprends bien, amis, que le Désir balance;*
> *Mais on voit scintiller en Lola de Valence*
> *Le charme inattendu d'un bijou rose et noir.*

> (Among so many beauties to be seen everywhere,
> I well understand, friends, how Desire oscillates;
> But in Lola of Valencia you see the sparkle,
> The unexpected charm of a pink and black jewel.)

As the author of *Les Fleurs du Mal* had done in poetry,

Manet demonstrated in painting a modern sensibility that had not appeared before that time. "The same horror of mythology and of ancient legend," says Armand Silvestre. "The same pursuit of strength even to the detriment of accuracy." And it is also to Silvestre, the finance inspector and writer of satirical Montmartre songs, that we owe this portrait of the painter of *Lola*: "This revolutionary—the word is not too strong—had the manners of a perfect gentleman. With his gaudy trousers, short jackets, a flat-brimmed hat set on the back of his head, and always with his impeccable suede gloves, Manet had nothing of the bohemian in him, and was in no way bohemian. He had the ways of a dandy. Blond, with a slight beard that came to a double point, he had in the extraordinary vivacity of his eyes—small, pale gray, and very sparkling eyes—in the expression of his mocking mouth—a thin-lipped mouth with irregular and uneven teeth—a strong dose of the Parisian *gamin*. Very generous and good-natured, he was openly ironical in his speech and often cruel. He always found the right words to tear and destroy at one blow" (*Au Pays du souvenir*, Paris, 1892).

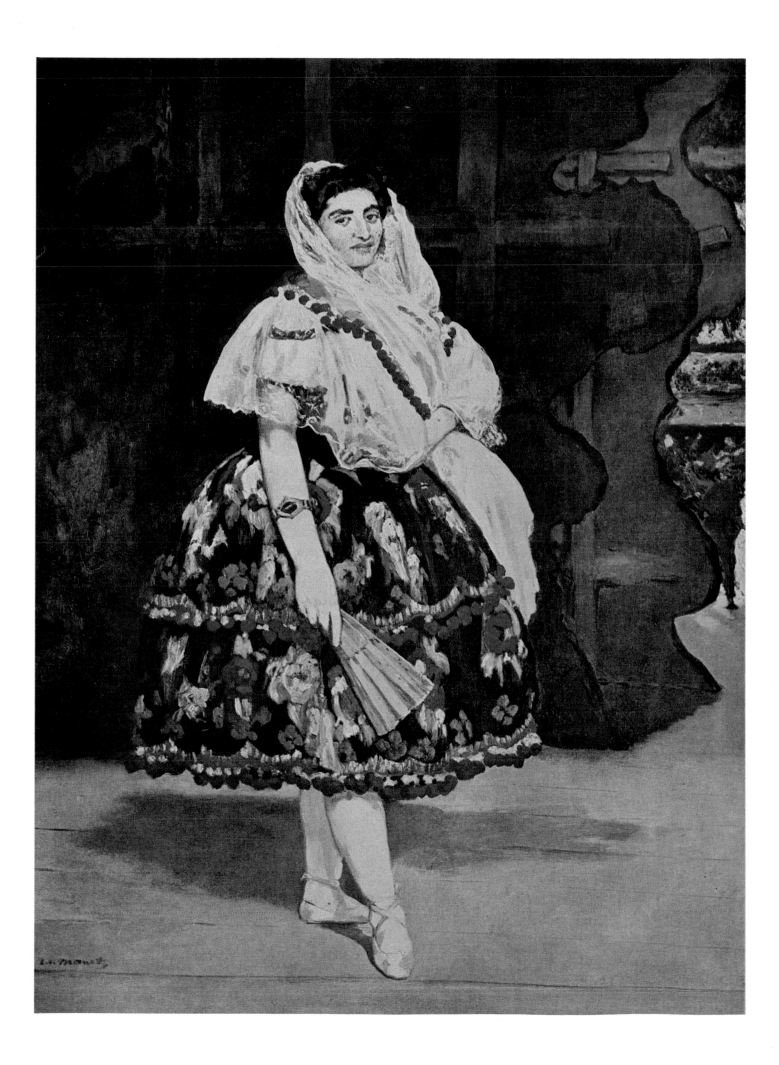

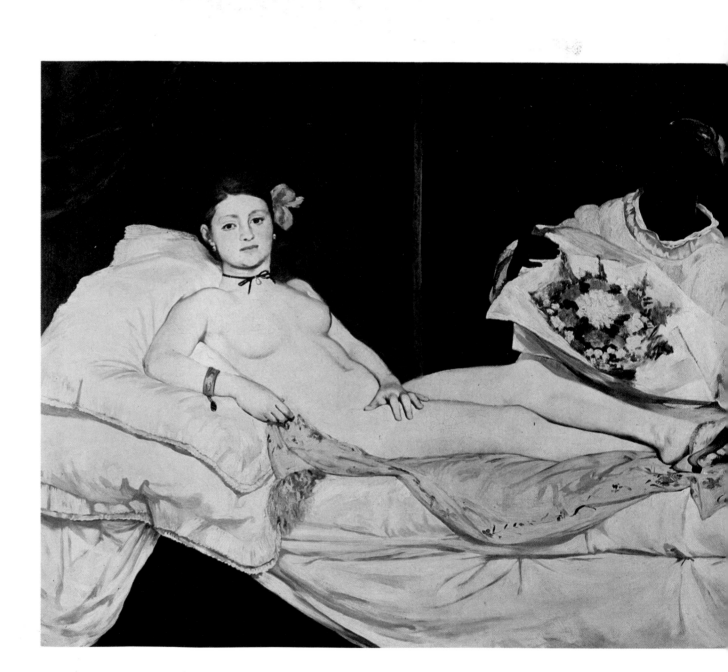

EDOUARD MANET (1832–1883)

Painted in 1863

Olympia

Oil on canvas, 51 × 73¾"
Museum of Impressionism, The Louvre, Paris

Here she is, the famous *Olympia* that aroused so much outcry at the Salon of 1865 (to protect her from the blows of canes and umbrellas, it was necessary to hang her high on the wall, from where she gazed down defiantly on the onlookers). What audacity on Manet's part to present this common little woman stretched out nude on a flowered shawl and the sheets of a hospitable bed, wearing only a slipper, a black velvet neck-ribbon, a bracelet with a locket, and a pink bow in her hair, and with a Negress bringing a bouquet from a client, and a little black cat beside her!

The critic Ernest Chesneau, a champion of Romanticism, wrote of this picture: "Manet succeeds in provoking almost scandalous laughter, which draws Salon visitors to the ludicrous creature (if I may be allowed the expression) whom he calls *Olympia*." Paul Mantz said that the outline of the figure seemed to be "drawn with soot."

"Insults rain down on me like hailstones," the painter wrote to Baudelaire, who replied from Brussels: "Do you think that you're the first man to be in this position?" and cited Wagner as one who had been ridiculed without dying of it.

As for Degas, he remarked astutely to Manet after the affair was over: "So now you're as famous as Garibaldi."

After a relentless campaign in its favor sponsored by Claude Monet, the *Olympia* was admitted by subscription in 1890 to the Luxembourg Museum. In 1907, by order of Clemenceau, then Prime Minister, it was transferred to The Louvre, transported in a simple carriage by the custodians, and hung in the Salle des Etats opposite Ingres's *Odalisque*.

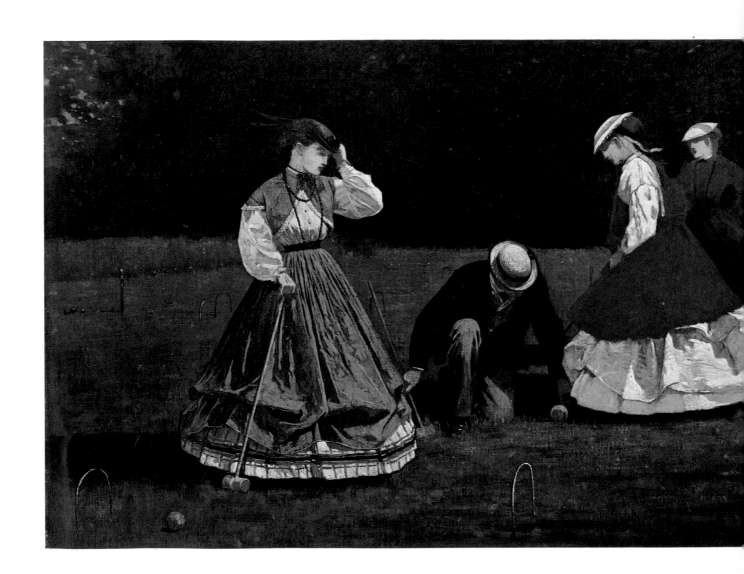

WINSLOW HOMER (1836–1910)

Painted in 1866

Croquet Scene

Oil on canvas, 15⅞ × 26"
The Art Institute of Chicago

Winslow Homer, along with Thomas Eakins, is the chief American painter of the second half of the nineteenth century. Some of his pictures, such as the *Croquet Scene*, take their place with those of Manet as pre-Impressionist works.

Croquet as a subject for painting, initiated by Homer in 1865, will soon be treated by Manet and the Impressionists (Manet was to paint his *Partie de croquet* in 1871, and another in 1873; Berthe Morisot executed her sketch, *Croquet à Mézy*, in 1890).

This conception of an open-air scene, the broad style, and above all the artist's way of catching the light in pronounced brushstrokes, could not have failed to be prophetic.

Unfortunately Winslow Homer's art is uneven and inconsistent. If he shows great qualities as a young man, his talent later seems to dry up, when this most obstinate of New Englanders joined the official National Academy of Design. From then on his painting takes on a meticulous and trifling precision.

Homer began his career in Boston as a lithographer and illustrator. Moving to New York in 1862, he worked for *Harper's Weekly* and other magazines. He began to paint in 1862, and lived in Paris from 1867 to 1868. In 1884 he settled in Maine, ending his days at Prout's Neck. He painted coastal and fishing scenes, and traveled to such places as Florida, Cuba, and Nassau.

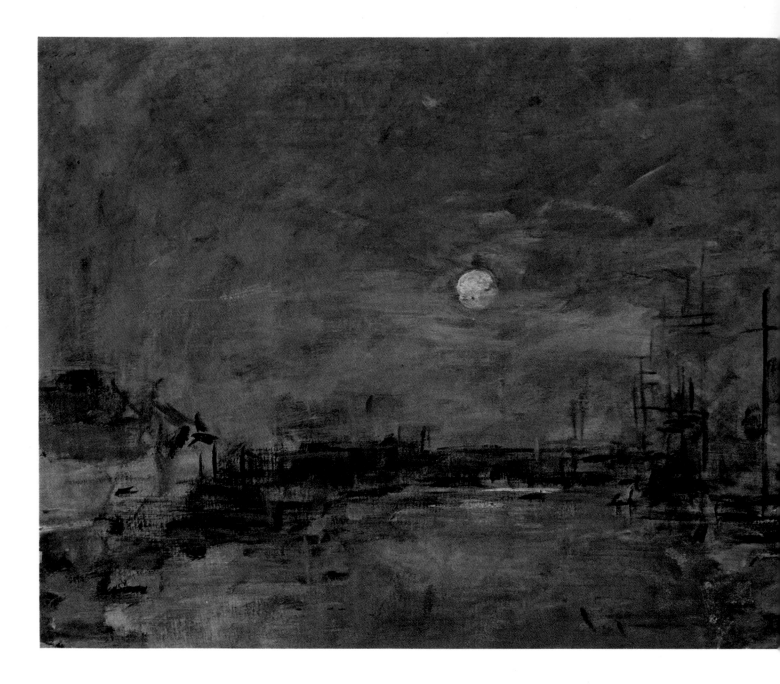

EUGÈNE BOUDIN (1824–1898)

Painted about 1872–78

Twilight over the Basin of Le Havre

Oil on canvas, 15¾ × 21⅝"
Musée du Havre

This work by Boudin is very close to the painting by Monet that gave its name to Impressionism. The technique is similar. Both pictures show almost the same punctuation of brushstrokes. Only the emphasis is different, dispersed in the Boudin over the whole picture to indicate the quais, the masts, the house chimneys, while in the Monet canvas the accent falls principally at the center, on the small boat. Another difference: Monet used much warmer colors for his sunrise.

Boudin and Monet took as their subject the port of Le Havre, where, as we know, the two painters worked together. Monet's picture is dated 1872, and Boudin's must surely fall between that time and 1878, when, in September, he wrote to Ricada, one of his admirers: "We are going to Le Havre with M. Monet." For his part, Monet always acknowledged what he owed to the older man, sixteen years his senior. "It was Boudin," he said to Marc Elder, "who initiated me. He revealed me to myself and started me on the right path."

Overleaf ▶

CLAUDE MONET (1840–1926)

Painted in 1872

Impression, Sunrise

Oil on canvas, 17¾ × 21¾"
Musée Marmottan, Paris

This painting is Turneresque with its blues and the orange of the sun. In this juxtaposition of planes and values, one divines more than one sees. But the space, the air, the atmosphere of the port of Le Havre, the reddened sky, the water, are all there. If one removes the dark accent placed on the boat, nothing remains.

The canvas was exhibited in 1874, in one of the smaller rooms of the Nadar studios on the Boulevard des Capucines in Paris. It was this painting that gave its name to Impressionism. On April 25, Louis Leroy wrote jestingly in *Le Charivari*: "Impression, I was sure of it. I also thought, since I am impressed, there must have been an impression in it." And he added: "Wallpaper in its earliest stages is still more finished than this seascape!"

Not until his last paintings, the *Waterlilies*, does Monet display again such audacity. He was reproached for not outlining the objects he painted. With regard to this, Gustave Kahn observes that "to enclose is to falsify. A color evokes countless echoes; reflections spread themselves far in a succession of ordered harmonies. What Monet calls forth wherever he sets up his easel are true symphonies" (*Mercure de France*, February 15, 1924).

Monet was Impressionism incarnate. He set everyone an example, as Boudin remarked, "by holding fast to his principles." And Renoir: "Without him, without my dear Monet who gave us all courage, we would have given up."

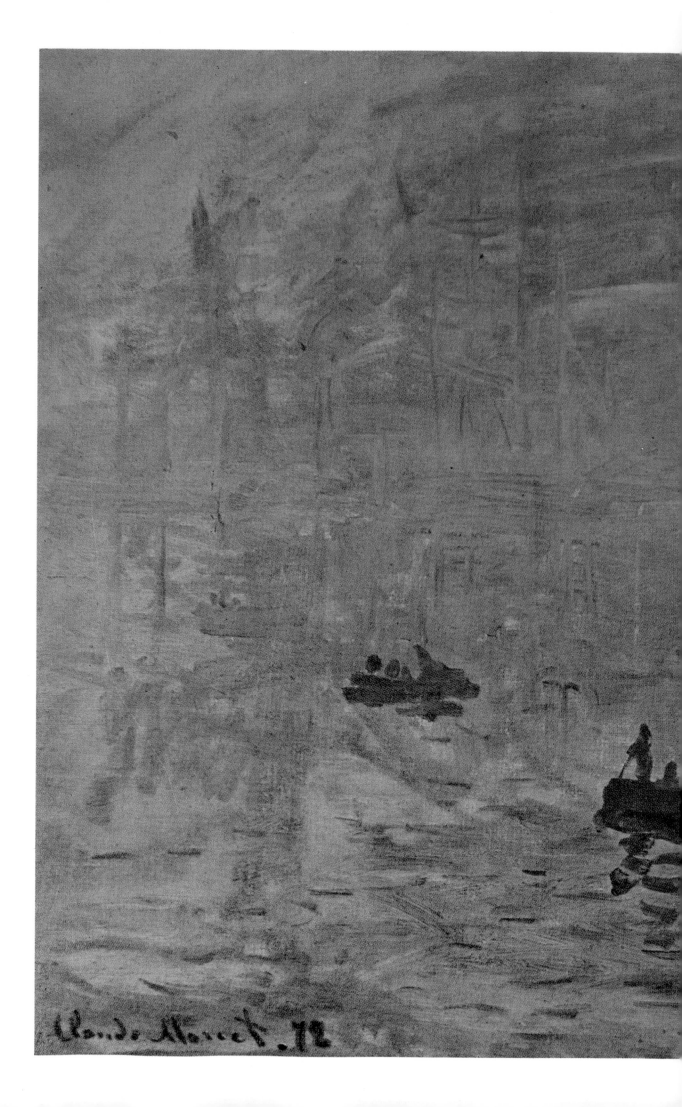

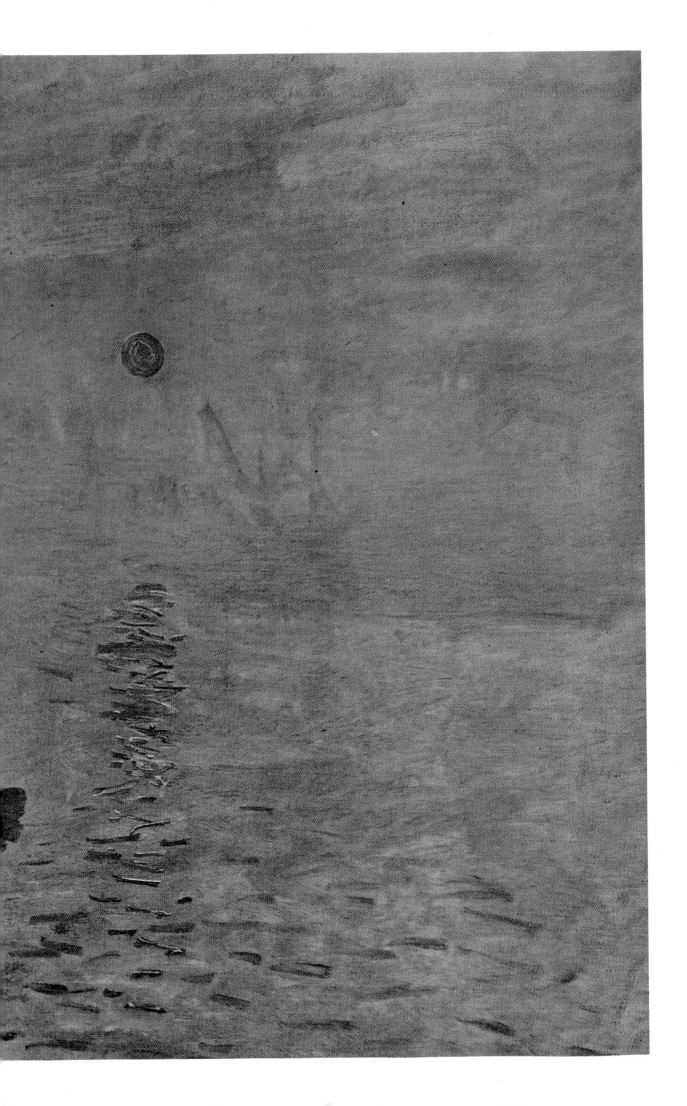

CLAUDE MONET (1840–1926)

Painted in 1875

The Basin at Argenteuil

Oil on canvas, 23⅝ × 31¾"
Museum of Impressionism, The Louvre, Paris

The *plein air* holds certain hazards for the painter. His camp-stool sinks into the ground, while twigs fall on his palette and the wind shakes his canvas when it does not knock it off the easel entirely.

Some figures are strolling, while others are seated. They are part of the whole in the same way as the bright patches of color mottling the path. The artist does not give them the importance he once did, when he painted the picnickers at Chailly or his wife, Camille, close up. Gustave Kahn seems to regret their gradual disappearance with the increasing maturity of the painter. But what interests Monet is light, color, nature in its daily variations, for he now takes his place as "head of this school of sunlight." Théodore Rousseau sought his inspiration outdoors and then worked in the studio. Courbet sketched in the open air but completed his work inside. Manet painted outdoors only occasionally, urged by Monet, his companion at Argenteuil.

"In two days, that is to say the day after tomorrow," Monet writes to his patron Dr. de Bellio, a Rumanian count, homeopathic physician, and friend of the Impressionists, "we must leave Argenteuil; to do that, one must pay his debts. I have been lucky enough since I saw you to raise 1,200 francs; I need only 300 francs more to pay some final bills and to arrange for our moving. Would you do me one last favor and advance me another 200 francs that I am otherwise unable to find?" (papers of the Musée Marmottan).

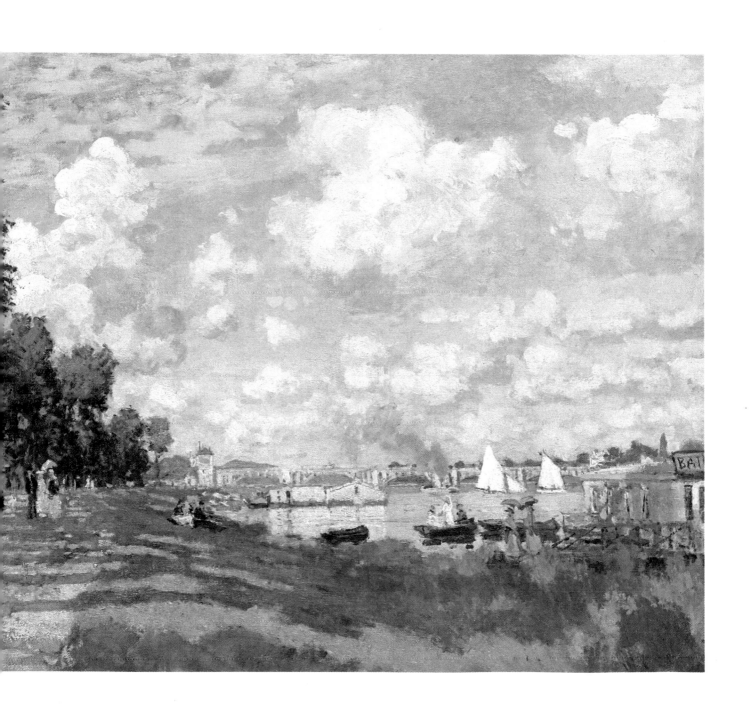

CLAUDE MONET (1840–1926)

Painted in 1904

Waterlily Pool

Oil on canvas, 35½ × 36¼"
Museum of Impressionism, The Louvre, Paris

On June 22, 1890, the painter wrote to Gustave Geffroy: "I have again taken up something impossible—water with grass rippling at the bottom. It's fine to look at, but it's madness to want to paint it. Oh well, I'm always getting into such things."

Monet had acquired his house at Giverny in 1890. It was in the garden of this property that he had seen these waterlilies, which attracted him by their presence amidst patches of color and reflections of the sky. The form and density of things dissolved in the play of light. To the time of his death he was to derive numerous variations from this theme. He was to paint these mirrors of water surrounding the waterlilies in harmonies of green or pink, in sunlight, and the dusk of evening.

The painting shown here is somewhat a synthesis of the others. The passage of time—in this picture where the horizon line cuts off the sky—is expressed simultaneously in the movement of the waterlilies from one side of the canvas to the other, and the movement of our gaze upward from the bottom. "Here and there, on the surface, floated, blushing like a strawberry, the scarlet heart of a lily set in a ring of white petals. Beyond these the flowers were more frequent, but paler, less glossy, more thickly seeded, more tightly folded, and disposed, by accident, in festoons so graceful that I would fancy I saw floating upon the stream . . . moss-roses in loosened garlands" (Marcel Proust, *Swann's Way*).

Later Clemenceau encouraged Monet to paint the immense panels now to be seen in the Orangerie of the Tuileries in Paris. For this the painter had a very large studio built. "I saw against the wall," Marc Elder wrote on May 8, 1922, "the large stretchers on which Claude Monet has fixed the ephemeral avowals of his waterlily pond. . . . The nails are in place, the edge taut. A strong, angry, flustered hand has torn the panel. . . . Under the table, the pile of canvases which the servants are ordered to burn" (*A Giverny chez Claude Monet*, Paris, 1924).

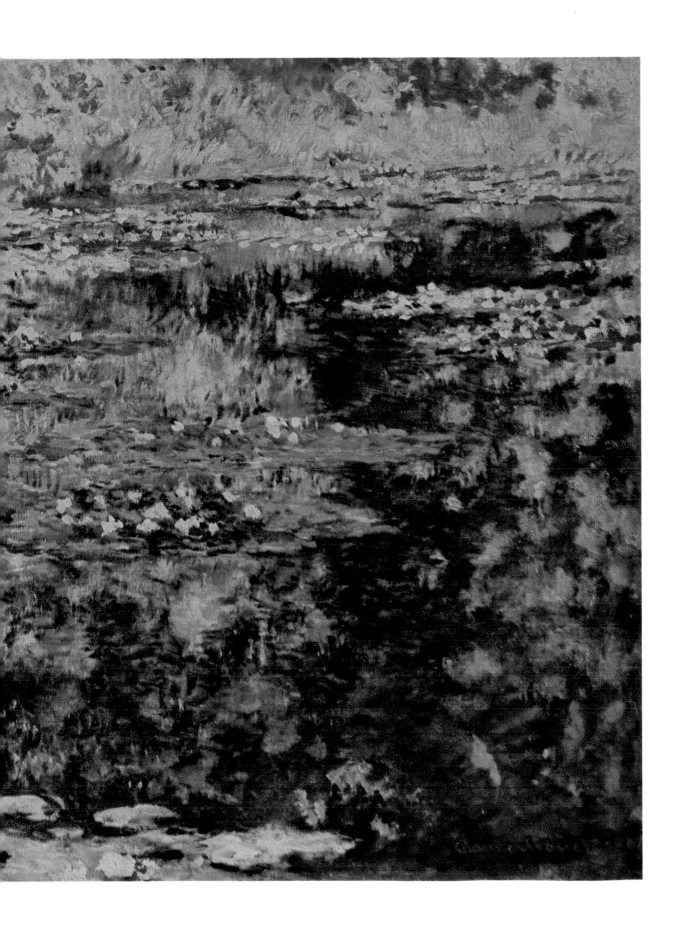

CLAUDE MONET (1840–1926)

Painted in 1878

Rue Montorgueil Decked with Flags

Oil on canvas, 24¼ × 13"
Musée des Beaux-Arts, Rouen

It was not, as is generally believed, the national holiday of July 14 that inspired this canvas by Monet, but the peace celebration held on June 30, 1878, at the opening of the Universal Exposition. For his part, Manet painted a canvas of his own on the same day, *La Rue Mosnier aux Drapeaux*, but Monet's painting is the more inspired. One can say that it is perhaps the masterpiece of Impressionism. Everything is present—the sensation, the color, the light, the proliferation of tricolor flags to which the artist has succeeded in imparting in their arrangement an extraordinarily lively rhythm. The picture is punctuated by emphatic brushstrokes, with staffs in the foreground that open the distance to the end of the street.

"He paints from afar," one of his colleagues said to the art critic Philippe Burty. Up close, the viewer sees "a mottled, intermingled, uneven, and velvety surface, like the reverse side of a Gobelins tapestry. . . . But from a distance in proper light the effect is achieved by the lines, the moderation of tones, the abundance of masses."

In that year, 1878, in a letter written from 26 Rue d'Edimbourg, Monet asks Zola to lend him two or three louis, "or even one." His wife had just given birth to a son. "You will be doing me a very great favor, for I ran around all day yesterday without being able to find a sou."

In this period, Monet was still out of favor. "He had to endure," as Geffroy says, "the gross judgments of the pretentious, the banter of the frivolous, the anger of successful painters who felt threatened, the plots that kept his work from being shown in public exhibitions."

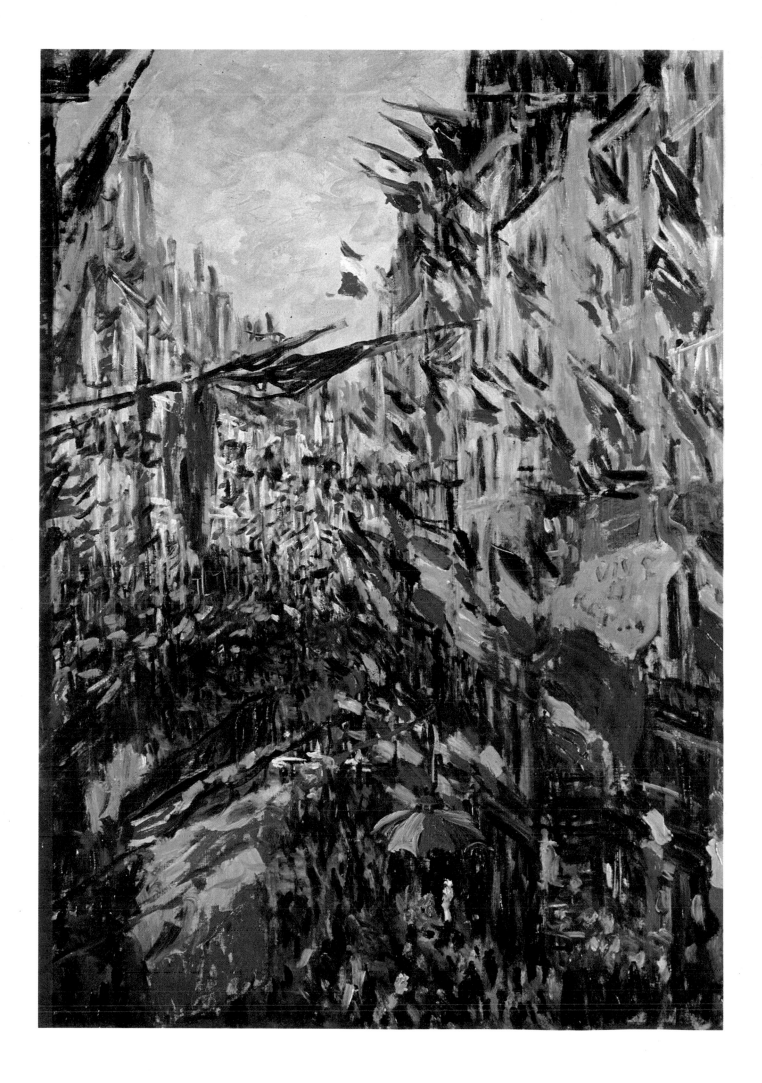

CAMILLE PISSARRO (1830–1903)

Painted in 1877

Orchard with Flowering Fruit Trees, Springtime, Pontoise

Oil on canvas, 25⅝ × 31⅞"
Museum of Impressionism, The Louvre, Paris

In 1877, Camille Pissarro worked at Pontoise with Paul Cézanne, whom he persuaded to paint in the open air. Having undergone the influence of Courbet, and especially of Corot, at the beginning of his career, he exhibited this *Orchard* and twenty-one other landscapes at the third Impressionist exhibition, held in the Rue Le Peletier in April of that year.

It was at this time that he came into his own. In this peaceful rural atmosphere which he would always paint, an orchard, an apple tree, are pretexts for color. "The light radiates to the most shaded corners of his pictures," said Georges Lecomte, adding, "Working in the countryside with Cézanne, Piette, and Guillaumin, he strove to illuminate his paintings with a quiet, incorporeal brightness." It was also in the year 1877 that Pissarro began using white frames for his pictures in order to preserve the exact value of the tones.

In 1870, *père* Martin, a picture dealer who lived at the end of the Rue Laffitte, at that time the street of art dealers (he had previously sponsored Jongkind), offered some of Pissarro's canvases to the public. Théodore Duret tells us that Martin had bought these works from the artist for forty francs, and although he tried to obtain twice that amount for them, he had to come down to sixty. These paintings, in our day, are among the most prized by connoisseurs—paths bordered by trees, orchards, and snowy streets.

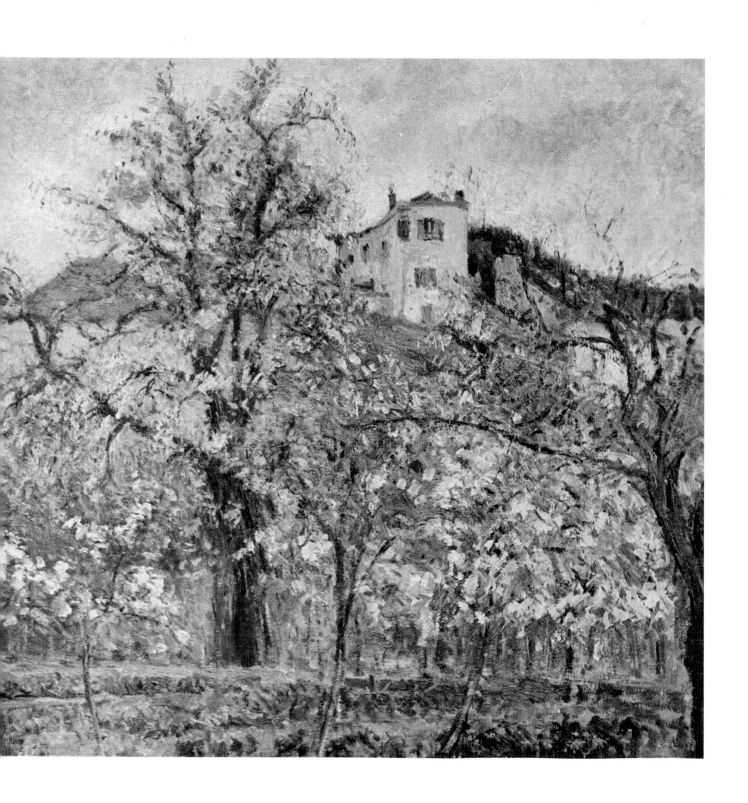

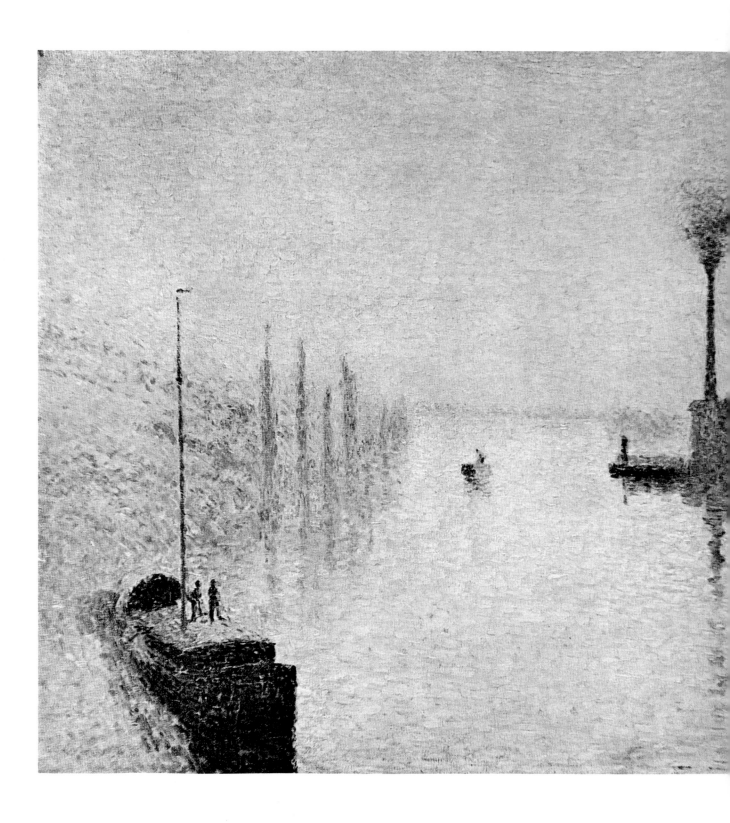

CAMILLE PISSARRO (1830–1903)

Painted in 1888

Ile Lacroix, Rouen—Effect of Fog

Oil on canvas, 18¼ × 21⅞"
Courtesy John G. Johnson Collection, Philadelphia

This Rouen scene, under the smog of tugboats, is from Pissarro's Neo-Impressionist period, or at any rate the one in which he adopted the Pointillist technique.

As in the case of Seurat, the new technique compelled Pissarro to work in masses and large silhouetted planes (the boat in the foreground to the left, the factory chimney in the background to the right). Nevertheless he succeeded in mastering the new system, which requires great control in the handling of pictorial space. Like Seurat and Dubois-Pillet, Pissarro here paints *where there is nothing* except sky and water to catch one's eye. Under his brush, these elements come to life, with a quivering, dazzling, and subtle clarity. We look across the expanse and the distance, delighted to see and experience what the painter has left (and is not that the essential?)—the feeling conveyed by his hand, the vibration of the light, the muted yet silvery overlaying of color.

There is a feeling of vastness in the painting, increased by the tiny figures of the two men on the deck of the moored boat.

CAMILLE PISSARRO (1830–1903)

Painted in 1898

Place du Théâtre Français, Paris

Oil on canvas, $28\frac{3}{4} \times 36\frac{1}{4}''$
The Minneapolis Institute of Arts

After 1897, in order to spare his eyesight which could no longer withstand working in the open air, Pissarro painted a series of Paris scenes. For this he rented rooms. It was from a window at the corner of the Rue Drouot that he painted the Boulevard Montmartre. From Mme Rolland's house in the Place Dauphine, he did numerous views of the Pont Neuf. In the apartment where he was to end his days, on the Boulevard Morland, he painted the Quai Henri IV. In the meantime, in 1898, he rented a room at the Palais Royal. On February 11 of that year, Signac notes in his journal: "Went to see *père* Pissarro at the Hôtel du Louvre, where he has installed himself to paint the Avenue de l'Opéra and the Place du Théâtre Français from the windows. . . . He is more hearty than ever, works with enthusiasm and talks heatedly about the [Dreyfus] case."

The delicate tones of this canvas evoke the life of the square, with its fountain by Hittorf, its congestion of carriages, throngs of passersby, and a few rather sickly trees.

He spent his days painting, awaiting the hour to meet his friends at the café, where, according to Gustave Kahn, "he always ordered a cold grog, then filled his glass with water and left the decanter of alcohol untouched. It was his elegant and exacting way of ordering a glass of water, for which the cafés did not charge, and thus paying for the privilege of sitting there."

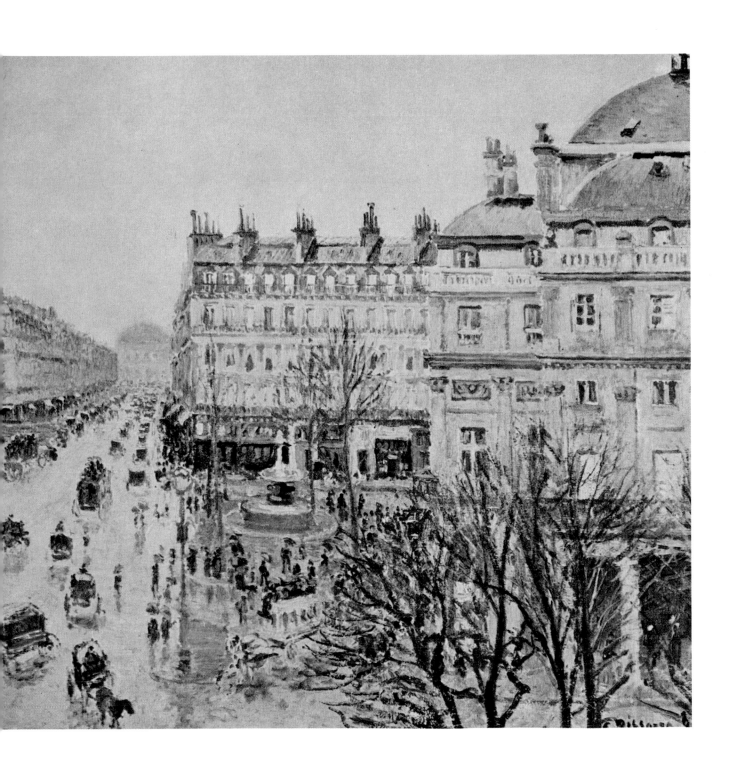

CAMILLE PISSARRO (1830–1903)

Painted in 1901

Fenaison à Eragny (Haymaking at Eragny)

Oil on canvas, $21\frac{1}{4} \times 25\frac{5}{8}''$
The National Gallery of Canada, Ottawa

In 1885, Pissarro settled for good at Eragny-sur-Epte, not far from Gisors. No one after Millet has felt such contact with the earth and its living growth. But he was more rustic than bucolic. Where Millet's attachment to the earth had been a little too generalized, his art a kind of pictorial sermon on country life, Pissarro—who owed much to him—was its true painter, more direct, more intimate, more real.

Pissarro probably painted this scene of peasant life in the summer of 1901 (he was at Eragny until July 19, before going to Dieppe). Everything is part of the atmosphere in this picture—the fields, the trees, the harvesters. The air enfolds these figures who partake of their surroundings and merge with the setting. All this is in a light palette, the color of honey, with tones of green and blue. The scene quivers with life and light. The woman at the right, in blue blouse and brown apron, her profile subtly delineated by the sunlight, stands motionless as a caryatid, watching her companions as they rake.

This picture is one of the most representative works of the artist to whom Cézanne owed his true initiation into painting. We pause over it for a long time, feeling the heat of a summer day, the vibration of the light, the wholesome joy of the open air.

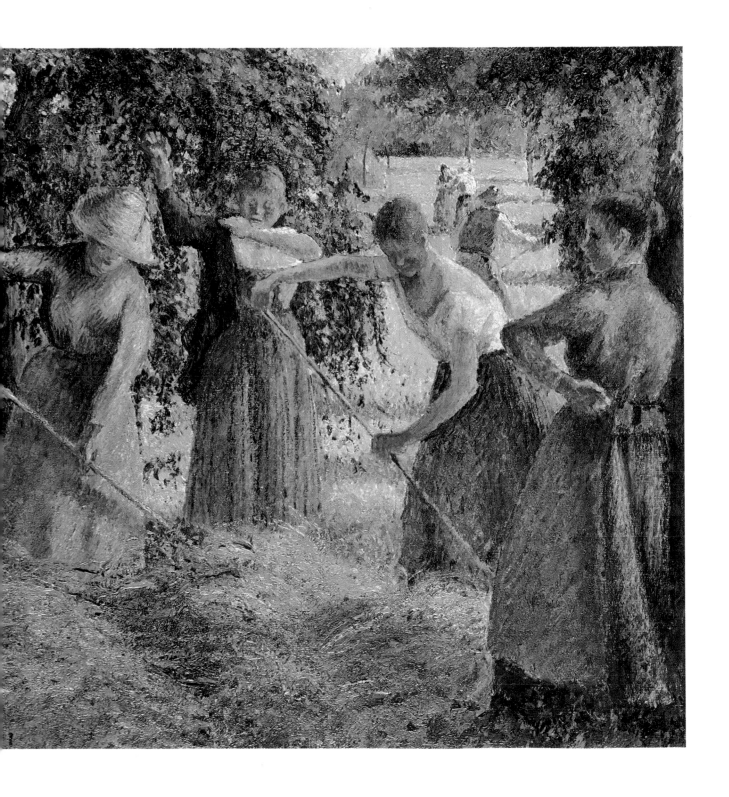

PAUL CÉZANNE (1839–1906)

Painted about 1873

A Modern Olympia

Oil on canvas, $18\frac{1}{8} \times 21\frac{5}{8}''$
Museum of Impressionism, The Louvre, Paris

At this time Cézanne, in his erotic fantasy, sought inspiration from the Venetians. He had painted the *Orgy* some years previously. In this *Olympia* where he has deliberately taken up Manet's theme to lend it an interpretation of his own, the painter from Aix for the first time declares himself a realist. One thinks of the closing lines of Flaubert's *Education sentimentale*, which Cézanne had read with great interest.

This picture, of which there exists an earlier version, was shown in Paris at the first Impressionist exhibition, held in the Nadar studios. It was painted at Auvers-sur-Oise, at the home of Dr. Gachet, whose son Paul has related its genesis. One day Dr. Gachet was speaking of Manet's *Olympia*, with such open admiration that Cézanne's self-esteem was piqued. He took up a canvas, and almost at once dashed off *A Modern Olympia* in all its fresh brilliance (Paul Gachet, *Deux Amis des Impressionnistes: Le Docteur Gachet et Murer*, Paris, 1956).

It is a baroque work in which Cézanne's blue-green palette is only suggested. He was only thirty-four years old. Having left Aix, like Zola, for the conquest of Paris, and ridding himself of all orthodox standards, he was, says Paul Gachet, "animated by a stubborn will to succeed. Unwilling to accept at any price the bourgeois life offered him by his banker father, he preferred a hard existence with Hortense Fiquet and their child at Auvers, where he arrived with a bundle of cheap unprimed cardboard and a few pieces of badly sized canvas, following the economical practices of Guillaumin (which by no means excluded a piece of very good canvas once in a while, such as for the *Maison du pendu* and *A Modern Olympia*)." Cézanne at this time wore a workingman's red belt to hold up his trousers. Another of his companions at Auvers was Camille Pissarro, with whom he painted in the surrounding countryside, and especially at Pontoise. It was Pissarro who lightened his palette and introduced him to the division of tones.

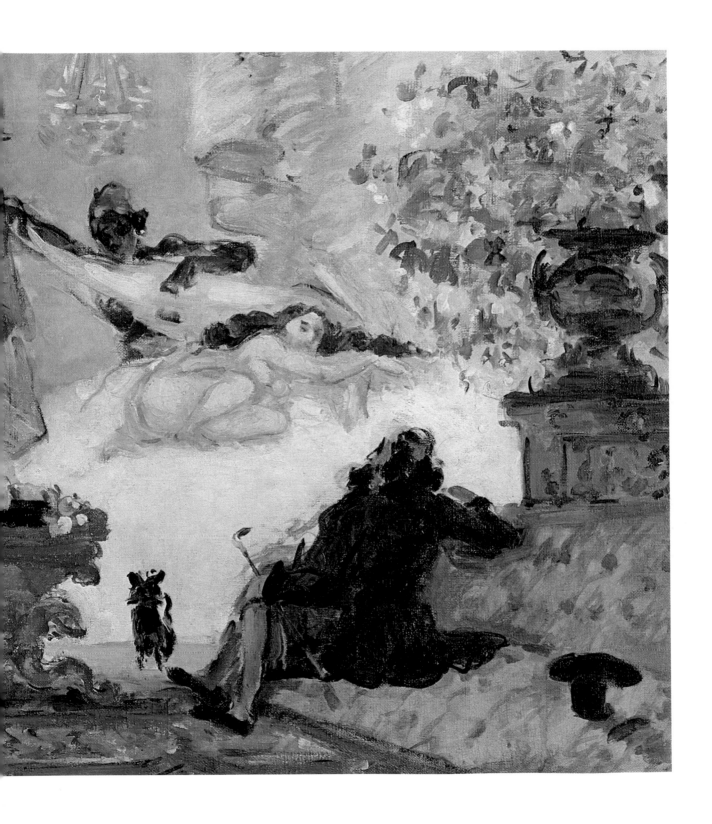

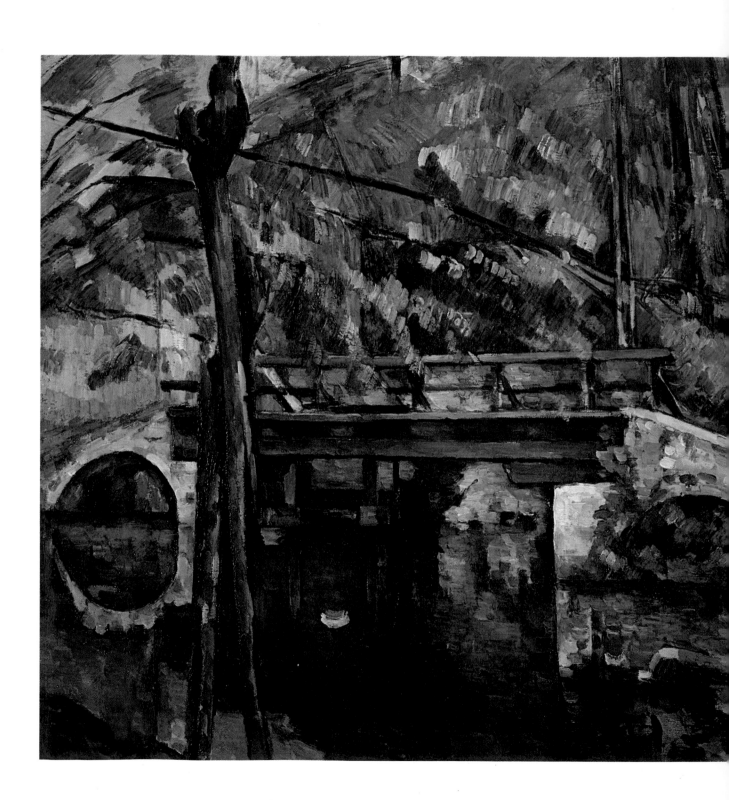

PAUL CÉZANNE (1839–1906)

Painted about 1879–80

The Bridge at Maincy

Oil on canvas, 23 × 28½"
Museum of Impressionism, The Louvre, Paris

Here there is incomparable freshness, a marvelous symphony of greens on the calm and sparkling waters, with the arches of white stone joined by the wooden footbridge. The sky, the pink house, the two nearly vertical tree trunks placed forward to open the space behind—everything in this picture combines to make it an unforgettable work. It is no longer a *corner* or a *piece* of nature, it is nature whole, seen through the artist's temperament. The painter has here become a transcendental poet.

Through form and color, Cézanne opens to our vision a new universe that goes far beyond the mere subject. Our eyes are drawn into a realm where we would like to be, where all is clean and pure, a refuge from the outer world. It is—despite some debts to Courbet and the Realists—a state of being, a profound sentiment, surpassing the thing represented. One recalls Baudelaire's admirable remark in his introduction to his translation of the stories of Edgar Allan Poe, the *Nouvelles Histoires Extraordinaires*—he speaks of the emotion induced by certain works which are "the testimony of an irritated melancholy, of a prostration of the nerves, of a nature exiled in the imperfect, and which would like to seize on this earth a revealed paradise."

In this picture, Cézanne has truly succeeded in "redoing Poussin on the basis of nature." His creative spirit bursts forth in color, which becomes his consolation, his everything. Before entering Victor Chocquet's collection, the work passed through the hands of *père* Tanguy, the paint dealer who, alone at the time, exhibited the canvases of unsuccessful artists in his shop on the Rue Clauzel. "You went to Tanguy's as to a museum," said Emile Bernard, "to see whatever studies there were by that unknown artist living in Aix . . . the young people felt his genius, the old men the folly of paradox, the jealous talked of impotence."

At the Chocquet auction in 1899, this canvas, for which the collector had paid Cézanne 170 francs, went for 2,200 francs.

PAUL CÉZANNE (1839–1906)

Painted in 1885–86

Village of Gardanne

Oil on canvas, $36\frac{1}{4} \times 29\frac{3}{8}''$
The Brooklyn Museum, New York

In traveling through Provence, one has the impression of seeing everywhere the palette and touch of Cézanne. Oscar Wilde was not wrong in saying that nature imitates art.

Only a very marked personality could achieve such understanding of the character of a region and depict it with such intensity as to give the traveler the conviction that the Apennines are copied from a Corot painting, or Le Tholonet and Gardanne from a Cézanne.

Gardanne is a landscape constructed with love. Cézanne has left the canvas showing at the lower right. This gives more importance, more monumentality, to the rest. The work, predominantly green and pinkish brown, is lifted in height by its houses and trees. It is all of Provence that rises before us, like a person who would speak to us.

Geffroy quotes Renoir as saying: "It was an unforgettable sight, Cézanne at his easel, painting and looking at the landscape. He was truly alone in the world, intense, concentrated, attentive, respectful. He came back the next day and every day, redoubled his efforts, and sometimes also he went away in despair, leaving his canvas on a stone or on the grass, at the mercy of the wind, the rain, the sun, to be absorbed by the soil, the painted landscape reclaimed by the surrounding nature."

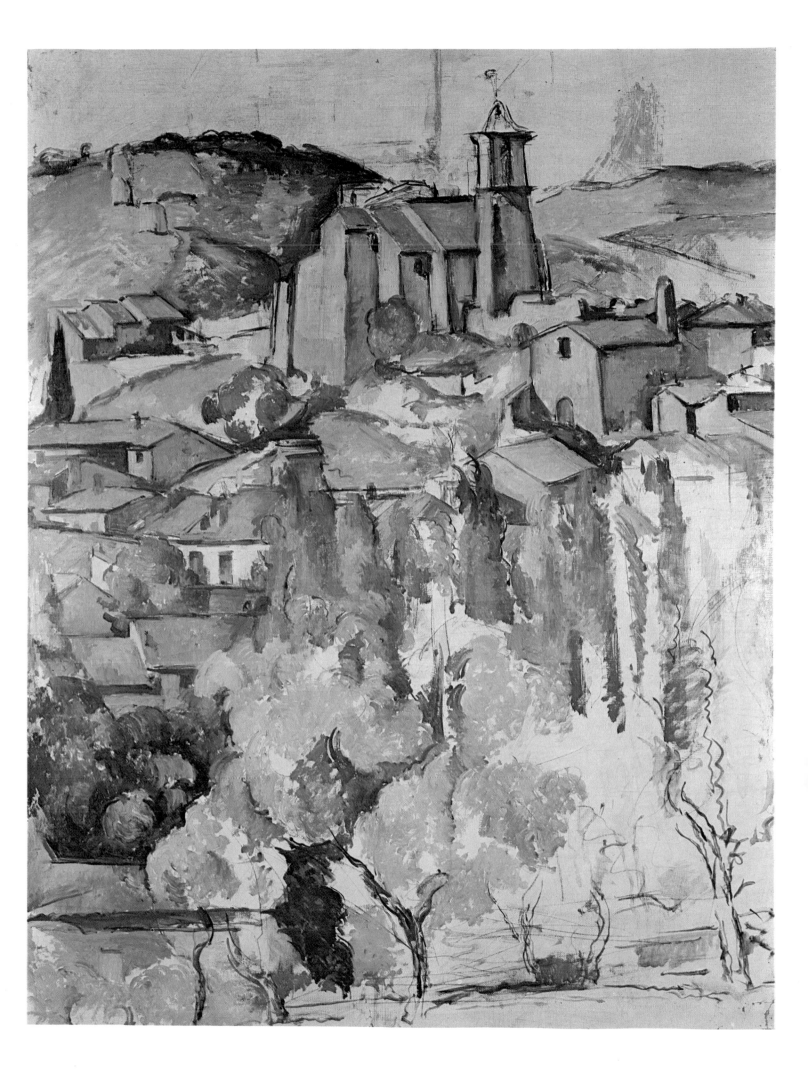

PAUL CÉZANNE (1839–1906)

Painted in 1893–95

Boy in a Red Vest

Oil on canvas, 35¼ × 28½"
Collection Mr. aud Mrs. Paul Mellon, Upperville, Va.

This is by far the finest of the series that Cézanne painted on this theme. The youth is thoughtful. The painter has put there all of his art, all the sensitivity of his eye, all his strength of color. The gesture is elegant. This painting occupies the same place for Cézanne as *Gilles* in the work of Watteau. There is great depth in the drawing, and yet everything is said with a few strokes. The red of the vest is like an untimely bloodstain on this boy still at the daydreaming age. The work achieves grandeur and deep feeling. The thick curtain is as heavy in its gray-blues as the youth is lithe.

It is an apparition, one which for some reason makes me think of the artist's appearance on the scene of the world.

What matters to Cézanne is not so much the logical imitation of the actual as the transcending of external reality. Throughout his work one feels this tension, this inner pressure that ends by draining everything with it. Values? He rejects them to replace them by color. The outline? He ignores it in order to concentrate on form in space. He would like never to finish, never to make the definitive stroke which often eludes him. From this comes his impasto and a rough texture, far from the smooth surfaces of Manet and Renoir.

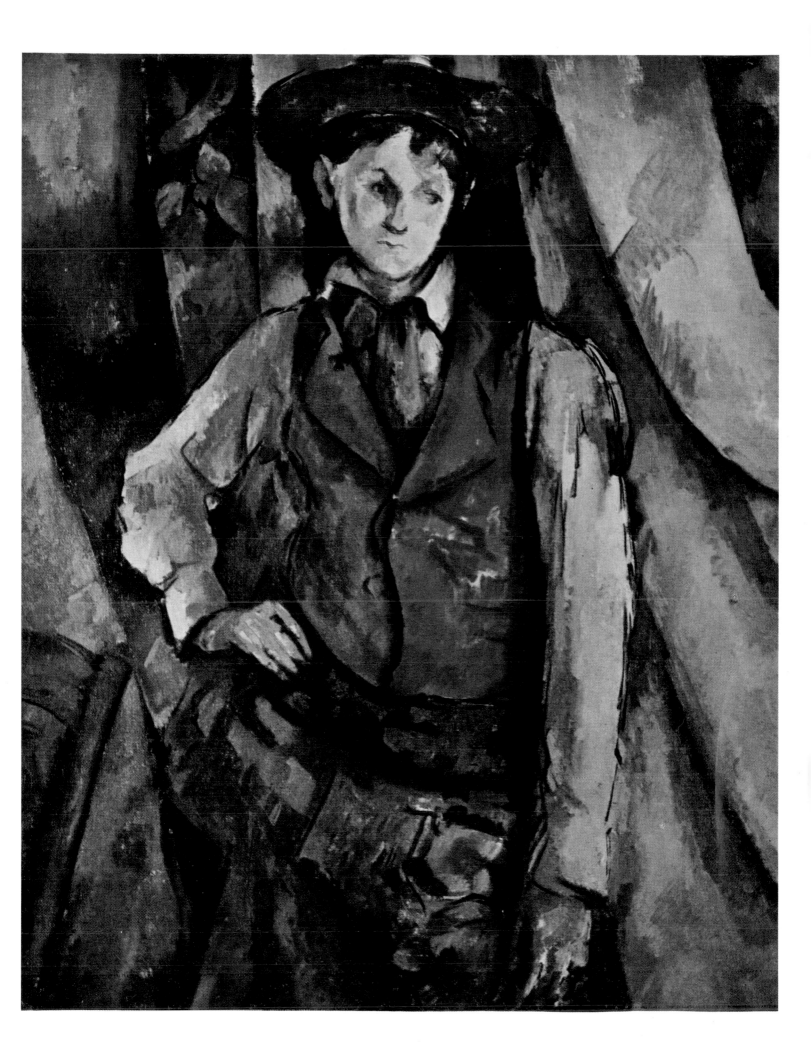

ARMAND GUILLAUMIN (1841–1927)

Painted in 1873

Sunset at Ivry

Oil on canvas, 25⅝ × 31⅞"
Museum of Impressionism, The Louvre, Paris

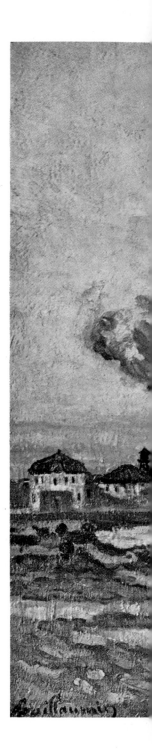

Here we have, in the heightened tones of the landscape, a foretaste of Fauvism, as well as a first view of the factory chimneys that Van Gogh will place in the background of his canvases on a similar theme. Nothing for Guillaumin was alive enough. In his study of the eighth and last Impressionist exhibition, Henry Fèvre remarks that Guillaumin "is capable of thrusting an insolent sun in front of your eyeballs that makes you lower your lids." And the critic speaks of the painter's "frenzy of sunlight," his "congested coloring." In his work, "the grass is gilded, the shadows an intense violet" ("Etude sur le Salon de 1886 et sur l'Exposition des Impressionnistes," *Demain*, Paris, 1886).

The Impressionists were said to be seized with "violettomania." The reproach applies primarily to Guillaumin. And it was he whom Huysmans had in mind when, writing of the fifth Impressionist exhibition in *L'Art moderne*, he remarked that "the eye of most [of these painters] was monomaniacal; this one saw hairdresser's blue in all of nature; that one saw violet; earth, sky, water, flesh, everything in their work borders on the color of lilac and eggplant."

Sunset at Ivry was shown in the first Impressionist exhibition in 1874. Before entering The Louvre, it belonged to Dr. Gachet.

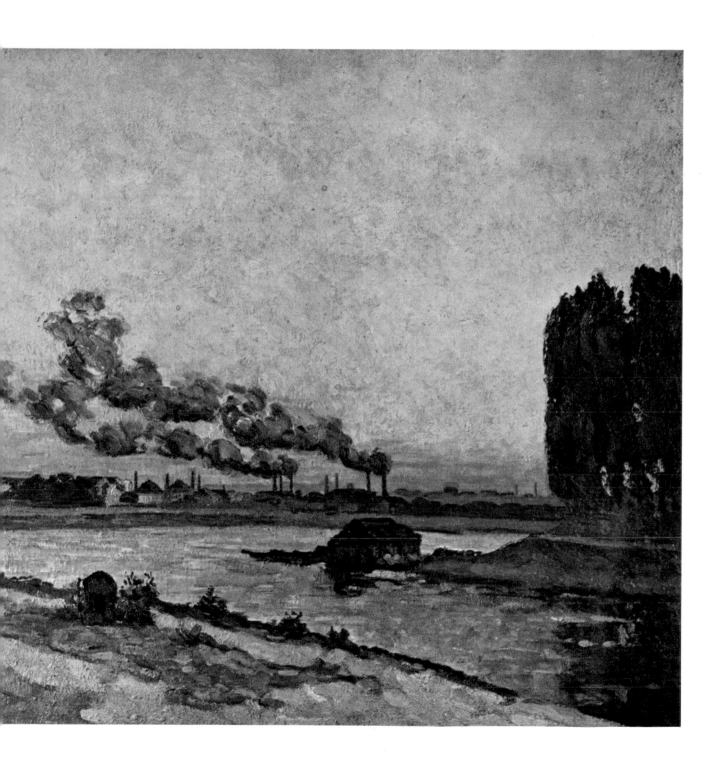

EDGAR DEGAS (1834–1917)

Painted in 1865

Woman with Chrysanthemums

Oil on canvas, 29 × 36½"
The Metropolitan Museum of Art, New York.
Bequest of Mrs. H. O. Havemeyer, 1929.
The H. O. Havemeyer Collection

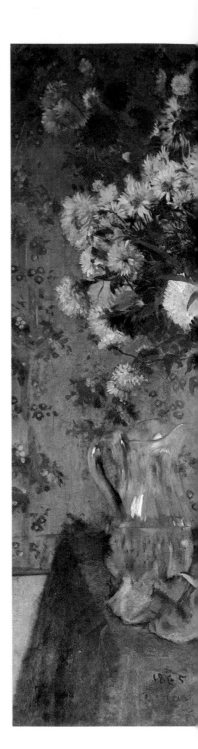

Degas here revives the art of the portrait by the audacity of his composition. One cannot say which is the most important, the bouquet, the table, or the lady; it recalls the line by Alberic II on the Pompeiian palace: *"Will it be God, table, or basin?"* It hardly matters since everything in the picture has the same plastic value; all is conceived in terms of drawing, color, and harmony. The chrysanthemums with their many and lively hues bring out the neutral, yellowish tones of the portrait. The drawing is distinct, and would even be dry were it not amplified by color. It is one of the first canvases in which Degas cut off his subject by the frame in the Japanese manner, a picture seemingly not composed, since the woman might almost have sat down at the table by chance. But everything here has been thought out and arranged, even the crystal pitcher and the carelessly tossed gloves.

Here the artist is mocking, witty, Parisian (with a touch of that Neapolitan spirit that had come down to him from his forebears). As an exhortation to himself, he wrote: "Paint portraits of people in familiar and typical attitudes, and above all give their faces the same choice of expression that you give their bodies."

Degas was more of a draftsman than any other Impressionist. Along with Ingres, he might have said: *Nulla dies sine linea.* He is the linear artist of the group. He liked to reflect while making notes from nature. "To do a portrait," he said, "have the model pose on the ground floor and go upstairs to work, to accustom yourself to remembering forms and expressions, and never draw or paint immediately."

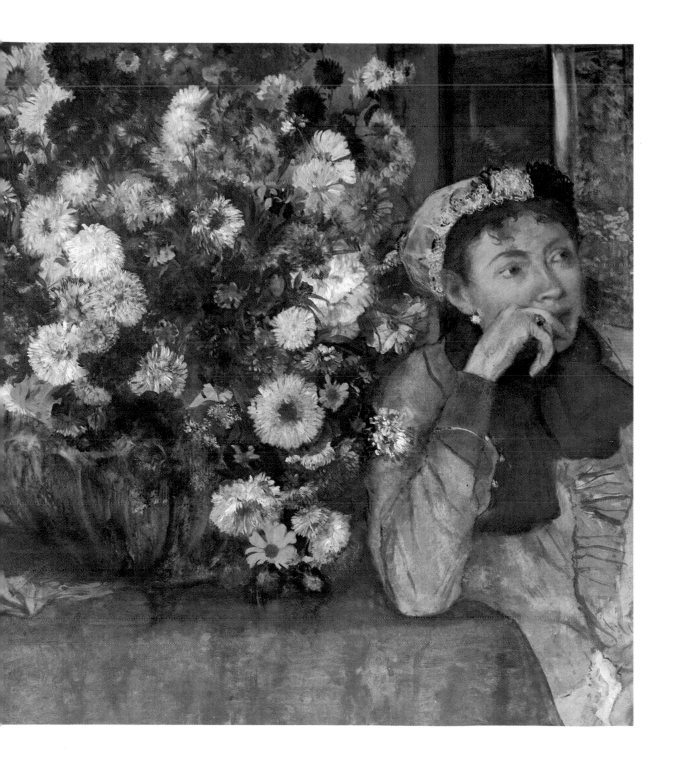

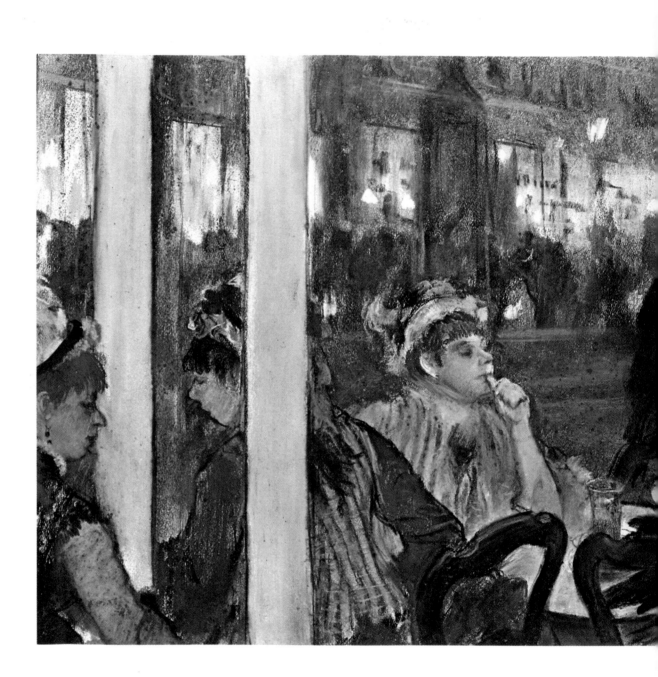

EDGAR DEGAS (1834–1917)

Drawn in 1877

Women on the Terrace of a Café

Pastel on monotype, 16½ × 23⅝″
Museum of Impressionism, The Louvre, Paris

Here, too, the presentation of the scene between the pillars of the Montmartre café has a certain daring. Degas has forcefully rendered the listlessness of these prostitutes discussing their clients' generosity or stinginess.

"Here are some women at the door of a café in the evening," wrote Georges Rivière in the first issue of the magazine *L'Impressionniste* (1877). "One taps her teeth with her fingernail, saying, 'That's not all!' Another spreads her large gloved hand on the table. In the background, the boulevard where the crowd diminishes little by little. It is an extraordinary page of history."

With this pastel, Degas abandons his smooth technique, adopting a more vigorous one in which the strokes overlap. He now achieves greater expression. Later he will catch the nude in her most private attitudes, prompting Henry Fèvre to remark: "M. Degas, with an artist's splendid shamelessness, strips bare for us the swollen, heavy, modern flesh of the public female. In the sordid bedrooms of registered houses, where they fulfill their social and utilitarian role as great collectors of love, these plump ladies wash, brush, soak, and dry themselves, in basins as wide as drinking troughs" ("Etude sur le Salon de 1886 et sur l'Exposition des Impressionnistes," *Demain*, Paris, 1886).

This pastel was shown in 1877 at the third Impressionist exposition in the Rue Le Peletier. It was afterwards part of the Caillebotte Collection.

EDGAR DEGAS (1834–1917)

Drawn about 1878

L'Etoile

Pastel, 22⅞ × 16½"
Museum of Impressionism, The Louvre, Paris

This is perhaps the most famous Degas, and one in which woman is not, as Félix Fénéon remarked, "soiled by being likened to an animal." This dancer on the stage is, on the contrary, a kind of fairy of illusion. The artist sees her "bending and pirouetting, her legs performing such difficult feats as *jetés* and *chassés, battements* and *entrechats*" (Roger Marx, *Maîtres d'hier et d'aujourd'hui*, Paris, 1914). Her bust is thrust forward, her arms raised in the graceful gesture of a prima ballerina; there are flowers in her hair, on her bodice, and at her waist; and everything is surrounded by a glowing haze from the footlights and the soft half-shadows of the scenery. The pastel texture gives the work the nuance and flat brilliance of a butterfly wing.

Seven years previously, on September 30, 1871, Degas had written to the painter James Tissot in London: "I have just had, and still have, some trouble with my eyes. This happened on the riverbank at Chatou, while I was painting a watercolor in bright sunlight, and for three weeks I was unable to read or work or go out, and was terrified that I wouldn't recover."

For its color, movement, and subtlety, this pastel is, in my opinion, the best example of Degas as an Impressionist. It is also a work in which his realism reaches a level of enchantment. It was part of the Caillebotte Collection.

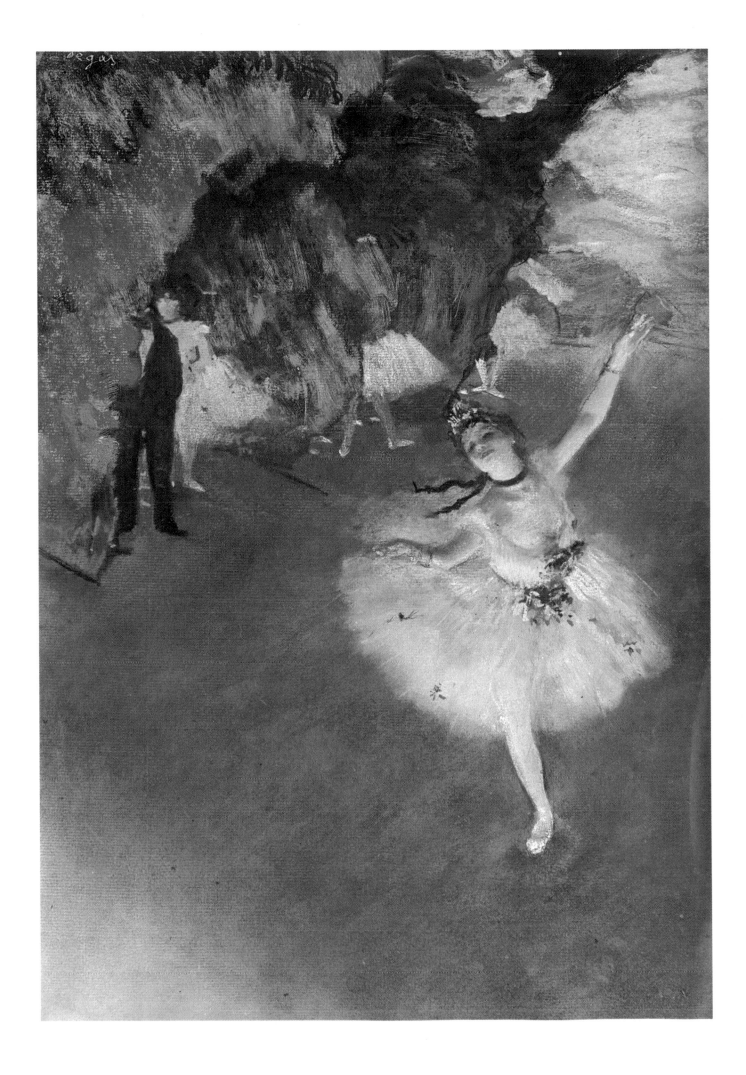

PIERRE-AUGUSTE RENOIR (1841–1919)

Painted in 1874

La Loge

Oil on canvas, 31 × 25"
Courtauld Institute Galleries, London

This is a marvel of femininity in its variations of pink and flesh tones. There is an enchanting harmony between the gold and the silver, the blue-blacks and the whites. Roger Marx speaks of those amber tones "which, in Renoir's pictures, give the skin a blond, velvet quality and the iridescence of mother-of-pearl."

We feel in this picture a flutter of eyelashes, a sense of breathing, a certain tremulousness, an emotion brought to the surface, that puts before our eyes that gift for life and happiness possessed by Renoir.

The flowers in the hair and on the bodice, the white gloves, the opera glasses held with such distinction,

would almost make us doubt that it was a professional model, Nini Lopez, who posed for this fine creature. The man leaning back and looking through his opera glasses at the gallery is Edmond Renoir, the painter's brother.

In this same year, 1874, Renoir participated in the first Impressionist exhibition with six oils. Later when his companions boasted of the freedom that they had discovered in landscape painting, Renoir began to doubt himself. "Alas, I am a painter of figures," he wrote to Claude Monet at the end of January, 1884. Therein, however, lay his originality.

110

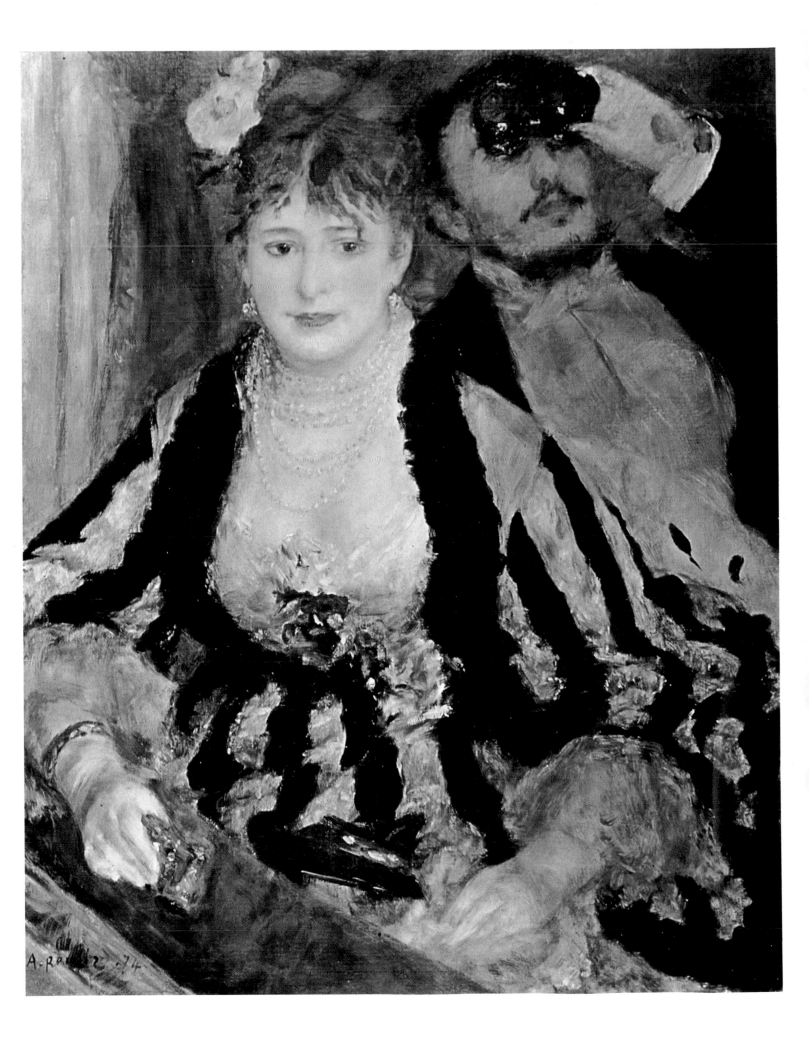

PIERRE-AUGUSTE RENOIR (1841–1919)

Painted in 1876

Dancing at the Moulin de la Galette

Oil on canvas, 51½ × 69"
Museum of Impressionism, The Louvre, Paris

It has been said that "Renoir put his contemporaries into pictures. *Dancing at the Moulin de la Galette* is one such scene, and along with the *Luncheon of the Boating Party* perhaps the most successful of all Impressionism. Certainly it owes something to Manet. But it is no longer a question, as with the painter of *La Musique aux Tuileries*, of broad luminous planes around a drawing in which the charcoal still shows in places. It is a wealth of notations taken from life, an exploding sky-rocket that has just spattered the dancers and spectators with sunlight. Form is introduced spontaneously by the brushstroke of color, by the relations of the tones, with no apparent contour.

It is, says Gustave Geffroy, "one of those complete summations of vital observation and luminous surroundings: the intoxication of the dance, the noise, the sunlight, the dust of an open-air festivity—excitement in the faces, carelessness of pose—a rhythm in which the clothing, pink, light and dark blue, black, whirls and pauses—a movement of passion, an advancing shadow, a running fire, pleasure and fatigue . . ."

The painting is a homogenous whole in which the artist has succeeded in evoking with equal facility the trees, the tables with glasses, the couples of drinkers and dancers. It has the gift of making us see, understand, and feel; it is rich in what poets have called *les correspondances*.

Most of the figures are either models or friends of the painter. Estelle, in a striped pink-and-blue dress, is seated on the bench in the foreground. Around the table are Lamy, Norbert Goeneutte, Georges Rivière; among the dancers, Gervex, Cordey, Lestringuez, Lhote. In the middle of the picture, the Spanish painter Solares y Cardenas dances with Margot.

The work formed part of the Caillebotte Collection.

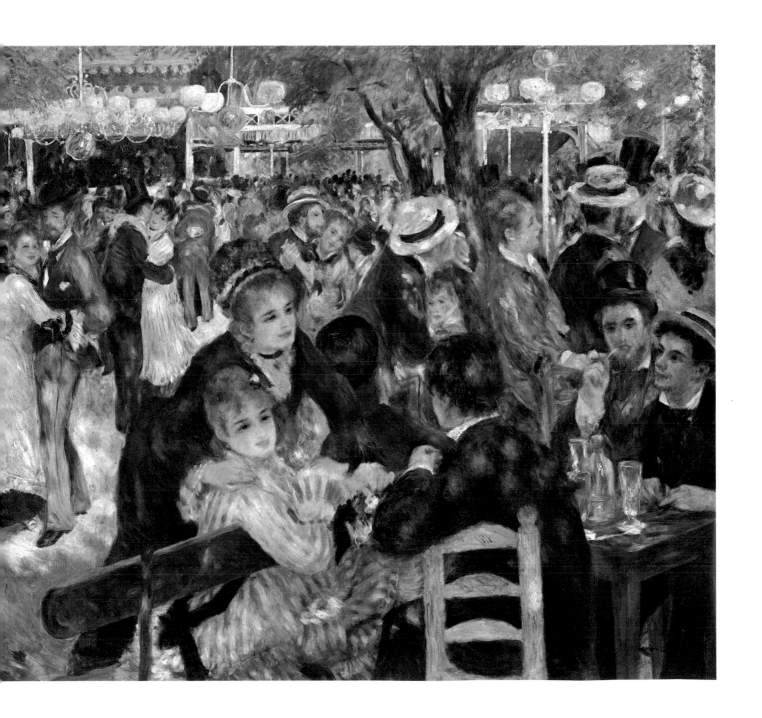

PIERRE-AUGUSTE RENOIR (1841–1919)

Painted in 1879

La Fin du Déjeuner

Oil on canvas, 39 × 32¼"
Städelsches Kunstinstitut, Frankfort

Here again we have an evocation of life and the joy of living. Renoir, who admired Delacroix, adopted this observation by that forerunner of Impressionism: "Flesh does not have its true color except in the open air and especially in sunlight." And no one equals Renoir in his unforgettable manner of rendering the play of light as it filters through the leaves. His secular Venuses have nothing lascivious about them; they belong to that happy realm composed of light, color, and affection that was particularly his.

The man in the corner lights a cigarette in the presence of two women, one dressed in black, one in white. The latter, holding a glass, is Ellen Andrée, who also posed for Manet and Degas. The standing woman is another of Renoir's models. The man, happy companion of these Montmartre nymphs here shown at the Cabaret d'Olivier, is the son of a Nantes shipowner, and one of the habitués of the Café de la Nouvelle Athènes.

Renoir had no rival in his use of thin mixtures of color with oil and turpentine. Sometimes he even abused this virtuosity, which prompted Degas to say: "He puts butterflies on the canvas." Renoir often heightened his tones (especially later in his *Bathers*), saying, "This will not be accepted for another fifteen or twenty years. First it is necessary to do the painting, then for time to pass, and finally for the public to get used to such colors" (Georges Rivière, *L'Art vivant*, July 1, 1925).

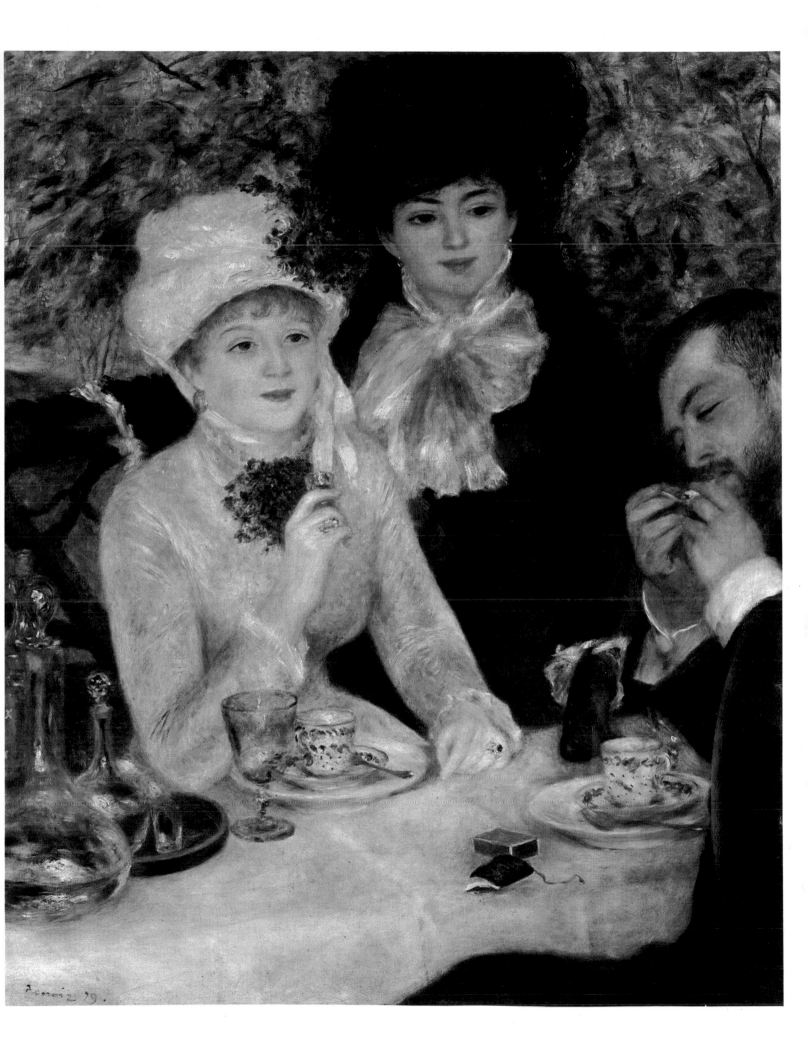

PIERRE-AUGUSTE RENOIR (1841–1919)

Painted in 1902

La Toilette (Grande Baigneuse aux jambes croisées)

Oil on canvas, 36¼ × 28¾″
Kunsthistorisches Museum, Vienna

This *Bather*, her skin dappled with light, with her firm breasts and splendid thighs, is one of Renoir's masterpieces after 1900. The curve of the shoulders and hips, the magnificent hair, soft and abundant, the lips bursting with animal joy, the sensuality of the rounded chin, the healthy exultation of the flesh—everything here speaks of happiness and fecundity.

This goddess is animated and sustained by a sense of humanity. *"Elle est belle et ça suffit*, she is beautiful and that's enough!"* Into the pain of our existence, she brings a vision of happiness without shadow, and sunlit days.

"His women," Albert Aurier remarks of Renoir's creations, "all belong to the eighteenth century." On this aspect of his style, in which he far surpasses Clodion, Renoir wrote modestly to his dealer Paul Durand-Ruel, when sending him a consignment of paintings: "They are a continuation of the eighteenth century . . . not as good." We might also note that Renoir in his sculptures is the forerunner of Maillol.

There exist several versions of this *Bather*, the theme of which was taken up time and again between 1902 and 1903.

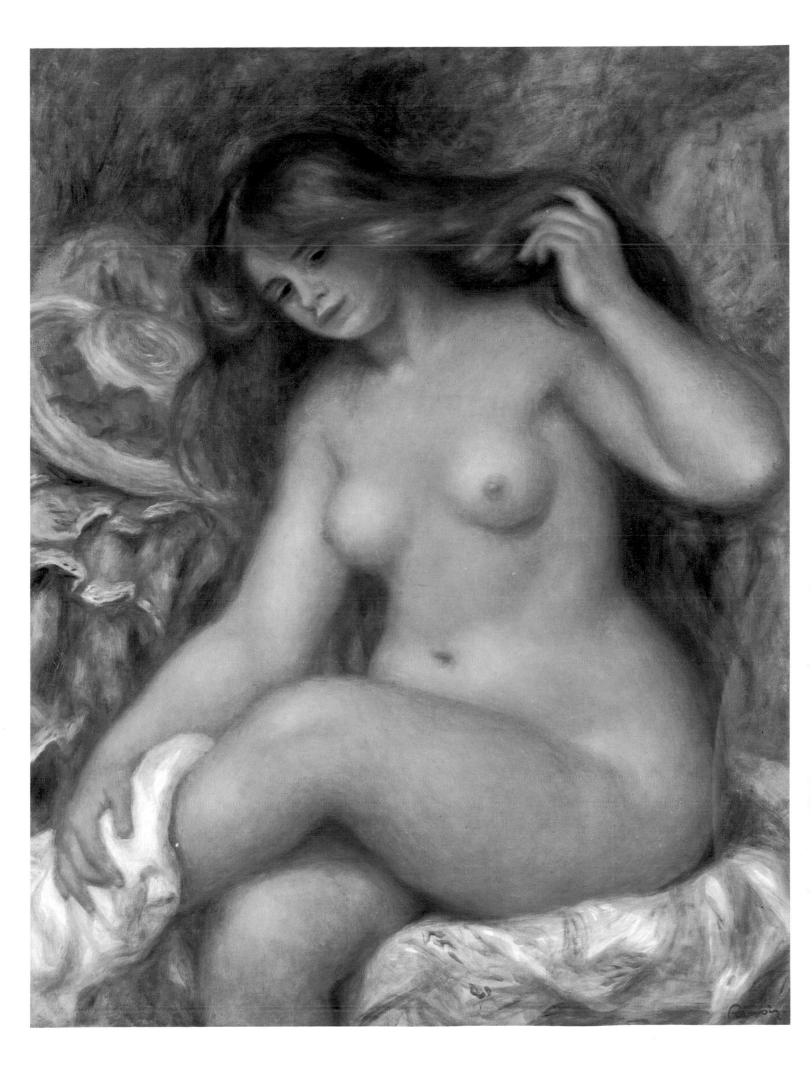

ALFRED SISLEY (1839–1899)

Painted about 1873

Louveciennes, Heights of Marly

Oil on canvas, 15 × 18⅛"
Museum of Impressionism, The Louvre, Paris

On leaving Gleyre's studio, Sisley worked with Frédéric Bazille at Chailly, and later at Marlotte near Fontainebleau with Renoir, with whom he lodged at *mère* Anthony's. In 1865, the two companions took a boat trip down the Seine as far as Le Havre. After painting at Argenteuil, Sisley went to live in Louveciennes in 1871, where his personality began to develop after a beginning influenced by Corot.

This painting, showing a path descending between houses surrounded by gardens, is both delightful and moving. One feels the artist's infinite love of nature, his pleasure in the presence of a visual reality which for him has become almost musical. Never more than here have the brushstrokes of painting come truly closer to the notes of music. Everywhere the joy of the painter enhances his subject, pretext for a lyricism that takes the shape of a gray slate roof, the stones of a path, a proliferation of blue-green foliage. And the woman walking away into the landscape, is she not a transposition of the artist himself, who stops time to take possession of the moment?

Eugène Murer, friend of those he called "the four musketeers of Impressionism," Monet, Renoir, Pissarro, and Sisley, said of the last: "If Claude Monet had not been his friend and contemporary, he would have been the most perfect landscapist of the end of the last century. Sisley knew this, and had the weakness sometimes to show a little bitterness toward his illustrious comrade. But although of second rank, he is all the same a very great artist, full of feeling and light" (Paul Gachet, *Deux Amis des Impressionnistes: Le Docteur Gachet et Murer*, Paris, 1956).

ALFRED SISLEY (1839–1899)

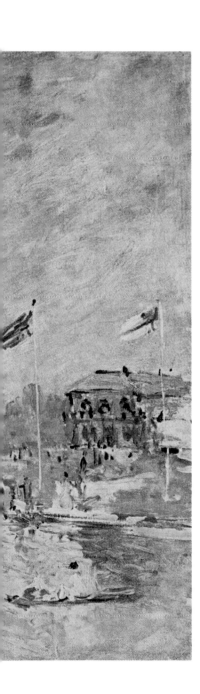

Painted about 1874

Boat Races at Molesey

Oil on canvas, 24⅜ × 36¼"
Museum of Impressionism, The Louvre, Paris

In this picture Sisley's technique achieves a singular freedom. It is almost with ideograms that he depicts the swiftly rowing oarsmen. His fresh, rapid, comma-shaped brushstrokes give the painting its resonance. Around the large flags billowing in the wind, he skillfully opposes the white verticals of the judges in the foreground and the spots representing strollers on the mound on the other bank to the oblique movements of the boatmen.

Of English parentage, Sisley at the age of eighteen had worked for a while in a business firm in London. It was near the capital that he painted this canvas, when, seventeen years later, he made a trip to the country of his parents' origin with Jean-Baptiste Faure, the baritone of the Opéra and friend and collector of Manet.

In this period, Sisley's paintings sold for between fifty and three hundred francs. They went still lower as time went on. But the artist persisted in sending his canvases to the official Salon, because, as he said: "If I were accepted, I think I would sell a lot." Théodore Duret helped him to find buyers. Around 1878, he found a patron in Jourde, editor of *Le Siècle*, who bought seven of his pictures (although the art critic of the paper, Castagnary, friend of Courbet and a champion of Realism, had little liking for Impressionist painting). *Boat Races at Molesey* formed part of the Caillebotte Collection.

ALFRED SISLEY (1839–1899)

Painted in 1874

Snow at Louveciennes

Oil on canvas, 21⅝ × 18⅛"
The Phillips Collection, Washington, D.C.

Sisley is above all the painter of snow effects. In this domain restricted to one season and a particular sensation, there is no one to equal him in all of painting. In seeing this flaky landscape, one is struck by the evocative quality of his art. One becomes part of this winter scene. Something more musical than painting seems to invade and envelop us like poetry.

The woman coming toward us through the snowfall, under her large umbrella, in the bluish whiteness of the snow covering the ground, is the note which makes this little symphony vibrate. By Sisley's engaging art and delightful technique, everyday nature is masked for a moment, shrouded with a white mystery.

As Paul Signac justly remarked on viewing the Sisleys exhibited at Durand-Ruel in April, 1899: "It is obvious that he was the first and foremost to divide his palette."

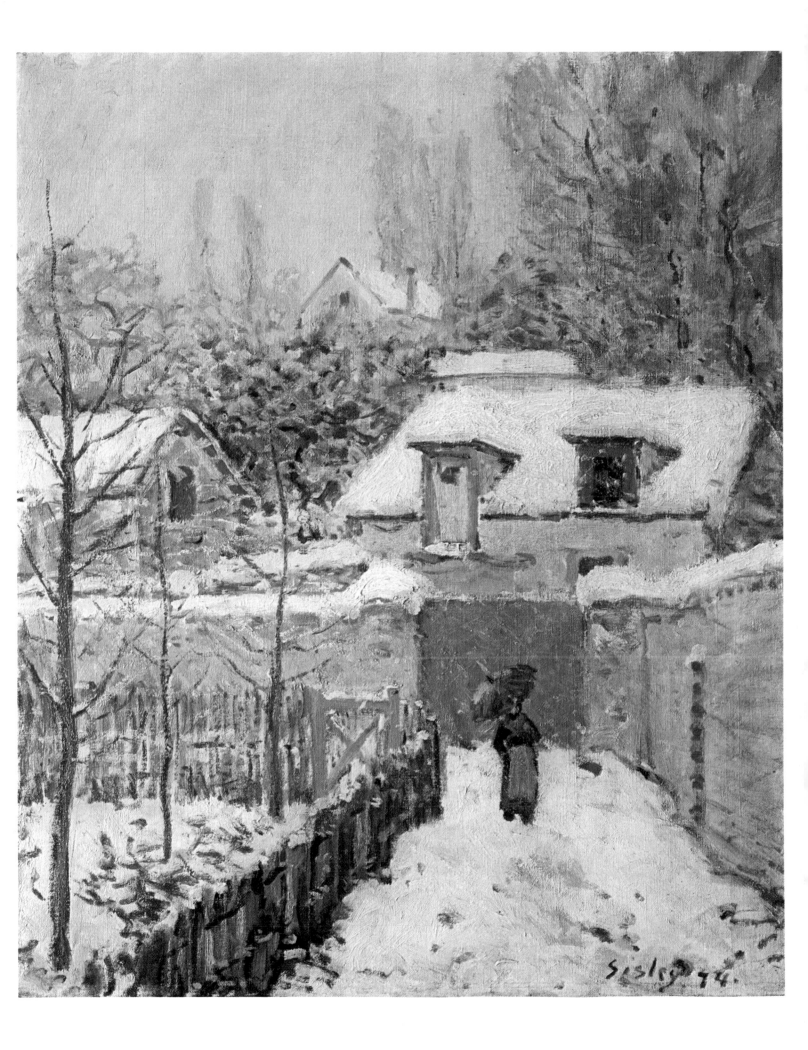

BERTHE MORISOT (1841–1895)

Painted in 1872

The Balcony

Oil on canvas, 23⅝ × 19⅝″
Ittleson Collection, New York

This painting shows the artist's sister, Mme Pontillon, and niece (later Mme Paul Gobilliard) on a hotel balcony in the Rue Franklin in Paris.

Here we have the charming side of this delicate, exquisitely feminine painter, whose development falls between the broad luminous compositions of Manet and the dancing strokes of Impressionism. There is a tenderness, a gift for evoking childhood and womanhood that touches the heart. From the terrace we see the Seine, across which rises the gilded cupola of the Invalides.

This woman in black looking over the city, the child clinging awkwardly to the railing of the balcony, the flowers to the right, placed there in tribute to Fantin-Latour, the evocation of the landscape (where the Eiffel Tower will not appear for another seventeen years)—everything here induces a kind of gentle reverie.

Look at the strokes on the parasol, the well-paved surface of the terrace, the profile of Mme Pontillon, the provincial lady coming to take a look at Paris. The entire scene, largely neutral in color and painted against the light, is so conceived as to bring out the details of the lighted portion and plunge us into the soft charm of this work with its delicate modulations, where the impression is conveyed more by the general atmosphere than by the style.

There is a watercolor version of this picture in the Art Institute of Chicago.

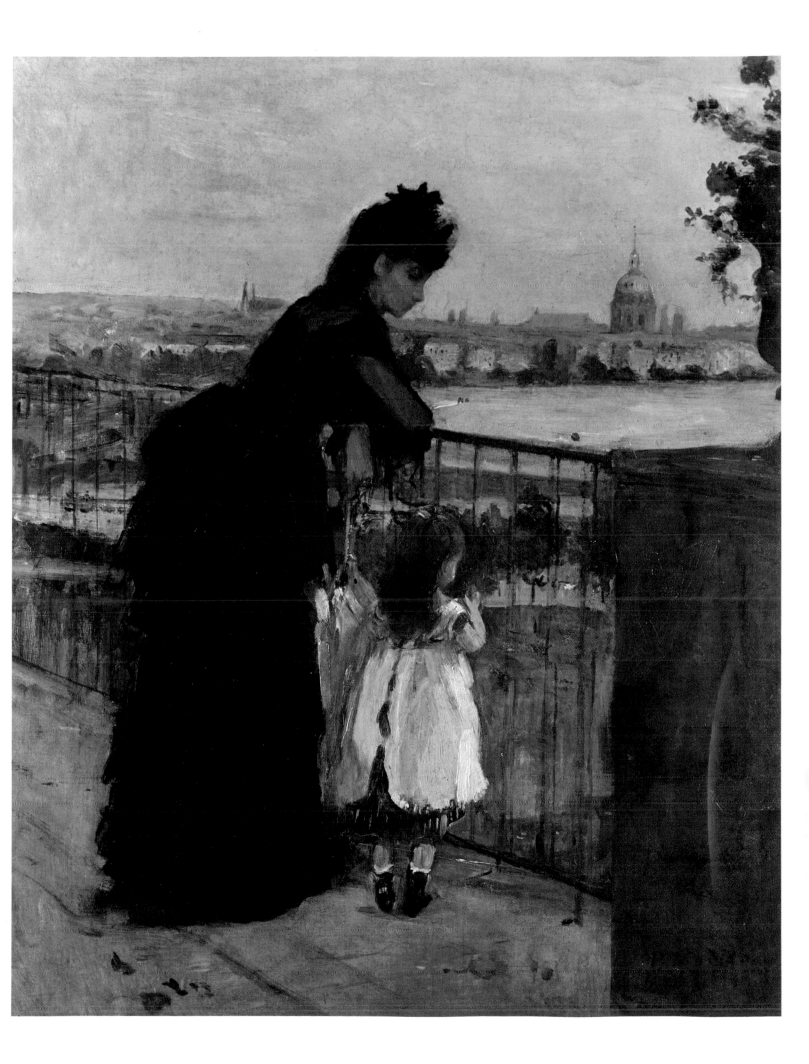

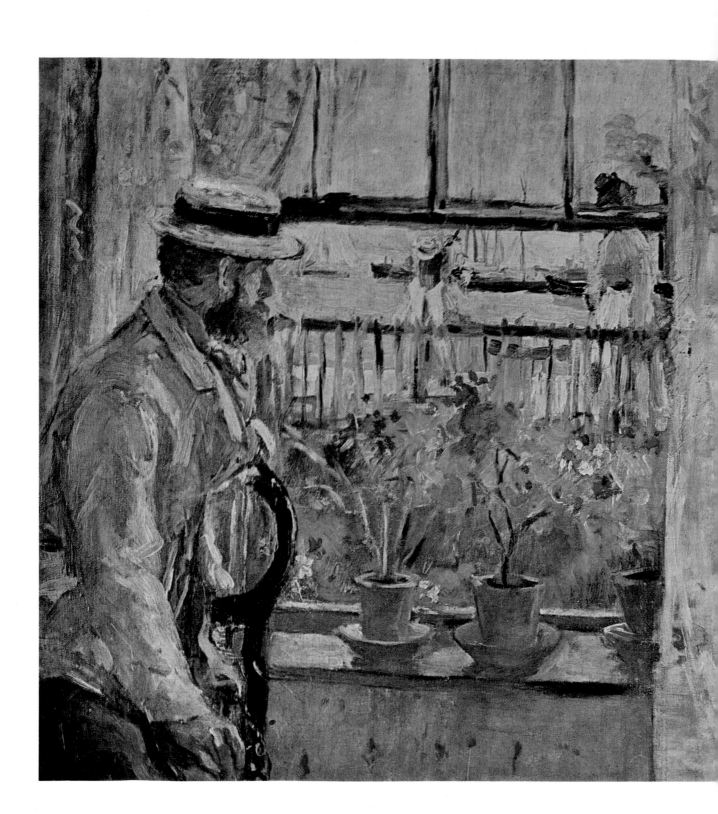

BERTHE MORISOT (1841–1895)

Painted in 1875

Eugène Manet on the Isle of Wight

Oil on canvas, 15 × 18⅛"
Private collection, France

Here is a little symphony of nuances, showing perhaps the most delicate sensitivity of any Impressionist work. The curtains are rendered in warm and cool grays, from bluish to pink, and there are the red accents of the flowers.

The man is Eugène Manet, brother of the painter. He and Berthe Morisot had been married the previous year, on December 22, 1874. Agathe Rouart-Valéry, the artist's grandniece, has said: "I do not believe that Berthe Morisot ever painted any other man but her husband, and he soon got tired of posing."

Here there is delicacy and feeling, and also a sense of openness on the quai and sea outside. Everything is marked by that "intense, almost morbid impression" of which the artist speaks in her notebooks, an "impression close to the joys and sorrows known only by the initiated."

Before her marriage, we may recall that it was through Fantin-Latour, at The Louvre, that Berthe Morisot—having been encouraged in her painting by Corot—met Édouard Manet, for whom she posed many times before marrying his brother. She was a descendant of Fragonard. Toward the end of her life, she said that the wish for fame after death seemed to her "an inordinate ambition. Mine," she added, "is limited to the desire *to set down something as it passes, oh, something, the least of things!*"

BERTHE MORISOT (1841–1895)

Painted in 1879

Young Woman in a Party Dress

Oil on canvas, 33⅞ × 20⅞"
Museum of Impressionism, The Louvre, Paris

Here one sees with what fresh sensitivity Berthe Morisot fulfilled her desire to set down the passing moment. Has not the artist said everything in this silken young woman preparing to launch herself on the dance like a human flower? Light penetrates the whole canvas, dazzling and transparent as in facets of crystal. Everything is expressed, everything is suggested by the powdered skin, the enraptured look, the bosom, the chaste line of the shoulders and arms, the refined oval of the face with the scarcely painted lips, the vague and luminous quality of the whole.

The accents are applied with consummate skill. First, those of the background, violent and slashing, make the rosy pallor of the flesh tones stand out. Those of the

hair are finer and softer. Everything, including the silvery whiteness of the peonies and the pliancy of the drawing, justified the admiration of Stéphane Mallarmé, who, at the sale of Théodore Duret's collection on March 19, 1894, recommended that the State acquire this canvas for The Louvre.

The work was painted the year in which, ill after the birth of her daughter Julie, Berthe Morisot had spent the summer in Beuzeval-Houlgate. The painting was shown at the Salon des Impressionnistes, Rue des Pyramides, in 1880 (it was the group's fifth exhibition). "There are five or six lunatics there, one of them a woman," said a critic.

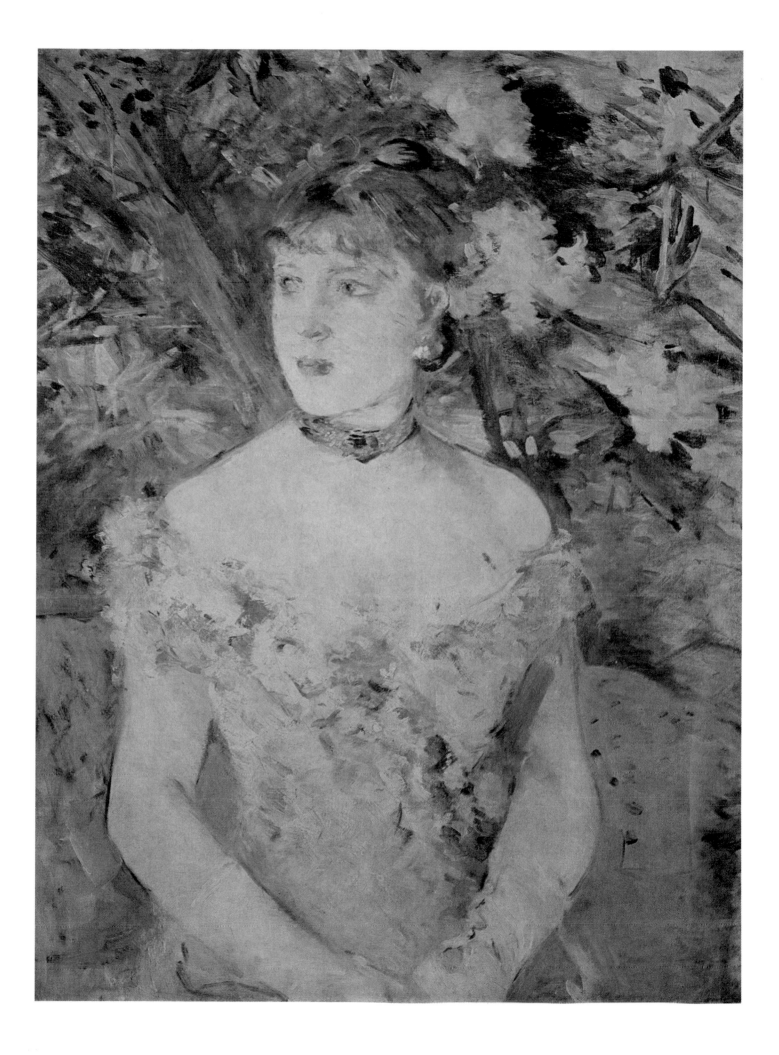

MARY CASSATT (1845–1926)

Painted about 1879

The Daughter of Alexander Cassatt

Oil on canvas, 33 × 24¾"
Collection Mrs. Richman Proskauer, New York

Among the Impressionists, Mary Cassatt was rather like an American fairy godmother who came to the rescue of her companions. Primarily it was she who introduced Paul Durand-Ruel, then in severe financial difficulties, to such wealthy American collectors among her friends as H. O. Havemeyer. She was a particular friend of Degas, who depicted her at The Louvre, at the Musée des Antiques (as it was then called) looking at an Etruscan tomb. "She paints as though she were making hats," he said of this woman, who was chiefly concerned with painting children.

Is there anything more tender, more suggestive of the child in its freshness, its happiness and health, than this picture of a little girl? And the strokes are delightful, with their variations of white, their cerulean blues.

Henry Fèvre called her "a good journeyman of Impressionism." Her children, open as flowers, are not little angels with halos. They are nothing less than happy children. To the insecurities, the social anxieties of the painting of a Carrière, Mary Cassatt opposes her own balanced art of a well-to-do woman at her ease.

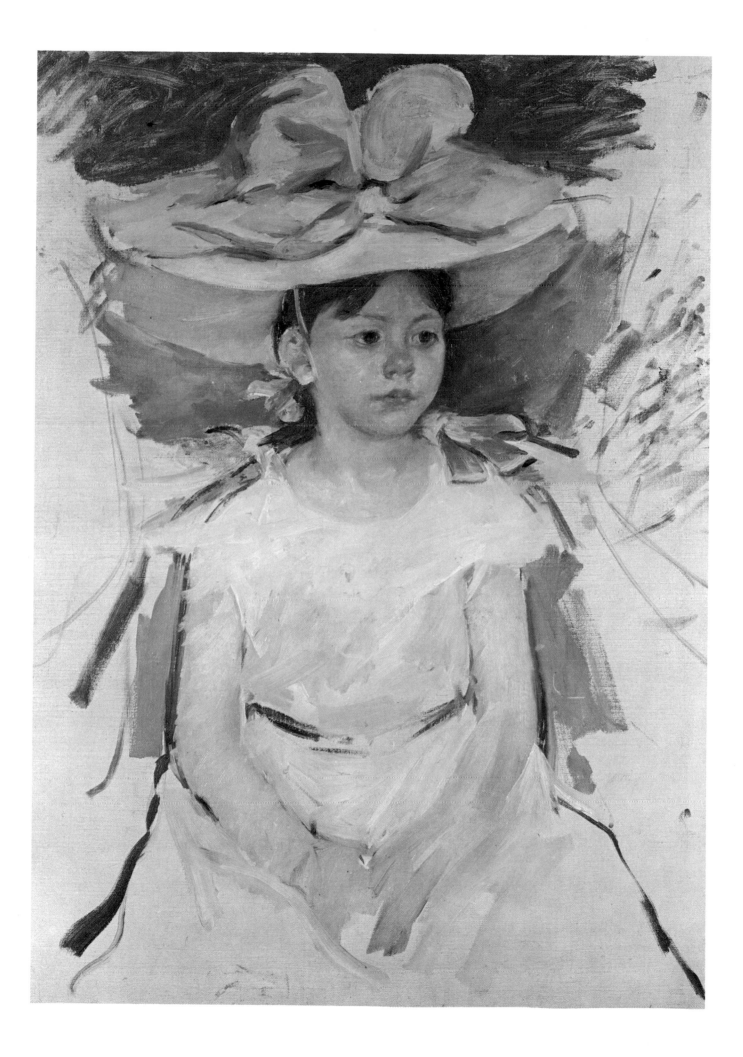

FRÉDÉRIC BAZILLE (1841–1870)

Painted in 1869

Scène d'Eté

Oil on canvas, 62¼ × 62½"
Fogg Art Museum, Harvard University, Cambridge, Mass. Gift of M. and Mme F. Meynier de Salinelles

"A big, strong, good-looking, and very cheerful fellow, free with his money"—thus Tabarant described Bazille. He was a Protestant from the South, and highly gifted. Sometimes he helped his friends Monet and Renoir, whom he had met at Gleyre's, by letting them share his studio. Despite their efforts to dissuade him, he enlisted in the army in 1870, and was killed in the battle of Beaune-la-Rolande (Loiret).

His *Scène d'Eté*, one of the masterpieces of *plein-air* painting, is luminous with sunlight and at the same time solidly constructed, almost anticipating Seurat's *Baig-nade*. The harmony of green and blue gives a cool tone to this large canvas, for which there exist several sketches. "For the bathers—be sure to compare the value of the clear water with the grass in the sunlight," reads a note written by Bazille in a sketchbook, in reference to this scene, more in a Naturalist than a Realist vein. The landscape was painted on the banks of the Lez.

It is, along with *Monet After His Accident at the Inn in Chailly* and *The Artist's Studio, Rue de la Condamine*, one of the most successful works by this painter, dead at the age of twenty-nine.

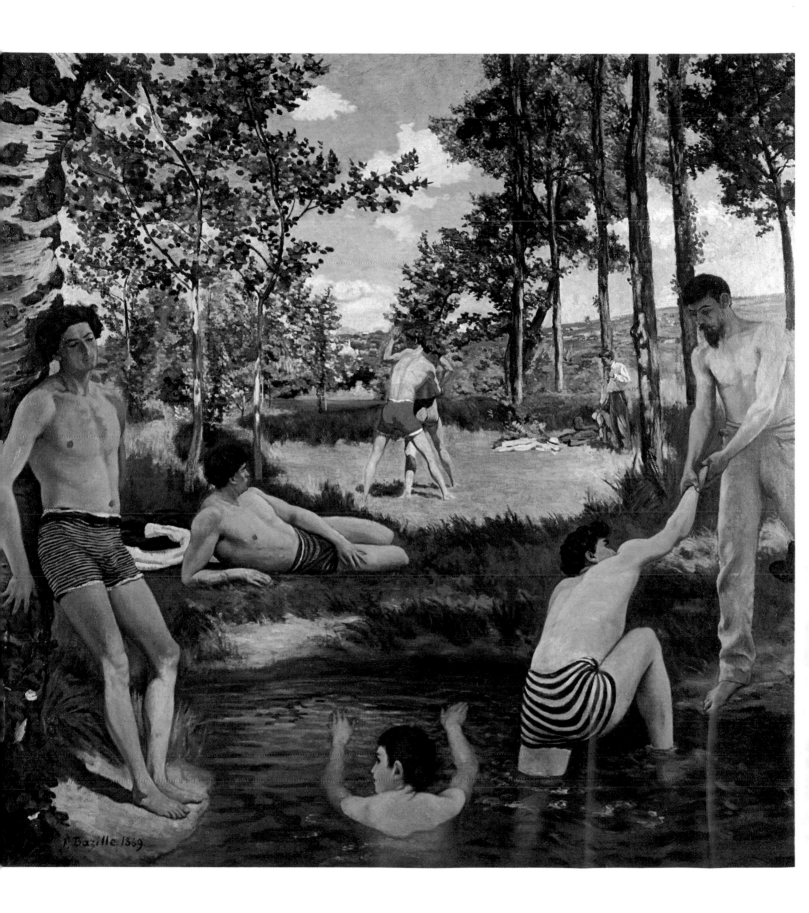

MAX LIEBERMANN (1847–1935)

Painted in 1905

The "Oude Vinck" Restaurant in Leyden

Oil on canvas, 28 × 34⅝"
Kunsthaus, Zurich

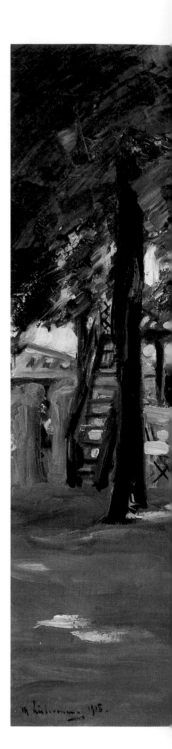

Max Liebermann is the only painter in Germany who can be called an Impressionist. Corinth and Slevogt (who participated with him in the Berlin Secession of 1898) only occasionally painted pictures influenced by the French movement.

The son of a Berlin banker, Liebermann lived in Paris from 1873 to 1878, and spent his summers in Barbizon. The influence of the Manet of Rueil is very recognizable in his work. In his own country, Liebermann introduced and championed Monet and his group. In 1878, he wrote an essay on Degas, with whom he felt certain affinities, notably that of considering black as a color.

In his transition from the Realism of Courbet and the Barbizon School to the subtle nuances of the Impressionists, Liebermann painted a number of self-portraits in which he depicts himself a dry and mordant observer.

He paints this outdoor restaurant in Leyden with a clear, transparent, and careful touch, venturing in the execution those difficult patches of sunlight dear to Monet and Renoir. By the sketchy expression of his brush, the improvised appearance of his drawing, the clarity of such tones as the white and yellow, his way of opening the canvas to light and air, and of preserving an often marvelous limpidness of color, Liebermann takes his place, although tardily, among the Impressionists of the early style.

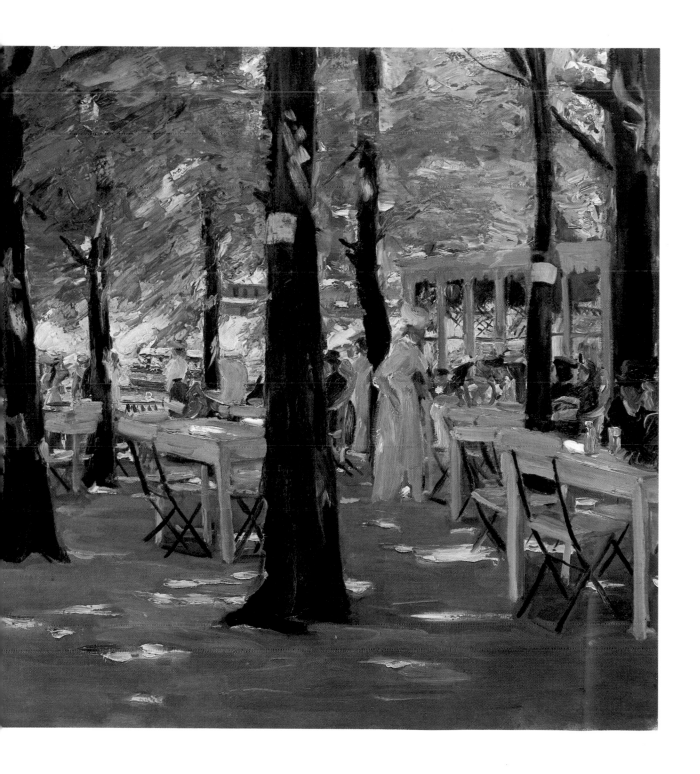

PAUL GAUGUIN (1848–1903)

Painted in 1885

The Beach at Dieppe

Oil on canvas, 28¼ × 28¼"
The Ny Carlsberg Glyptothek, Copenhagen

This picture is very clear in its color, light, and technique. But one is aware of that pursuit of the monumental toward which Gauguin was already inclined. The construction of the picture in horizontal bands under the sky with its rounded clouds is broken by the masts of the sailboats and the figures of the bathers who have waded beyond the first line of breakers.

In the foreground, the seated figures lend weight and are rendered in large silhouettes, as Seurat does in his turn.

In those of his paintings where we find the influence of Pissarro, Gauguin at this time is still an Impressionist in his love of sunlight, his freedom of technique, the freshness of his colors, and finally for a certain Japanese quality. "But," says Maurice Denis, "he aspired to read the book wherein the eternal laws of beauty are inscribed."

A fierce individualist, Gauguin nevertheless liked popular art reflecting the spirit of collectivity. And he was soon to turn toward what he called "savage design" and "barbarous color."

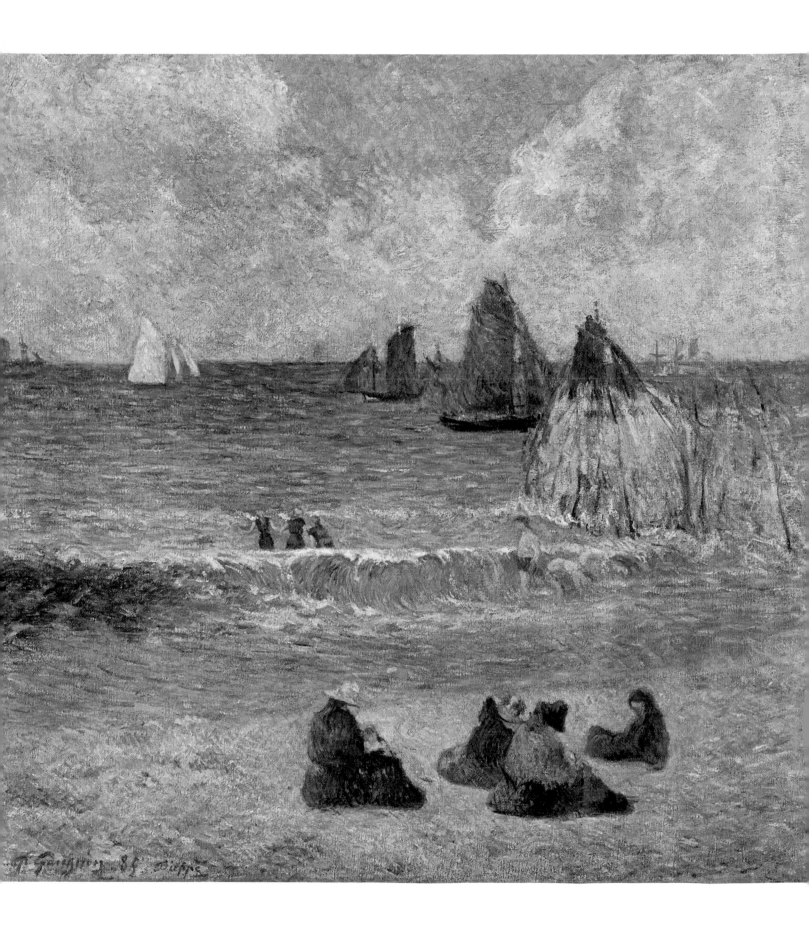

VINCENT VAN GOGH (1853–1890)

Painted in 1886–88

Fourteenth of July in Paris

Oil on canvas, 17¼ × 11¾"
Collection Jaeggli-Hahnloser, Winterthur, Switzerland

This is an unusual canvas in the work of Vincent van Gogh. It is Impressionistic in its rapid, brightly colored, and seemingly improvised technique, but in its use of exaggerated color it points the way toward Fauvism.

The strokes are very broad and the tones seem to suggest the three colors of the French flag, but unconsciously, in a marvelous frenzy of technique. The turbulent color and brushwork, characteristic of Van Gogh's works, has prompted Jacques-Emile Blanche to speak caustically of "pictorial Parkinsonism." I see here, on the contrary, the religious drama of Van Gogh, a man perpetually flayed who committed himself to

painting as a means of salvation. This profound artist was something other than a "Flying Dutchman of Provence." He and Gauguin both lent themselves to legend, Gauguin by his Bretonized South Sea Islands, Van Gogh by his madness and the episode in which he cut off his ear with a razor. But Van Gogh is the one who seems victorious to those who can see the vision that lies beyond his painting.

This canvas shows Van Gogh attempting to turn away from the fleeting sensations of the Impressionists. One feels his effort to recover a certain conciseness.

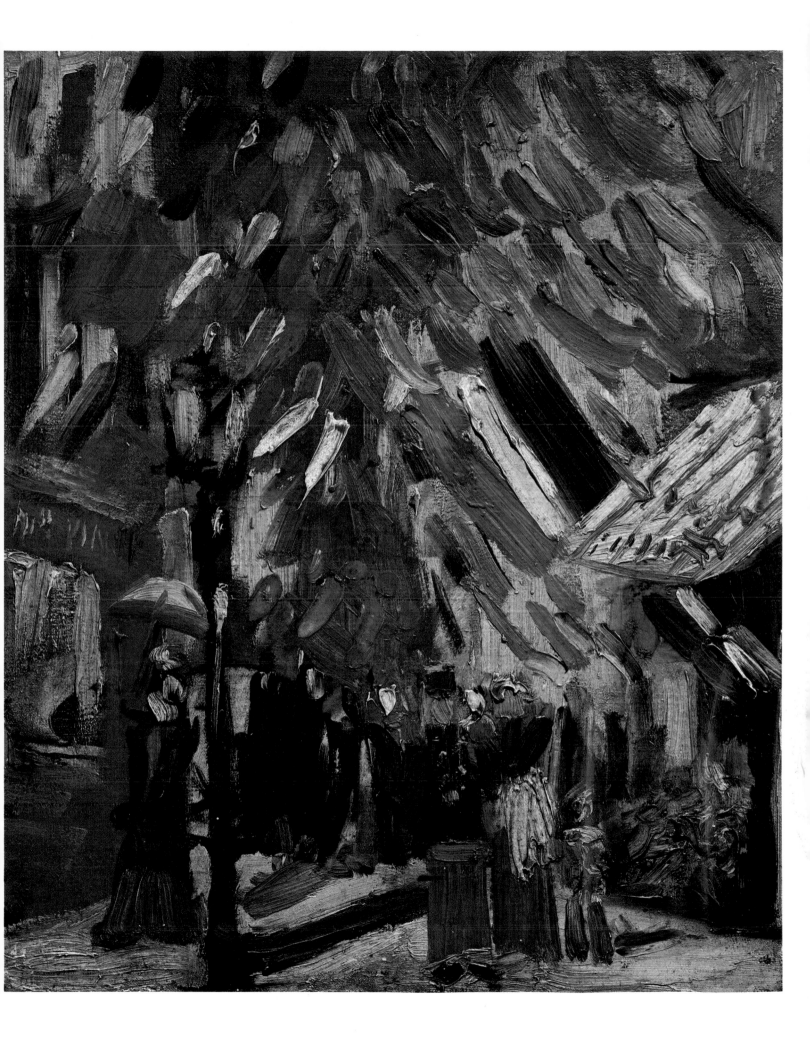

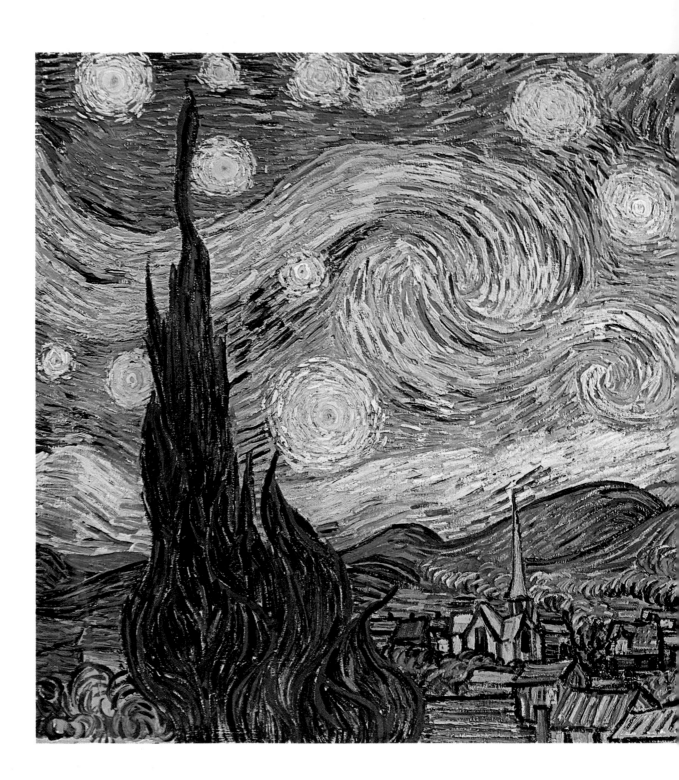

VINCENT VAN GOGH (1853–1890)

Painted in 1889

The Starry Night

Oil on canvas, 29 × 36¼″
The Museum of Modern Art, New York. Lillie P. Bliss Bequest

This is a late work. But if little remains of an Impressionist character in its technique, there is still some in its nocturnal illumination, its truth, and its moving comprehension of nature as transcended by an exceptional temperament. This night Impressionism extends that of Whistler and of Degas. But the picture goes still further. In its blues and greens, its brilliance of golden stars, it contains the mystery of all creation.

In his presentation of Van Gogh in *Les Hommes d'aujourd'hui* (No. 390), Emile Bernard observes that "one feels sad in the presence of the cypresses, somber as magnetic lances piercing the stars; such nights strew comets in the dense ultramarine darkness."

GEORGES SEURAT (1859–1891)

Painted about 1884

The Canoe

Oil on wood, 6¼ × 10¼"
Private collection, Paris

This is surely the most Impressionist picture in all of Seurat's work. We might say that here, under the pretext of his title, the painter has tried to combine all that is transient: the fragile craft gliding swiftly on the river, the wind in the leaves, the passage of time. No other work gives such a feeling of the moment—and of a moment taken more or less at random, like a fragment detached from the whole.

In my book on Seurat, I followed De Hauke in dating this picture about 1887, but it now appears to me to be one of the works preparatory to *La Grande Jatte*, one of the landscapes of which Angrand speaks in recalling his friendship with Seurat: "Conversations at the studio and return to the Café Marengo, in the evening, after the afternoon meetings at the *brasserie . . . and we side by side before our respective canvases on the Grande Jatte. . . .* He would welcome me without pausing, without putting down his palette, hardly turning his half-closed eyes from the motif. When we were finished for the day, we crossed the Seine on a little ferry, the *Artilleur*, and came back by Courbevoie and the Rue de Levis. . . . [Seurat] pointed out—in one of our hundreds of conversations along the way—the purplish red aureole of the young trees that had just been planted on the boulevard along the river" (Letter to Lucie Cousturier, July 4, 1912, published in *La Vie*, October 1, 1936).

Overleaf ▶

GEORGES SEURAT (1859–1891)

Painted in 1883–84

Bathing at Asnières (Une Baignade)

Oil on canvas, 79×118½"
National Gallery, London

This is Seurat's first great picture. It is painted in flat strokes, and precise outlines are still here and there apparent. This technique, still linear at times, will disappear in the artist's next compositions, *La Grande Jatte* and *The Models*.

But already we can measure this revolutionary artist's gift for synthesis. Whatever there was in Impressionism of the fragmentary, or rather the fragmented, has completely disappeared from this broad synthesis. The artist made sketches for every detail in the picture, and put them together in this admirable composition which, against the factory background of Asnières, may be said to stand for the water, sun, and bathers of all the summers of the world.

It is sufficient to compare this symphony of blue, green, and pink to Manet's *Argenteuil* and Renoir's *Dancing at the Moulin de la Galette* to perceive at once Seurat's extraordinary contribution in the composition, his knowledge of color, and his skill in setting the scene (in which, as Meyer Schapiro has shown, he was inspired by Puvis de Chavannes). Another innovation lies in his study of the significance of line according to its direction and position in the picture. These considerations were suggested to the painter by reading a work by Humbert de Superville, published in Leyden in 1827.

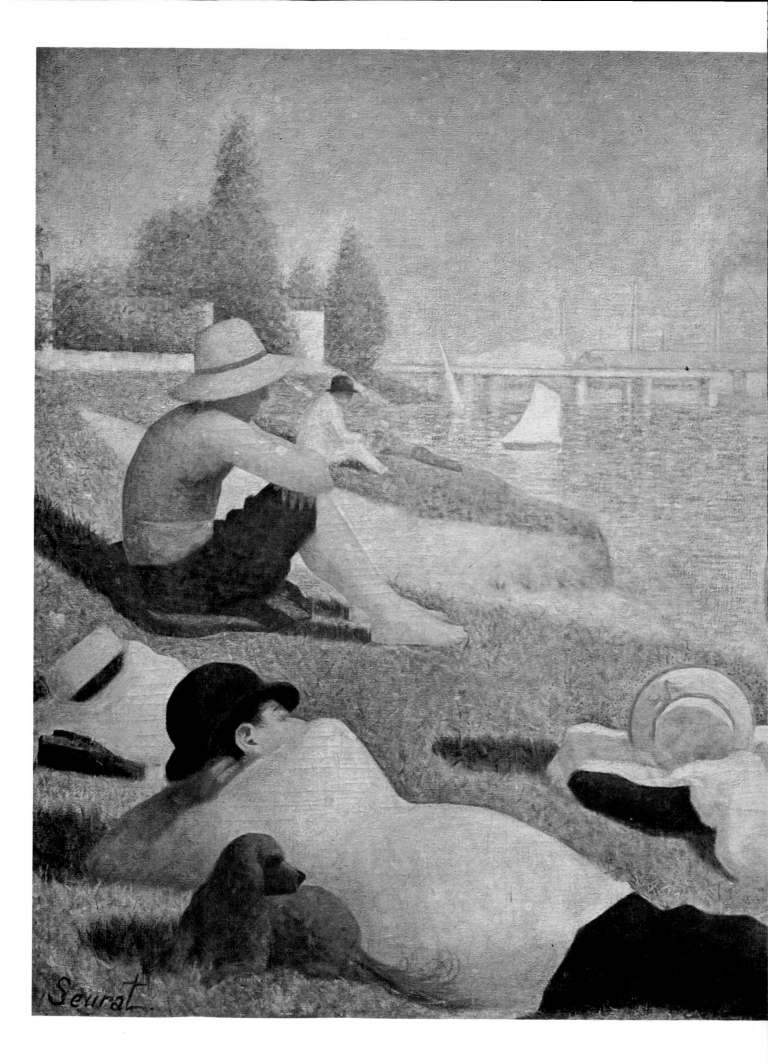

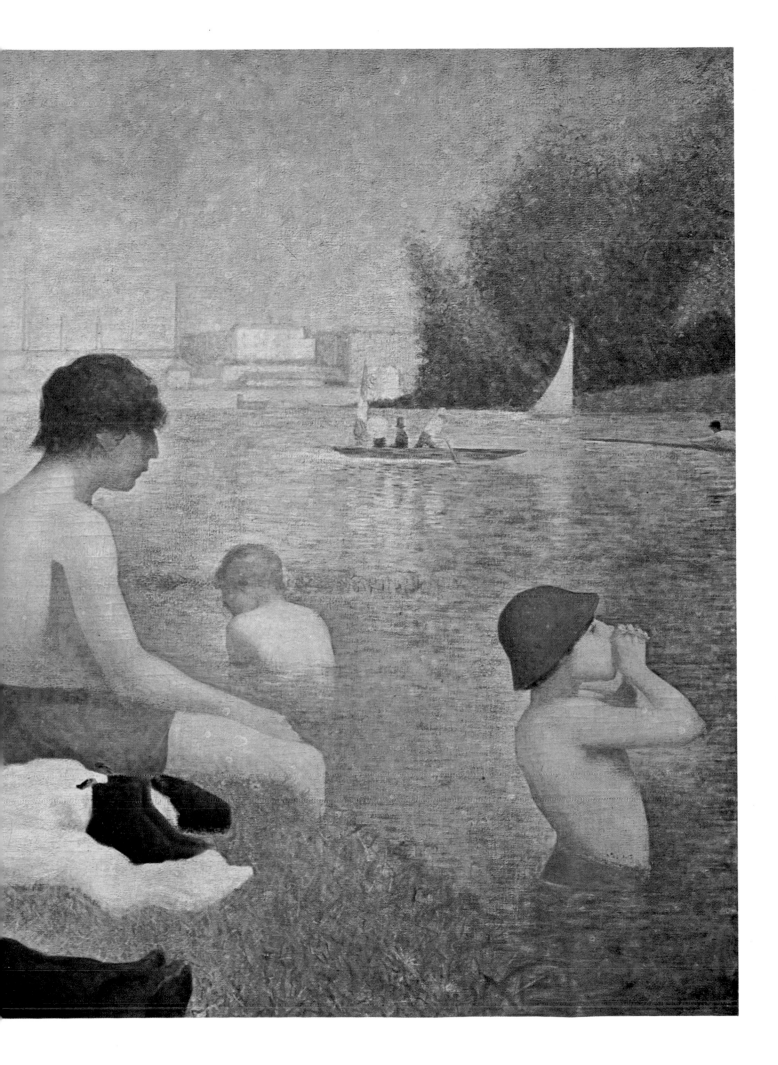

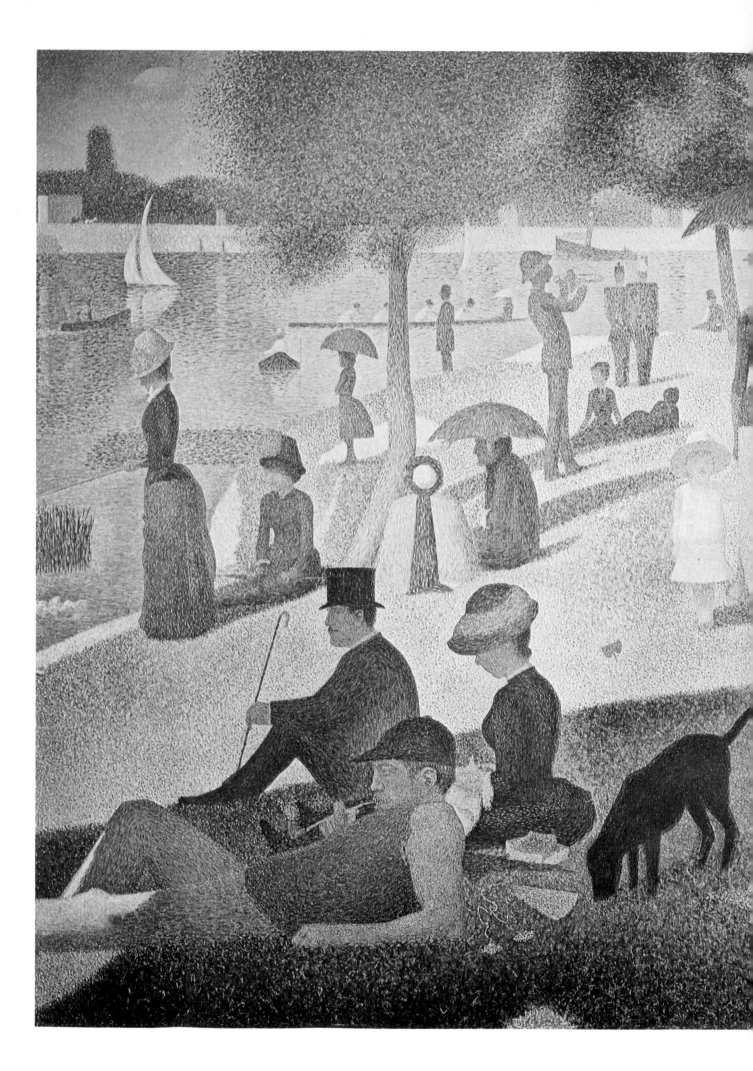

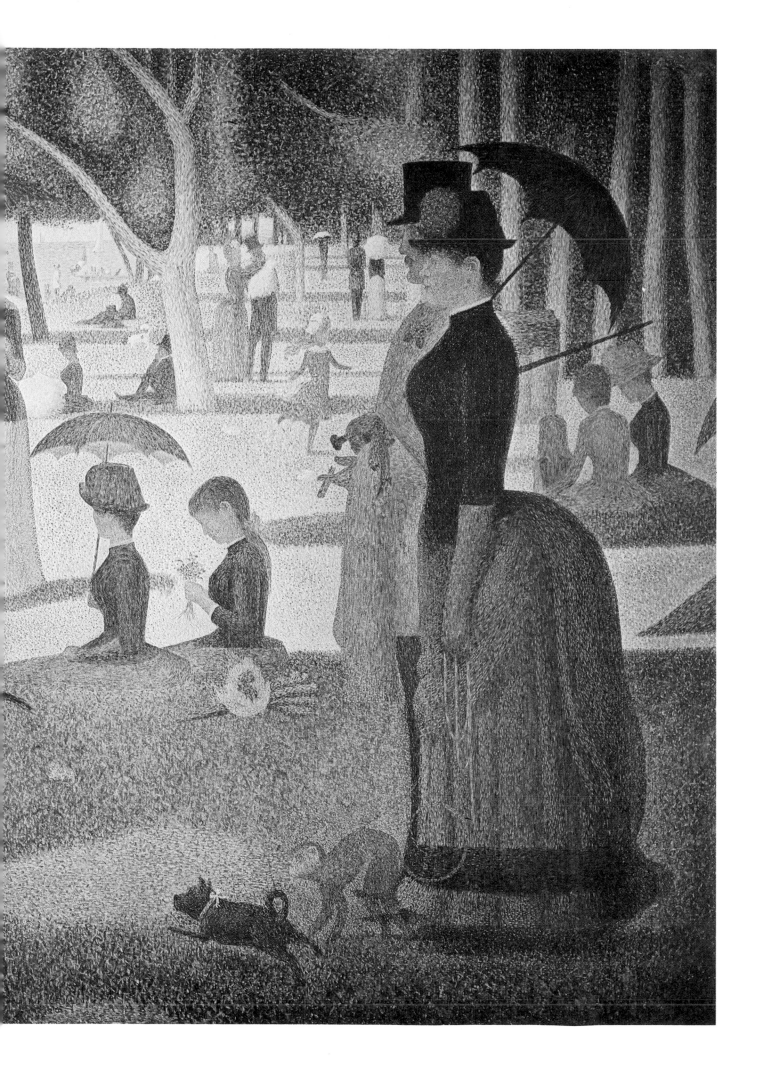

GEORGES SEURAT (1859–1891)

Painted in 1884–85

A Sunday Afternoon on the Island of La Grande Jatte

Oil on canvas, 81 × 121″
The Art Institute of Chicago. Helen Birch Bartlett Collection

Everything here has its place in the composition. One would not be able to shift the smallest element in this great summer scene—a standing or seated figure, a tree, a distant vista, a blade of grass—without disarranging the whole. It is a work executed with deliberation, in which every detail has been thought out in advance. The painting gives us a general vision. The light, the colors, the transition from shadow to sunlight—everything has been admirably calculated and apportioned.

This great work, which at the time of its creation aroused violent controversy (even among the Impressionists), calls to mind these reflections by Chevreul, the chemist whose writings made a deep impression on Seurat, in his *De l'abstraction* (Dijon, 1864): "When it is a question of representing the view of a landscape or a group of figures participating in some action, whether public or private . . . the painter to be truthful can represent only a *moment* in a landscape in which light and shadow vary continually, he is obliged to choose *this moment* from among others; henceforth this moment should be considered a *veritable abstraction of the sum of the moments making up the duration of the occurrence of the scene he has chosen* as his subject. If the painter thus makes an abstraction for time, he does the same for space, especially when it is a question, for example, of a vast landscape or a large assemblage of people."

The Watering Can

Painted about 1883
Oil on wood, 9¾ × 6″
Collection Mr. and Mrs. Paul Mellon, Upperville, Va.

This is one of the studies in which, by limiting himself to the painting of a single object, a watering can, the painter demonstrated his ability to his circle of friends. The setting is the garden of Le Raincy, belonging to Chrisostôme Seurat, the painter's father; it is also the sun, the color, the heat of summer. Thus Seurat takes a detail of the kind adopted by the Impressionists before him, and isolates it in a monumental close-up.

"Seurat," says Angrand, who was often his working companion, "was truly predestined, one of the elect. He was as much a painter as anyone among the great— and this despite an artistic concept virtually limited to harmony. What a rare vision! He usually reduced his subject, a deliberately modest one to begin with, still further by eliminating all picturesque details, and then clearly and expressively re-created it by the single device of miraculously subtle nuances" (Letter to Lucie Cousturier, dated July 4, 1912, published in *La Vie*, October 1, 1936).

Even more than with Monet and his companions, the outline here is nonexistent, at least in any linear sense. It is formed by gradations, a halo of light, a proliferation of color spots. Likewise, in the drawings of that period, the pencil leaves a thin deposit around the silhouetted form but never circumscribes it with an outline.

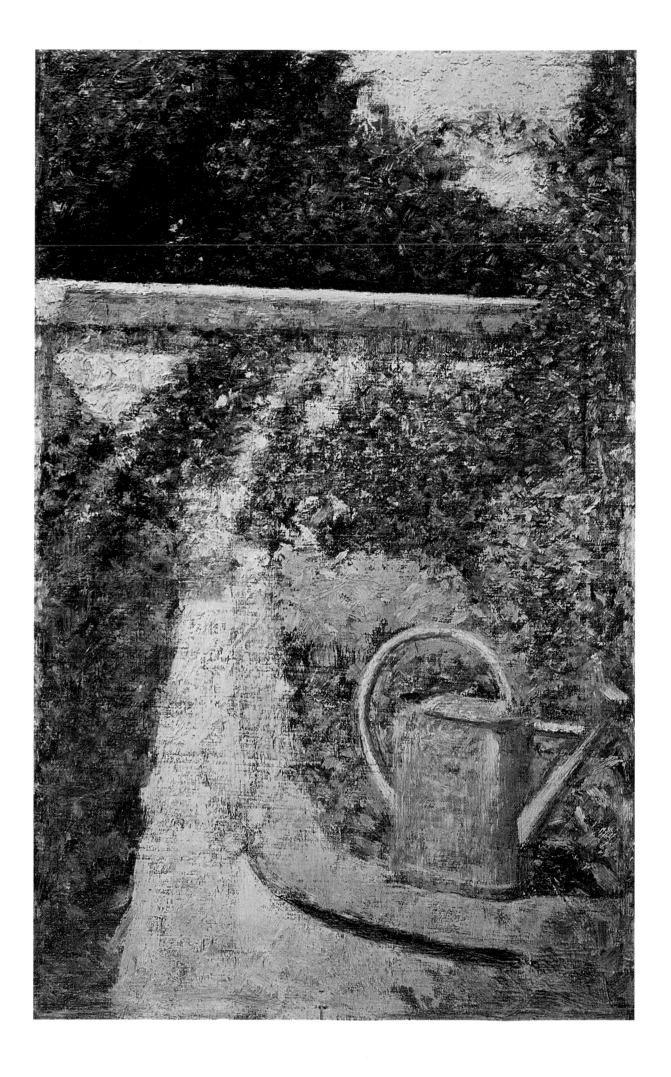

PAUL SIGNAC (1863–1935)

Painted in 1886

Boulevard de Clichy in Paris

Oil on canvas, 18 × 25¼″
The Minneapolis Institute of Arts. Putnam Dana McMillan Bequest

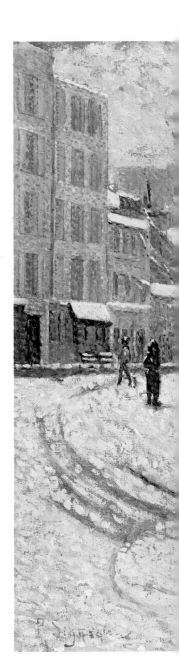

Signac painted this work before becoming a systematic Divisionist. This evocation of Paris still shows complete freedom in its technique, the brushstrokes being comma-shaped rather than dots. The white and bluish tones of the snow are admirably rendered. The artist's touch seems to dance with the snowflakes.

This is the early Signac, the colorist who "decks the corners of Paris with clear light" (Arsène Alexandre). The accents are sharply pronounced in the trees and passersby.

Signac, according to Gustave Kahn, was "methodical, all ardor and impulse. His first admiration had been for Guillaumin. He adopted the theories of Seurat, whose rival he became because of his brilliant gifts as a painter. He read a good deal and was a bibliophile." It might have been advisable for him to have stayed with the conception and technique of this *Boulevard de Clichy*. A good writer and always a fine craftsman, Signac possibly abused these theories, which he was less prepared than Seurat to master and to violate when necessary.

He was one of the founders of the Société des Artistes Indépendants, which, in 1884, at the Tuileries, "opened our eyes," as de Maupassant wrote, "to all those who were attempting something new, all those working sincerely outside the old customs, seeking true color, unobserved nuances, everything that the Ecole and a misleading classical education hinders one from knowing and understanding."

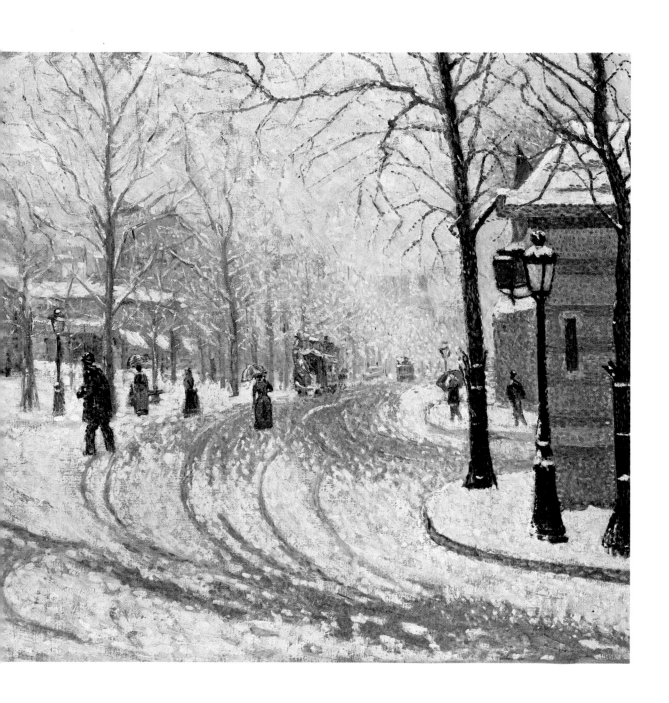

MAURICE PRENDERGAST (1859–1924)

Painted in 1899

Ponte della Paglia

Oil on canvas, 28 × 23″
The Phillips Collection, Washington, D.C.

It was in 1899, during a stay of several months in Venice (a trip to Europe having been made possible thanks to the help of Mrs. Montgomery Sears of Boston), that Maurice Prendergast painted one of his most striking canvases.

The Ponte della Paglia is in the heart of Venice. Prendergast depicts it in quick, lively strokes that represent the numerous passersby. These rapid, flowing notations, sometimes crossed or rounded, with curves, circles, and ovals cut by a vertical or horizontal, are still related to Impressionism and distantly to the baroque manner of Cézanne.

Hanging in Mrs. Duncan Phillips's large drawing room outside Washington, this work has the impact of a display of fireworks.

It was on seeing the canvases that Prendergast painted in Venice that Robert Henri invited him, in 1908, to participate in the famous exhibition of The Eight, derisively dubbed the Ashcan School, which brought together the best American artists of the time.

The son of a poor family, Prendergast began to earn his living very early as a commercial artist. With the little money he was able to save, he went to Paris in 1886, and for three years worked at the Académie Julian and the Atelier Colarossi. The reputation of this independent artist was slow in coming, and this lack of recognition, as Suzanne La Follette notes in *Art in America*, is "a severe judgment of American taste during his time."

Prendergast lived the rest of his life in New York, in a studio in Washington Square, where he died in 1924.

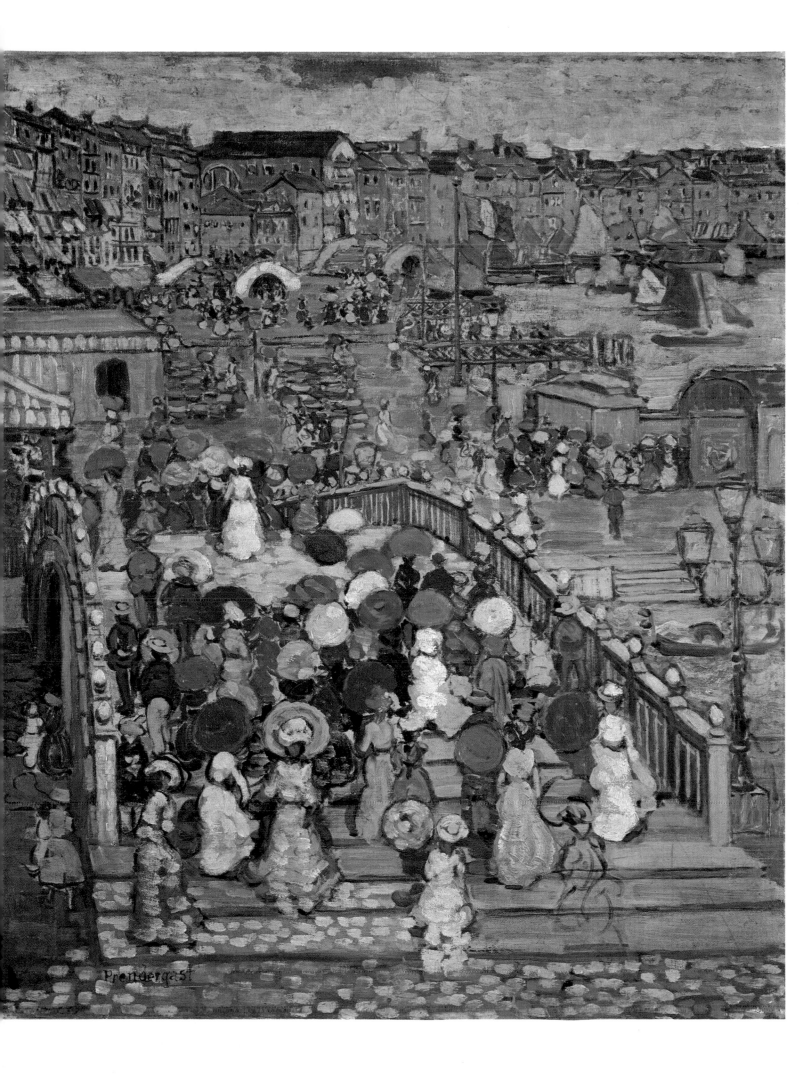

PIERRE BONNARD (1867–1947)

Painted in 1913

Dining Room in the Country

Oil on canvas, 63 × 80"
The Minneapolis Institute of Arts

Along with the panels that he painted for the Trocadero and those that are in the home of Mme Kapferer, this is, I believe, one of Bonnard's largest works. Even when reproduced in black-and-white, one can admire its solid construction and its counterpoint of light and shadow. To see it in color is to be even more struck by its harmony.

Our eyes are enraptured on being drawn into the transposed reality created by this painter of the marvelous. Only the most consummate art can so lead the spectator's gaze from within to the outside and again within, with light and shadow balanced in perfect equilibrium.

In this painting we see all the splendor of summer. Outside, among the luminous greens, one seems to hear all the sounds of a July day; inside, an absolute silence. The palette varies from the vermilion blouse of the woman leaning inward against the light, to the more purplish reds of the tapestry. By its contrast to the rest, the mauve white of the cloth on the round table makes the painting vibrate. Even the cat on the chair has lost any anecdotal significance to become an element of this incomparable work.

The style has great freedom. It is flexible, obedient to the artist's sensibility, and adapts itself with entire ease to his intended meaning. Thus from this everyday scene—and, unlike Turner, without losing his grasp of the simple and ordinary—Bonnard was able to create a higher reality.

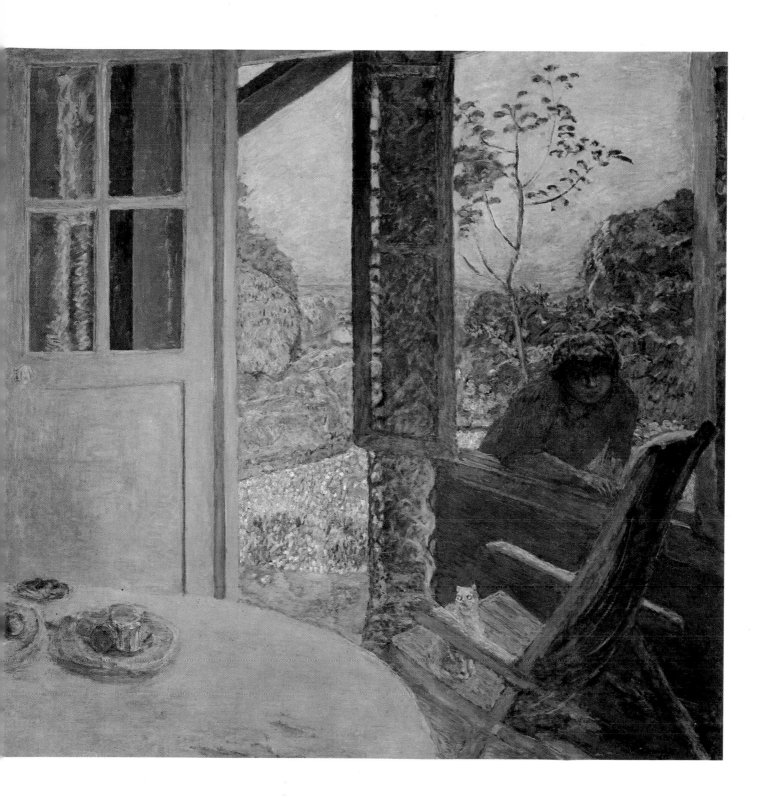

Pierre Bonnard. *The Hours of the Night.* 1893.
Lithograph from *Petites Scènes familières*

BIBLIOGRAPHY

ADHÉMAR, HÉLÈNE, and DREYFUS-BRUHL, MADELEINE. *Catalogue des peintures, pastels, sculptures impressionnistes du Louvre.* Paris, 1958

ALEXANDRE, ARSÈNE. *La Collection Canonne: une histoire en action de l'Impressionnisme.* Bernheim Jeune, Paris, 1930

AURIER, ALBERT. *Oeuvres posthumes.* Paris, 1893

BLANCHE, JACQUES-EMILE. *Les Arts plastiques.* Editions de France, Paris, 1931

———. *De Gauguin à la Revue Nègre.* Paris, 1928

CASSOU, JEAN. *Les Impressionnistes et leur époque.* Cercle Français d'art, Paris, 1953

COGNIAT, RAYMOND. *French Painting at the Time of the Impressionists.* Hyperion Press, New York, 1951

COQUIOT, GUSTAVE. *Les Indépendants.* J. Dardaillon, Paris, 1921

COURTHION, PIERRE. *Autour de l'Impressionnisme.* Nouvelles éditions françaises, Paris, 1964

———. *Manet.* Abrams, New York, 1961

———. *Seurat.* Abrams, New York, 1968

DENIS, MAURICE. *Du Symbolisme au Classicisme, théories.* Paris, 1949

DURANTY, EDMOND. *La Nouvelle Peinture.* Librairie E. Dentu, Paris, 1876; new edition with foreword and notes by Marcel Guérin, Floury, Paris, 1946

DURET, THÉODORE. *Critique d'avant-garde.* Charpentier, Paris, 1885

————. *Histoire des peintres Impressionnistes.* Paris, 1894; 4th ed., Floury, Paris, 1939

FÉNÉON, FÉLIX. *Les Impressionnistes en 1886.* Publications de la Vogue, Paris, 1886

————. *Oeuvres.* Gallimard, Paris, 1948

FERMIGIER, ANDRÉ. *Bonnard.* Abrams, New York, 1969

FÈVRE, HENRY. "Etude sur le Salon de 1886 et sur l'Exposition des Impressionnistes." *Demain,* Paris, 1886

FOCILLON, HENRI. *La Peinture aux XIX et XXème siècles.* H. Laurens, Paris, 1928

GEFFROY, GUSTAVE. *Histoire de l'Impressionnisme—La Vie Artistique,* 3rd Series (articles written after 1885). Paris, 1894

GOLDWATER, ROBERT. *Gauguin.* Abrams, New York, 1958

HAMANN, RICHARD. *Der Impressionismus in Leben und Kunst.* Verlag des Kunstgeschichtlichen Seminars, Marburg, 1923

————, and HERMAND, JOST. *Impressionismus.* Berlin, 1960

HERBERT, ROBERT L. *Neo-Impressionism* (catalogue). The Solomon R. Guggenheim Museum, New York, 1968

————, ed. *Neo-Impressionists and Nabis in the Collection of Arthur G. Altschul* (catalogue). Yale University, New Haven, 1965

————, and EUGENIA W. "Artists and Anarchism: Unpublished Letters of Pissarro, Signac, and Others." *Burlington Magazine,* Vol. CII, November and December, 1960

HUYSMANS, JORIS-KARL. *L'Art moderne.* Charpentier, Paris, 1883

————. *Certains.* 5th ed. Plon-Nourrit, Paris, 1908

KAHN, GUSTAVE. "Au Temps du Pointillisme." *Mercure de France,* April, 1924

KOEHLER, ERICH. *Edmond und Jules de Goncourt, die Begründer des Impressionismus.* Leipzig, 1912

LAPRADE, JACQUES DE. *L'Impressionnisme.* Aimery Somogy, Paris, 1956

LA SIZERANNE, ROBERT DE. *Questions esthétiques contemporaines.* Hachette, Paris, 1904

LECOMTE, GEORGES. *L'Art Impressionniste d'après la collection de M. Durand-Ruel.* Chammerot & Renouard, Paris, 1892

LETHÈVE, JACQUES. *Impressionnistes et Symbolistes devant la presse.* Armand Colin, Paris, 1959

LEYMARIE, JEAN. *Impressionism.* 2 vols. Skira, Geneva, 1955

MARX, ROGER. *Maîtres d'hier et d'aujourd'hui.* Calmann-Lévy, Paris, 1914

————. *Un Siècle d'art.* Paris, 1900

MATHEY, FRANÇOIS. *The Impressionists.* Praeger, New York, 1961

MEIER-GRAEFE, JULIUS. *Impressionisten.* P. Piper, Munich, 1907

MELLERIO, ANDRÉ. *L'Exposition de 1900 et l'Impressionnisme.* Floury, Paris, 1900

MIRBEAU, OCTAVE. *Des Artistes,* 1st series (articles appearing in 1886–96). Flammarion, Paris, 1922

MOORE, GEORGE. *Reminiscences of the Impressionist Painters.* Maunsel, Dublin, 1906

MOSER, RUTH. *L'Impressionnisme français: Peinture, littérature, musique.* Librairie Droz, Geneva, 1952

NOVOTNY, FRITZ. *Die grossen französischen Impressionisten.* Anton Schroll, Vienna, 1953

PACH, WALTER. *Renoir.* Abrams, New York, 1950

PICA, VITTORIO. *Gli Impressionisti francesi.* Istituto Italiano d'Arti Grafiche, Bergamo, 1908

PISSARRO, CAMILLE. *Letters to His Son Lucien,* edited with the assistance of Lucien Pissarro by John Rewald. Pantheon, New York, 1943

PLATTE, HANS. *Les Impressionnistes.* Paris, 1963

POGU, GUY. *Néo-Impressionnistes étrangers et influences Néo-Impressionnistes.* Paris, 1963

————. *Sommaire de technologie divisionniste: Catalogue de l'exposition Hippolyte Petitjean.* Paris, 1955

RAGGHIANTI, C. L. *Impressionismo.* Chiantore, Turin, 1947

REUTERSVÄRD, OSCAR. "The 'Violettomania' of the Impressionists." *Journal of Aesthetics and Art Criticism,* Vol. IX, No. 2, December, 1950

REWALD, JOHN. *The History of Impressionism,* rev. ed. Museum of Modern Art, New York, 1961

————. *Pissarro.* Abrams, New York, 1963

————. *Post-Impressionism, from Van Gogh to Gauguin.* Museum of Modern Art, New York, 1958

RICH, DANIEL CATTON. *Degas.* Abrams, New York, 1951

RIVIÈRE, GEORGES. *L'Impressionniste, journal d'art.* Paris, 1877

SCHAPIRO, MEYER. *Cézanne.* Abrams, New York, 1952

————. *Van Gogh.* Abrams, New York, 1950

SEITZ, WILLIAM C. *Monet.* Abrams, New York, 1960

SIGNAC, PAUL. *D'Eugène Delacroix au Néo-Impressionnisme.* Hermann, Paris, 1964

STEIN, MEIR. *Fransk Impressionisme.* Copenhagen, 1962

STOLL, ROBERT THOMAS. *La Peinture Impressionniste.* Clairefontaine, Lausanne, 1957

THON, LUISE. *Impressionismus als Kunst der Passivität.* Munich, 1927

UHDE, WILHELM. *The Impressionists.* Phaidon Press, Vienna, Oxford University Press, New York, 1937

VAUDOYER, JEAN-LOUIS. *Les Impressionnistes de Manet à Cézanne.* Nouvelles éditions françaises, Paris, 1948

VENTURI, LIONELLO. *Les Archives de l'Impressionnisme.* 2 vols. Durand-Ruel, Paris, New York, 1939

WALDMANN, EMIL. *Die Kunst des Realismus und des Impressionismus im 19. Jahrhundert.* Propyläenverlag, Berlin, 1927

WEISBACH, WERNER. *Impressionismus, ein Problem der Malerei in der Antike und Neuzeit.* 2 vols. G. Grotesche, Berlin, 1910

WILENSKI, R. H. *Modern French Painters.* Harcourt, Brace, New York, 1954

INDEX OF PLATES

All numbers refer to pages; *italicized* page numbers indicate colorplates